THE EVERYTHING® Digital Photography Book

2ND EDITION

Dear Reader,

If you like to take pictures and you see scenes you want to capture everywhere you go, digital photography is for you. It is an exciting art form that has opened up new worlds of visual expression—and it is easy to learn.

In this book I have put together my best tips, learning strategies, and solid information from forty years of experience in photography, twenty of them including computers and digital imaging. Having taught photography for twenty years, I know how to explain technical concepts in simple but accurate terms. My purpose is to create the most useful book available on the craft of digital photography.

Learning the how-to of photography is just the start. Once you know how photography works, you can record and create your own view of the world. I've also included plenty of ideas to whet your creative appetite.

I have been recording my own view of the world for years on my Web site at *www.RickDoble.net*. My digital work has been shown in museums, magazines, and symposiums around the world. I hope that you, too, will have a satisfying future in photography, whether for personal or professional enrichment.

Richard de J. Doble

Welcome to the EVERYTHING® Series!

These handy, accessible books give you all you need to tackle a difficult project, gain a new hobby, comprehend a fascinating topic, prepare for an exam, or even brush up on something you learned back in school but have since forgotten.

You can choose to read an *Everything®* book from cover to cover or just pick out the information you want from our five useful boxes: e-questions, e-facts, e-alerts, e-ssentials, e-definitions. We give you everything you need to know on the subject, but throw in a lot of fun stuff along the way, too.

We now have more than 400 *Everything®* books in print, spanning such wide-ranging categories as weddings, pregnancy, cooking, music instruction, foreign language, crafts, pets, New Age, and so much more. When you're done reading them all, you can finally say you know *Everything®*!

QUESTIONS?
Answers to
common questions

FACTS
Important snippets
of information

ALERTS!
Urgent
warnings

ESSENTIALS
Quick
handy tips

def·i·ni·tion
Definitions

DIRECTOR OF INNOVATION Paula Munier

EDITORIAL DIRECTOR Laura M. Daly

EXECUTIVE EDITOR, SERIES BOOKS Brielle K. Matson

ASSOCIATE COPY CHIEF Sheila Zwiebel

ACQUISITIONS EDITOR Kerry Smith

DEVELOPMENT EDITOR Elizabeth Kassab

PRODUCTION EDITOR Casey Ebert

Visit the entire Everything® series at *www.everything.com*

THE EVERYTHING®

DIGITAL PHOTOGRAPHY BOOK

2ND EDITION

Shoot, upload, and enhance
photos like a pro

Rick deGaris Doble

avon, massachusetts

To Ross Scroggs, Director of the UNC–Chapel Hill photo lab, who
taught me that photography was both simple and exacting

An Everything® Series Book.
Everything® and everything.com® are registered trademarks of F+W Publications, Inc.

Published by Adams Media, an F+W Publications Company
57 Littlefield Street, Avon, MA 02322 U.S.A.
www.adamsmedia.com

ISBN 10: 1-59869-569-X
ISBN 13: 978-1-59869-569-4

Printed in the United States of America.

J I H G F E D C B A

Library of Congress Cataloging-in-Publication Data
is available from the publisher.

This publication is designed to provide accurate and authoritative information with regard to the subject matter covered. It is sold with the understanding that the publisher is not engaged in rendering legal, accounting, or other professional advice. If legal advice or other expert assistance is required, the services of a competent professional person should be sought.

—From a *Declaration of Principles* jointly adopted by a Committee of the American Bar Association and a Committee of Publishers and Associations

Many of the designations used by manufacturers and sellers to distinguish their products are claimed as trademarks. Where those designations appear in this book and Adams Media was aware of a trademark claim, the designations have been printed with initial capital letters.

Interior photographs by Rick deGaris Doble

This book is available at quantity discounts for bulk purchases.
For information, please call 1-800-289-0963.

Contents

9 Creative Controls and Other Features / 113

10 Taking Great Pictures / 129

11 What Makes a Photograph Memorable / 145

12 Types of Photographs / 165

13 Memory Cards, Downloading, and Storage / 183

Top Ten Milestones in Photography

1. About 1,000 years ago, the camera was invented by an Iraqi scientist named Abu Ali al-Hasan (AKA Ibn al-Haytham). It was called the camera obscura, and it projected an image onto a surface in a dark room.

2. About 200 years ago, light-sensitive material that could record images from a camera was invented. Joseph Nicéphore Niepce, a French inventor, made these first photos around 1814.

3. Kodak invented flexible film and mass-marketed the Brownie camera in 1900. Millions of people were able to take family pictures for the first time.

4. Arthur Korn invented the electronic transfer of photographic images in 1902. The pictures were called wire photos and used primarily by newspapers.

5. Leica introduced 35 mm cameras in 1925. Their small size made them the cameras of choice for professional journalists.

6. Contax made the first commercially produced modern single-lens reflex in 1949. It became the professional's camera of choice.

7. Minolta added autofocus to the single-lens reflex camera in 1985.

8. Digital photography became commercially available to the public around 1995 with cameras made by Apple, Casio, Kodak, and Sony.

9. Today 30 million digital cameras are sold annually in the United States.

10. About 10 years from now it is estimated that more than one billion people will have digital camera cell phones, many of which allow posting on the Internet.

Introduction

▶ PHOTOGRAPHY IS BOTH simple and exacting. Just about anyone can take an okay picture these days, but few understand how to take a dynamite photo. The difference between a snapshot and a stunning photograph is knowledge.

This book is designed to be a complete guide to the art and science of digital photography. In its pages you will find simple, practical how-to information. In addition to the nuts and bolts, you will also find plenty of suggestions about unleashing your creative potential.

Digital photography is much easier to learn than film photography, but like any discipline it is full of pitfalls that can derail your progress. This book guides you step by step through each aspect of the photographic process. If you have a creative bent, it shows you how to add your own personal touch to your photos.

Drawn from decades of hands-on experience, this book is different from most others on the subject. In its pages you will often find in-depth information other books only mention in passing or miss entirely.

Here's what you'll discover in this book that won't be in the others:

- A full consumer guide to buying a camera that is in your price range
- A complete explanation of eight different kinds of software for digital photography, plus listings of more than a dozen top-notch free programs
- How to have more fun and learn quickly by using the LCD monitor at the back of your camera

- How to be creative with digital photography in ways that were not possible with film photography
- How to preserve your precious family digital photos for up to 100 years
- How to file and store your photos so they will never be damaged and you will always be able to find them

This book is intended for novices and advanced photographers alike. Unless you have been working with digital photography for years, you are bound to find something you did not know in these pages.

It is also designed to be a complete reference that makes it easy for you to find specific information and tips on just about any aspect of digital photography. You can read it cover to cover or skim each chapter or jump around through the pages as the mood hits you. The point of this book is to show you how to get the pictures that you want and how to get the most out of digital photography without letting you drown in a lot of technical terms.

The technical aspect of photography is undeniably inescapable, and the more you understand, the better your photos will be. This book aims for a middle road: to give you the fundamental information you need in a way that lets you apply it to your own adventures in digital photography. The book aims to be as accurate as possible and at the same time give you real-world tips on how this knowledge will help you create better photos.

So what are you waiting for? Take the plunge into the new world of digital photography and find out how you can learn to express yourself with the art form of today. In a short period of time you could be taking cutting-edge photos. All it takes is a little understanding.

CHAPTER 1

Understanding How Digital Cameras Work

Digital photography is exciting. Even novices can take stunning pictures almost from the beginning because of the powerful features of the digital camera. Yet the basic aspects of photography have never changed and all cameras, film and digital, share the same basic elements. To get the most from your camera, you need to understand how all cameras work and know how to use the features that you will find on most digital cameras.

The Digital Photography Revolution

Digital photography has changed the nature of photography. Photographers are no longer chained to film, negatives, paper, and darkrooms. Digital photography allows the art of photography to expand so that even amateurs can be certain of getting good pictures and professionals can work with editors thousands of miles away. This change has been so profound that unless you have been working with photographs for many years, the differences may not be obvious. So here are the ways that electronic imaging has altered the photographic landscape.

Digital Images Are Electronic, Not Physical

Instead of actual negatives, the photographer now has electronic images that are stored on memory cards or within the memory of a computer. With film photography, the negative was the original, and it had to be guarded carefully. If the negative was damaged or lost, the photographer was in trouble. While copies could be made from prints, the quality was not very good.

Some photographers refer to memory cards as digital film. After a picture is taken, the camera usually stores the image on a memory card, which can then be read by a computer. Once the images are downloaded to a computer or uploaded to a storage site on the Internet, the card can be erased and used again for more pictures.

Carefully filing and storing one original is now a thing of the past. With digital photography, you can easily make a number of copies of your original picture that are just as good as the first one.

Digital Images Are Flexible

Because digital pictures are saved in a format compatible with computers, they can be shown on the Internet, sent as e-mail attachments, viewed on a computer, uploaded to a magazine or publication anywhere in the world, put on a CD, or printed out on paper.

Because digital images are stored on memory cards or hard drives, you will avoid having boxes of prints and negatives you have to sort through. File-management software will let you quickly flip through small pictures (called thumbnails) of your images until you find what you are looking for. Then you can easily look at the full-size picture and modify it, copy it, or transfer it over the Internet.

Even shooting photographs is different. Since most rolls of film held only thirty-six pictures, the photographer often had to stop at crucial moments to change film. With digital cameras you can often shoot hundreds of pictures until you fill up your memory card and delete the ones you don't want.

Digital Photographs Do Not Fade

Film fades over time. Fading occurs with film and prints, with color and black and white. No matter how carefully you store these images, they will fade noticeably—precious family pictures, for example, will be lost forever. On the other hand, electronic pictures will never fade. The colors today will be as good as they were the day they were shot. However, there are still precautions that photographers must take, which will be covered in this book.

FACT

Your pictures will not fade but the storage medium might degrade over time. Hard drives only last for a limited time, for example. The best storage for archival purposes is a CD-R, which, if kept away from high temperatures, should last many years. Other media, such as CD-RWs and magnetic disks, will not last as long.

Digital Photographs Can Be Modified More Easily

Unless photography was your hobby and you had your own darkroom, correcting film images was often quite difficult. Even simple changes like cropping and color correcting had to be explained to a darkroom technician, who often made mistakes.

Now with digital photography, you can easily change images with software to suit your taste. While learning the skills of the digital darkroom will

take a while, it is no more difficult than learning any other kind of software. In addition, because these photographs are digital, they can be modified like any graphic file. This means they can be put into a Christmas card or a newsletter or dropped into a logo for a business.

Other Advantages of Digital Photography

The electronic nature of digital photography has a number of other advantages that make photography easier to learn and reduce costs. These two things make people more comfortable with their cameras and more willing to use them and try out new techniques.

Immediate Feedback

Perhaps the most frustrating part of film photography was not knowing if your pictures came out. It might be hours or days before you knew, and by then the event you photographed was long over. The priceless pictures of your child's birthday party or your daughter's wedding could be too dark or blurry, for example, and you would not know until it was too late.

ALERT!

While not perfect, the LCD (liquid-crystal display) monitor solves many picture problems and allows accurate previews of many lighting situations in real time. However, flash, focus (depth of field), and camera movement that causes blurry pictures can only be judged immediately after a picture has been taken when the LCD monitor is in review mode.

Again, this has all changed with digital photography. The immediate feedback of the LCD monitor on the back of a digital camera both gives you a good preview of what your pictures will look like before you take them and lets you review pictures after they are taken. This ability has removed most of the uncertainty of photography and has also made it much easier to learn new skills, since the LCD shows the amateur photographer the results of her efforts.

Digital Photography Costs Much Less

As experienced photographers know, the more pictures you take, the better your chances of getting that really dramatic shot. With film, however, the cost was prohibitive—about ten to fifteen dollars a roll with small prints.

However, with a digital camera, once you have bought a memory card you can shoot hundreds of pictures, download them to your computer, erase the memory card, and begin to fill it up again with new pictures. The only cost, after the initial expense for the memory card, is the cost of the space on your hard drive, which is practically nothing. Furthermore, the cost of cameras and memory cards keeps dropping.

Also, you will probably be more willing to try new techniques, new lighting, and new angles with your digital camera because mistakes won't cost you anything and can be erased. And since you can view images blown up to any size on your computer, you do not have to go to the expense of having all your pictures made into prints.

Understanding How All Cameras Work

Although the cameras of the twenty-first century are quite sophisticated, the fundamental principles of photography have not changed. The most important concept in photography is this: photography is all about light. It is the action of light on light-sensitive material that creates an image. For example, a photo of an apple is not really a picture of an apple; rather, the image is created by light that is reflected off the surface of the apple.

def·i·ni·tion

Exposure: The term *exposure* is critical. Light-sensitive material is exposed when light hits that material. An overexposed photograph is one in which there is too much light; an underexposed image is one in which there is too little light. Film or memory cards that contain pictures that have been shot can correctly be called exposed.

How Light Creates Photographs

In order to understand the world of digital photography, it helps to understand how cameras create images from light. You will also need to be familiar with some technical terms. By learning a few fundamental concepts, you will be better able to grasp information on digital photo Web sites and in your camera's manual. This understanding will help you take much better pictures and troubleshoot any problems.

Fundamental Camera Design

All cameras contain six basic elements:

- **Lens:** A plastic or glass element that collects light and focuses an image on light-sensitive material. Every lens also has an aperture, which is an adjustable opening that controls the amount of light entering the camera through the lens.
- **Shutter:** A device that can be opened and closed to control how long the film is exposed to light entering the camera.
- **Light-sensitive material:** The medium on which an image is created. The lens and shutter combine to expose the light-sensitive material to register the image. In a film camera the light-sensitive material is film; in a digital camera it is light-sensitive computer chips (image sensors).
- **Viewfinder:** A lens, frame, LCD monitor, or LCD viewfinder that lets the photographer view the picture before it is taken and as it is being taken, either directly through the lens (in single-lens reflex, or SLR, cameras) or through a separate viewfinder (in simple cameras).
- **Method for removal or transference of photographs:** All cameras allow you to remove the images from the camera. In a film camera you take the film out; in a digital camera you can transfer the images to your computer.
- **Body housing:** A light-tight plastic or metal outer casing that contains the camera mechanism.

Film Cameras Versus Digital Cameras

The big difference between film cameras and digital cameras is the way in which they capture an image. A film camera creates an image when light

passes through a lens onto film. The film is coated with light-sensitive chemicals that react when light strikes the film, creating an image. In the developing stage, the image reacts with additional chemicals to produce a photograph.

FACT

A light meter is also essential to photography but in the past was a separate device. Most photographers used a hand-held light meter, but today it is built into the camera. Most modern cameras have a system for reading the amount of light. This calculation then determines and often sets the lens opening and the shutter speed.

A digital camera also uses light to create images, but it does so with an array of very small light-sensitive computer chips. A chip is composed of rows of tiny light sensors called photosites that capture color and light. These chips are similar to solar cells in which light intensity is converted into an electrical charge. This charge is then read and translated into a digital format using an analog-to-digital converter. The chips are categorized as either CCD (charge-coupled device) or CMOS (complementary metal oxide semiconductor). The majority of digital cameras made today use CCDs.

Image Resolution and Image Quality

When you buy or use a camera, the highest resolution it can record will be important to you. The number of separate points, recorded by the camera's image sensors, that make up a photograph determines the resolution of an image. The more of these points (pixels), the higher the resolution.

Pixels

Digital images are made of pixels. The word *pixel* is short for picture element. Each pixel is a tiny dot, similar to the ones that form the image on a television screen. When a digital image is viewed normally, the pixels blend together. When the image is magnified, you can differentiate the individual pixels. It is similar to enlarging a traditional photograph printed in a newspaper to the point where you can see the dots that make up the image.

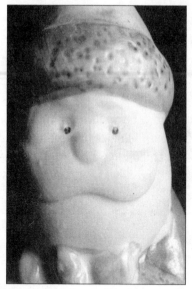

▲ This is a Santa figurine up close.

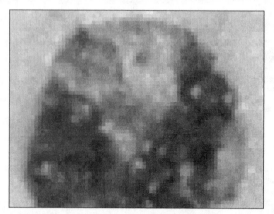

▲ These are enlarged pixels at a high magnification that make up the eye in the previous photo of Santa.

Resolution Can Be Relative

As a rule, the higher the resolution, the better the quality of the photograph. However, there are plenty of exceptions to this rule. The trick is to match the resolution of an image to the device that is displaying that image. A printer has one requirement, a computer monitor another, and an e-mail attachment another. The concept of resolution can be quite confusing, especially to a novice. This book will go into much more depth about resolution in Chapter 8.

def·i·ni·tion

Megapixels: When you buy a camera, it will typically be listed by make and model and the maximum number of megapixels the camera can shoot, such as the Canon PowerShot A400 3.2 megapixel. This number is the highest-resolution photograph that the camera is able to record.

Color Your World Digital

Both film and digital cameras create images by registering the amount of light in a scene. A digital camera works much like the human eye to translate that information into the colors that appear in the final image.

FACT

Many aspects of the human eye correspond to aspects of photography. Each eye has a lens, an aperture, and even a focal length, for example. In the following chapters you will learn that much of photography is quite simple once you understand how it works just like your eyes.

Red, Green, and Blue

Light is made up of three primary colors: red, green, and blue. A digital camera captures the light intensity—sometimes called brightness value—of the red, green, and blue light. It records the brightness value for each color in separate portions of the image file, or color channels, then combines them to form a full-color image.

The RGB System

When images are created using these three primary colors of light, they are called RGB (red, green, blue) images. The RGB system is also called the additive color system, because when the three colors are combined, or added, in equal quantities, they form white. We look at RGB images when we view television sets, computer monitors, and scanned images.

Capabilities That Most Digital Cameras Have

Now that you know what all cameras have in common, you need to understand how digital cameras are different from film cameras and what you will typically find on most cameras, from the inexpensive to the deluxe. Each of these features is explained in detail in later chapters, but the following list is a good overview and checklist for what to expect in a digital camera.

Overview of Common Features of Digital Cameras

This list will help you to understand what features you will find on a digital camera as well as help you with a buying decision:

- **Megapixels:** Inexpensive cameras will record about 3 megapixels, and the most expensive will record almost 20 megapixels or more. Cell phone cameras will generally record the least.
- **Viewfinder:** Most digital cameras will have two viewfinders, an optical or digital eye-level viewfinder and an LCD monitor at the back.
- **Memory:** Pictures are stored in a digital computer-readable format in the memory that is either built into the camera or on a removable memory card that slides into the camera—or both. Today most cameras will have both: basic memory that is part of the camera when you buy it and then a slot for adding a memory card, which most people will want to do.
- **Image-transferring method:** All cameras will have a way to transfer images from the camera to your computer. Most cameras today use a USB (universal serial bus) connection, but there are other ways to do this, such as a memory-card reader or a serial connection. If the camera saves the image to a floppy or CD, the floppy or CD can be put directly into a computer's drive.
- **Lens:** Even the most inexpensive cameras now come with a built-in zoom lens, either optical or digital or both. DSLR (digital single-lens reflex) cameras have interchangeable lenses.
- **Body:** Since basic and prosumer cameras have a built-in lens, the photographer cannot open the camera to change lenses. DSLR cameras allows you to remove one lens and replace it with another.
- **Exposure:** Just about all cameras will offer a variety of exposure modes. The more sophisticated the camera, the more exposure modes should be available.
- **White balance:** All cameras should have a way of reading the color of the light and making a setting so that the dominant light source is seen as white and the picture will have a true white in the image.
- **Flash:** Most cameras will have a built-in flash.
- **Image sensor sensitivity (ISO):** Even basic cameras allow you to adjust the sensitivity so that you can shoot in low light, for example.

- **LCD monitor:** All digital cameras have an LCD monitor, which can be used as a viewfinder, for a review of pictures just taken, and for file management. In addition, the LCD screen will provide a number of readouts that let you know as you are shooting, for example, what settings you have chosen.
- **Power source:** All cameras require batteries. Some use standard batteries such as AAs and others have rechargeable ones. Many will also allow you to shoot if you connect the camera to a wall socket.
- **Software:** Most cameras will have software built into the camera for review, file management, changing shooting settings, and more. For example, this software will let you manage pictures with a built-in menu. Generally, you can delete pictures and also lock pictures so that they cannot be deleted.
- **Focus:** Inexpensive cameras will have either a fixed focus that you cannot change or automatic focus. Only the most expensive will allow manual focus.
- **Video:** Even basic cameras will record short little video sequences.
- **Audio:** Many cameras have the ability to record audio.

def·i·ni·tion

Equivalent: You will often find the word *equivalent* used with digital photography. Since most people are familiar with 35 mm photography, several digital photography designations are stated as 35 mm equivalents. For example, focal length is often stated as a 35 mm equivalent. You might also see the term ISOE, for example, meaning ISO (image sensor sensitivity) equivalent.

Expensive Cameras Versus Basic Cameras

If you spend more money, you will get:

- More megapixels
- A more powerful zoom
- A better quality lens
- A stronger flash
- More sophisticated flash exposure

- More exposure modes
- More manual control over exposure and other features
- Greater range of image sensitivity (ISO)
- Much more focus control
- Macro capability
- More sophisticated in-camera software

QUESTION?

Do you get what you pay for?
Not really. A more expensive camera is not necessarily the best deal if it is too big or difficult to understand or hard to use. Make sure you get what you need; that is the very best deal.

What to Do Next

If you are in the market for a new camera, the next chapters will explain how to get the very best deal for your needs and your budget. If you already have a camera, you may discover that your camera has a number of features that you were unaware of.

Buying a Digital Camera

Use the questions and checklists in the next two chapters to decide which camera is best for your needs, what extras you must buy (you will definitely need some), and where to shop for your camera. Many manufacturers have their camera manuals available online. Typically these can be downloaded as Adobe Acrobat PDF files and then printed out. If you cannot find your camera's manual, go to the manufacturer's Web site and look for it. Or you can do a search for "[camera make model] manual."

Features on a Camera You Already Own or Use

If you have a camera, you may have discovered in this chapter capabilities that you did not know your camera had. If you can find the manual for the camera, read it from cover to cover and try everything out. It is a rare photographer who does not learn something new by reading the manual.

CHAPTER 2

What to Look For in a Digital Camera

Whether you already own a digital camera or want to upgrade, you can find the perfect camera for your budget. Even inexpensive cameras have very sophisticated technology. In fact, you may have too many choices. Make sure that you understand your own needs and why you want a camera in the first place. Answering this basic question will quickly narrow down your choices and help you locate the best buy for the money.

Ask the Right Questions

The good news is that just about any digital camera will give you all the benefits of digital photography. There are cameras from $100 or less to more than $1,500. The bad news is that quite a few cameras are loaded with sophisticated technology that you may find confusing or that you will never need. In order to investigate the choices, you should ask a number of questions about what you want your camera to do and what you will be using it for.

What Kind of Pictures Will You Take?

How you will use your camera is most important. Use the following questions as starting points to determine what kind of camera will fit your needs:

- What do I want my camera to do?
- What kinds of pictures do I want to take—family, work, travel, art, or a combination?
- How much time do I have to learn a new camera?
- What kinds of environments will I be using it in? For example, an outdoor photographer might have very different needs than someone who takes pictures of her children and family.
- Do I want to print large pictures or small pictures, send pictures with e-mails, or post pictures on the Internet?

Test-drive a digital camera. Call your local camera and electronics retailers to see if they rent digicams. As digital cameras gain popularity, more and more stores are allowing consumers to take advantage of one-day rentals. It's the best way to try one before you buy. Another alternative is to borrow one from a friend. Ask questions and read the manual.

What Do You Already Own?

If you already own some items, you could save money. Evaluate your situation by answering the following questions:

- Do you own picture file management software?
- Do you own digital darkroom and/or graphics software?
- Do you have a way to burn CDs so that you can store and send pictures?
- Do you have lots of hard drive space for storing pictures?
- Do you have a backup hard drive for backing up your pictures?

What Experience Do You Have?

The more experience you have, the easier it will be to learn digital photography. Look through these questions to get a sense of your skill level:

- Are you comfortable with digital technology or are you afraid of it?
- How much experience have you had with photography? Are you a rank amateur, moderately knowledgeable, advanced amateur, semi-pro?
- How much experience have you had with computers? Do you understand file formats and USB transfers, for example?
- How much experience have you had with the Internet? For example, do you know how to upload pictures to a photo album site on the Internet and then tell your friends how to access your album section?

Ask a friend. If you are unfamiliar with software, Internet albums, and attaching e-mail pictures, get a friend to show you how it is done. He can explain how the software works and how the Internet site operates, and he can show you how to send an e-mail to yourself with a picture attached so that you can test your skills.

Finding the Right Camera for You

Don't buy more camera than you need, but at the same time, be careful to buy a camera that will let you grow as a photographer and that will allow you to learn. Buying an expensive camera now with features that you will

never use is not a good use of your money. Electronic technology tends to cost less over time, so if you decide in the future that you want a more sophisticated camera, you should be able to purchase one for even less than it costs today.

Avoid feature overload. Most people will not use all the features on a camera, yet they will pay for all those fancy bells and whistles. Choose the camera with just the right combination of capabilities and features to get the most for your money. With so many cameras available, you should be able to find exactly what you need.

What Features Does the Camera Have?

Examine features to make sure you get what you need:

- How much does the camera cost?
- How much can I afford to spend?
- How much storage does it provide without an additional memory card?
- What extras will I need to buy after the initial purchase?
- What type of memory card does it use for storage?
- What resolution does it have?
- How does it get photos to my computer?
- How much of a zoom range does it have?
- Does it have optical or digital zoom?
- Does it offer voice or video recording?
- Can I use an external flash with it?
- Can I override automatic controls for manual control?
- How quickly can I shoot pictures in succession (the frame rate)?

What Accessories Will You Need to Buy?

You will definitely have to buy extras; be realistic. Prioritize the accessories you would most like to have, and keep the following points in mind:

- Most cameras do not come with a memory card or much memory, so you may need to buy a card.
- Some kind of case for carrying the camera, card, batteries, and cables will be necessary.
- Camera batteries vary by type and cost. Can you buy extras, and how much do they cost?
- While your camera will come with software, most people will want to buy more-sophisticated software such as picture file management software and picture modification and printing software.

def·i·ni·tion

Spec sheet or **specifications sheet:** All cameras have a specifications sheet that gives a list of its capabilities such as shutter speed range, zoom range, maximum aperture, minimum aperture, ISO range, and much more. You can often find a copy of the spec sheet by searching on the Web for "spec sheet specifications [camera make and model]."

Basic Digital Cameras

Don't overlook basic cameras that cost less than $150. If you have a limited budget, only need to put pictures up on the Internet, or are new to photography, these could be a very good choice. Even though they are inexpensive, keep this in mind that you will need to buy a number of accessories.

What Basic Point-and-Shoot Digital Cameras Offer

Even a rock bottom camera will have a lot of features. Expect a moderate zoom lens of about 3x and a resolution of 3 to 4 megapixels, which is more than enough for moderate 5" × 7" prints and for putting your pictures on the Internet. You will also get a variety of exposure modes, shutter speeds, exposure compensation, and even a built-in flash. There should be an LCD monitor on the back and an optical viewfinder. These cameras also have the capability to take short movies. There should be a self-timer and a basic ability to review pictures just taken on the LCD monitor. Some variation in ISO may even be possible. Not too bad for less than $150.

In addition, since basic cameras do not have as many features as more-advanced models, they are very light and compact. They are quite portable and can easily be carried anywhere in a pocket or purse.

In bright light, LCD screens can be difficult to see. When considering a camera, take it outdoors so you will know how easily the LCD operates in bright light. Change the brightness setting for outdoor viewing. You may find that an alternate viewfinder is necessary. Simple and low-tech optical viewfinders are inexpensive and easy to use.

Limitations of Basic Digital Cameras

Generally, these cameras do not have enough resolution for enlargements of 8" × 10" or larger. There will be limited ability to control exposure and limited zoom range. Flash capability will be quite basic. The flash will not have much power and you will probably not be able to add an external flash. Most features will be automatic, so overriding these for more creative control will be next to impossible. The quality of the lens will not be as good as those in the next price range. Canon, Kodak and other well-known manufacturer's make a variety of entry level cameras in this price range.

Prosumer and Semiprofessional Cameras

The next level of digital camera costs from $150 to about $600. Dubbed "prosumer" (meaning professional consumer products), these cameras should do just about anything the advanced amateur and even professional photographer may want to accomplish. While bulkier than the basic digital cameras, these cameras are light and compact with tons of features for the most demanding photographer.

What Prosumer Digital Cameras Offer

The next step above basic digital offers capabilities and quality images that are about as good as you can get. Expect a wide range of features and

settings. Resolutions up to about 8 megapixels are available, as are zoom lenses up to 12x, multiple sophisticated exposure modes for just about any lighting situation, manual override for creative control, a wide ISO range, and sophisticated flash exposure with the ability to add either a dedicated or an external flash. Lens quality should be excellent. The in-camera menu and preview should be quite sophisticated.

Many cameras will come with an electronic LCD viewfinder in addition to the LCD monitor on the back of the camera. This viewfinder solves many of the problems of shooting in sunlight as well as parallax problems that are encountered when you take pictures at close range. Movies and voice recordings are often possible. You may be able to take very close pictures in the macro mode. Compared to the next level of camera (DSLRs), prosumer cameras are quite compact, although they are considerably bulkier than the lowest cost level of point-and-shoot cameras.

FACT

If you want a camera that allows you to make large prints up to 12" × 17", you'll find that a prosumer camera can provide those sizes with good detail. Pick a camera with the highest megapixel rating but do not think that you must buy a super-high megapixel DSLR unless you need the extra features (and headaches) that a DSLR offers.

Limitations of Prosumer Cameras

These cameras do not allow interchangeable lenses, and for maximum resolution you will want to move up to a DSLR camera. Virtually all prosumer cameras will save pictures in a JPEG format, which does not offer as much control over the final image as the RAW format offered by many DSLR cameras. You will probably not find the sophisticated flash controls or ability to connect a flash to the camera that are available in DSLRs. The high-end Olympus UZ, ultra zoom, series, for example, will take extreme close-ups and extreme telephoto shots all in one self-contained camera.

Professional Cameras

DSLR cameras are generally considered to be the best quality but cost more than $600. Besides their top-of-the-line quality, these cameras offer a flexibility not available with lower-cost cameras. For example, with DSLRs you can use interchangeable lenses and attach an external flash. These also allow total control over the final image.

What DSLR Cameras Offer

For the maximum in picture quality, DSLRs cannot be beat. Except for their inability to make extremely big enlargements, these cameras rival the best film cameras. You can buy a number of interchangeable lenses. DSLRs often have the capability of saving picture data as RAW picture files. This format allows complete control over the final image, more than the standard JPEG format. You will also find the most range in shutter speed, ISO, manual control, focus, and exposure metering. The viewing system for most DSLRs is an optical through-the-lens (TTL) prism system.

ALERT!

DSLRs have a problem with dust. Because prosumer cameras are sealed, they have few problems with dust. But because DSLRs can be opened to change lenses, dust can end up on their image sensors. This dust will cause blank spots in the image. Unless you are experienced at doing it yourself, you should get a trained specialist to clean your DSLR when dust starts to become a problem.

Limitations of DSLR Cameras

These cameras are expensive and their purchase price is just the start. Since they can take interchangeable lenses and flashes, you can expect to spend much more than the initial cost. In addition, these cameras are bulky and heavy, and you may need a number of camera bags to cart around all the accessories in. The RAW file format creates very large files that can fill up memory cards and computer hard drives quickly. Canon and Nikon both make top quality DSLRs.

Cameras for Special Needs

A camera is a very personal device. If it does not feel right or you cannot use it easily, you will not be happy. Make sure the camera you buy works the way you need it to work.

Webcams

Some digital cameras can be used as still photo webcams. This means they can be positioned so that they take photos at periodic intervals and the pictures are automatically uploaded to the Internet, where they are displayed almost in real time.

Camera Phones

Cell phones that have cameras have come to be known as camera phones. While the photographic capabilities may be limited to small-resolution photos, you can often share photos with other cell phone users. You can even post photos on photo-sharing or photo album Web sites directly from your cell phone. In addition, the resolution and sophistication of camera phones keeps growing. Seven-megapixel cell phones are available in parts of the world, for example. It is estimated that most cell phones will have cameras in about ten years, so camera phones could become a major force in photography.

Problems with Eye Glasses

Glasses can be a real problem with any camera, and digital cameras in particular. There are several solutions. If you feel comfortable using the LCD monitor as your viewfinder, you can keep your glasses on all the time since you hold the camera away from your body to aim and shoot. In this case, it is important to find a camera that you will feel comfortable with when used in this manner. Some viewfinders, both LCD and optical, allow a diopter adjustment. This adjustment means that you can set the viewfinder to match your eyesight. Some high-end cameras have this feature.

Left-Handed Cameras

While most left-handed people are used to living in a right-handed world, you should find a camera that works with your particular way of holding a camera. Controls in the wrong place can be really annoying, and having to switch back and forth between hands to make settings and view the LCD monitor will not give you a pleasant experience.

Physical Handicaps

A photographer with physical limitations might find a remote triggering device much easier to use than having to hold a camera for each shot. A remote control device is offered for some digital cameras. In most cases it simply trips the shutter, but some offer a zoom setting. These remotes should offer more features in the future, including an LCD monitor on the remote.

Checklist of Secondary Digicam Features

In addition to camera features, there are other important items that you'll want to know about. The following is a helpful checklist that you can refer to when you're evaluating digital cameras. It is designed to remind you of some of the secondary features of a digicam.

What Else Is Included?

Don't overlook these aspects or you may suffer buyer's remorse:

- **Batteries:** Find out what kind of batteries the camera uses and how many shots you can expect to get with a set. Find out if a separate battery charger and rechargeable batteries are included in the camera kit. Also, in the original kit, can the battery only be recharged in the camera? This can keep you from using your camera while the battery charges.
- **AC adapter:** Do you have to pay extra for an AC adapter or is it included with the digicam?
- **Warranty:** How long is the manufacturer's warranty?

- **Software:** Your camera will have software for downloading images. Some digicams also include image-editing software. Is the software a full-blown program or only minimal?
- **Computer and printer hookups:** Investigate how the camera connects to your computer. Is it a USB port? Some models offer wireless transfer, allowing you to send images to a printer or computer using infrared ports, called IrDA (Infrared Data Association) ports.
- **USB cable:** Does it come with a USB cable for transferring the pictures to your computer?

If the manufacturer has a Web page for the camera, you should be able to find a spec sheet for the camera and a list of all the extras that come in the basic purchase package.

Investigating the Choices

Before narrowing down your choices, decide on the features and general category of camera you want. Next, look for the most popular cameras that meet your needs.

To make the best choice, take some time to read reviews, look at camera descriptions at the manufacturers' Web sites, read comments on newsgroups, and print out copies of spec sheets for each camera you are considering.

Useful Web Site and Searches

You can often go directly to a manufacturer's Web site by typing in the company name and adding ".com". For example:

- Kodak: *www.kodak.com*
- Sony: *www.sony.com*
- Nikon: *www.nikon.com*
- Canon: *www.canon.com*
- Fuji film: *www.fujifilm.com*
- Casio: *www.casio.com*

Window-Shop on the Internet for Prices

Like automobiles, cameras have a manufacturer's suggested retail price (MSRP) and this price is almost always discounted. An Internet search for "price [camera make model]" should bring up a list of places that offer a particular camera make and model for sale.

Explore impartial digital photography sites, many of which will compare features of various models. Look for reviews and user comments. There are also many newsgroups that discuss digital photography. Search these groups for particular makes and models. To find user comments, search Google Groups for [camera make model]; for reviews, search Google for "review [camera make model]."

At this point, you should not consider plunking down your money. Rather, take note of the range of prices that the camera is being offered at. It is very important to check out the reputation of each online seller, to carefully read their return policy, and to make sure that everything that is supposed to be included in the camera package is included. Chapter 3 delves into deciding on a retailer.

Hands-On Experience

There is nothing like holding a camera in your hands after you know what to look for. Go to your local Wal-Mart, Best Buy, or office supply store such as Staples. There you can find a number of cameras to look at and ask questions of the knowledgeable salespeople.

Try out all the features, ask questions, and above all get a sense of the feel of the camera. Even a reliable model may not be the best choice if it does not feel comfortable in your hands or has features that are hard to use, such as changing the exposure modes as you are shooting. Try out several cameras and don't assume that a higher-priced model is a better choice.

What You Can Expect to Spend

Basic and prosumer digital cameras range in price from less than $150 to more than $600. DSLRs cost more than $600—and in fact can cost more than $7,000 if you absolutely want the very best. The number of features available can be mind-boggling, so start at a level where you feel comfortable.

A Range of Prices and Features

Most people will pay between $100 and $1,000. In this range there will be a large number of cameras with just a few dollars separating them. No matter which camera you think about buying, there will be another one with just a few more features for just a few more dollars. For example, Canon sells a range of thirty-six cameras in this price range.

With this many choices and the minuscule differences in pricing, it is important that you make sure you know what you need. That way you will avoid being seduced by additional features in the next model above the one you have chosen.

Start Small

If you are new to digital photography, buy a low-cost camera to learn on. You will not use a feature-laden camera nor understand all its capabilities. A basic camera will be much less intimidating, and after you feel comfortable with such a camera, you can graduate to the next level.

Buying the Digital Camera That's Right for You

Buying a digital camera can be tricky. There are now a number of ways to make a purchase, such as through an online retailer, a brick-and-mortar store, and an Internet auction. Buy only from the most reputable dealers, as some sales pitches are deceptive. Before you buy, make sure you will have plenty of time to test out your new device and can return it if it is not working properly.

A Step-by-Step Guide for Buying

To keep a clear head, you should have a plan. It is easy to get caught up in the heat of the moment, make an impulsive decision, and wake up the next morning wondering if you made the right choice. Follow the next steps so you don't suffer from buyer's remorse.

Set a Budget

Decide exactly how much money you can afford to spend. Be realistic and include all the expenses that a new camera will involve. In addition to the camera, along with taxes and shipping, make a list of necessary accessories. Essential accessories generally include:

- **A memory card:** Most cameras come with limited memory and need a card.
- **A camera case:** This case should have room for accessories that you take with you, such as batteries, cables, memory cards, and filters.
- **An extra battery:** Rechargeable batteries are great, but they are generally made by the manufacturer and can be very expensive.
- **A battery charger or auxiliary battery charger:** You may want an extra charger to charge your spare batteries while you are using your camera.
- **File management and image manipulation software:** Your camera will come with some basic software, but you will probably want something more powerful.

Evaluate What You Already Own

You may already own a number of things that you will not have to buy:

- If your camera takes SD (Secure Digital) memory cards, you may have other devices that use this common card and you will not have to buy another card.
- You may already have image management software that you know how to use.
- You may have a case that will hold your camera and accessories.

System Requirements

Like software, every camera will list its system requirements. The term "system requirements" refers to the operating system, such as Windows XP or Macintosh OS X. In addition, the camera requirements will list minimum RAM (memory) and hard drive space. USB specifications should be listed as well.

Keep your budget simple. Decide how much you can spend and divide that number by two. This means that you can spend half your budget on the base price of the camera. The other half will go for memory cards, cases, software, batteries, taxes, and shipping. For example, if you can afford $500, plan to spend about $250 on the camera itself.

The amount of RAM and hard drive space you will need will depend greatly on the size of the photos you want to work with. If you plan to work small, you should have no problem. However, since image processing can take up a lot of computing power, you might want to factor in the cost of upgrading your equipment when you consider digital cameras. For your digital darkroom to run smoothly, you will want extra computing power to work with.

Decide on a Few Cameras You Want to Buy

It is probably a good idea to have a Plan B. Decide on two cameras that you find acceptable. With electronics changing so fast, you may find an outdated model that is no longer available or a brand new model that has been announced but has not yet started shipping. Make a list of the pros and cons of each of your favorite cameras and decide on two that you like the most.

Essential Accessories

There are some accessories you just can't do without, and you will want to buy them along with your digital camera. Investigate the specific brands of

software, for example, that you will buy. As you did before buying the camera, you should read reviews, go to manufacturers' Web sites, and search for user comments in newsgroups for all of the accessories you will need.

Software

You can spend nothing on software by either using the software bundled with the camera or finding free software on the Internet (see Chapter 17 for good Internet software options). Buying software can cost you from $30 to $600 depending on what features you want. Managing and modifying picture files is a major part of digital photography, so take a good deal of time to determine what capabilities you need and how much you want to spend.

A Camera Case

The best camera case holds a camera securely, organizes any accessories, and is easy to open and close. A large bag-type camera case with a large lid and soft cushioning is generally the best kind. Some extra pockets on the outside are useful for things that you may want to grab quickly, such as batteries. Avoid black cases as these can be hard to find, especially in the dark. Also avoid expensive-looking cases; these stand a good chance of being stolen—along with your camera.

Extra Batteries and a Charger

Rechargeable batteries can cost as much as $50. If the charger for these batteries plugs into the camera, you may want an auxiliary charger that charges a battery while you are using the camera. Also after a while, perhaps a year or so, some rechargeable batteries will no longer hold their charge and you will be forced to buy another battery.

Extra Flash and Other Accessories

If you do a lot of work in low light or at night or in available light, you may want a more powerful and flexible flash than the one that comes with the camera.

There are dozens of accessories that you can buy for just about any camera, such as add-on lenses for a fixed zoom lens, filters, slave units for flash photography, extra memory cards, memory card readers that read cards directly into your computer without using your camera, and printers that print directly from the camera. You will need to decide what you must have and what you can live without.

def·i·ni·tion

Dedicated flash: A dedicated flash is one that will work only with one manufacturer's cameras and maybe only certain models. However, these flashes are much more powerful than the on-camera flash and usually can take advantage of the camera's various sophisticated features, including exposure modes.

Understanding Return Policies

Before you consider buying a camera from any store or dealer, you should understand the return policy. The more expensive the camera, the more careful you should be. Returning a camera that does not work properly can be quite tricky, so make sure that you don't get stuck.

Various Return Policies

Never consider buying without first carefully reading the return policy. Some dealers will not allow any returns and all sales will be final. Other stores will specify that a product must be returned within a certain time frame. If the item is shipped, you need to know when the clock starts ticking. Is it from the time the order was taken or from the time that you receive the item?

Restocking Fees

Any of these stores may charge a restocking fee of 10-20 percent when an item is returned, which means that even though you return your camera, you may owe the store $100 or so. This practice has become much more

common in the electronics industry, so never assume that a well-known retailer does not have such a policy.

Return Authorization

Most mail-order stores will require that you get a return authorization and will not accept items sent back to them without that authorization. This is very important. Make sure that you understand the procedure for returning before you buy.

FACT

Pay with a credit card. If you have a problem with the retailer, a credit card charge gives you more protection than a debit card, check, or money order. It will be much easier to get a refund with a credit card than with any other kind of payment because you can often withhold payment while you dispute the charge.

Return authorization forms usually ask you to fill out information about your product and specify your reason for returning it. Most companies have the form available on their Web site, and you can fax or e-mail it to them. Once the company receives and processes your form, it will send you information on how to return the product, such as where and how to mail it.

Finding the Store's Policy

Often the details of this policy will be buried in the fine print. The "About" page at the retailer's Web site should have a link to such a policy. You can also use the site's general search feature to find and print the page where the policy is spelled out.

Buying from an Online Store

The Internet makes it easy to compare prices at a variety of stores. A number of sites can show you a range of prices for a particular camera—but buyer beware. A low price is not the only reason for buying from one store

over another. Check the reputation of the dealer by searching the Internet. You can do this by looking up the name of the company in newsgroups by searching for "[company name] complaints," for example.

Authorized Dealer or Seller

Manufacturers often designate various reputable stores as authorized dealers or sellers. These stores must meet the highest standards of the industry. It is generally a good idea to buy from an authorized dealer even if it costs a bit more. A quick search for "digital camera [brand name] authorized dealer" should bring up a number of such sellers on the Internet. However, always double check at their Web site that they are, in fact, authorized sellers.

Never buy from a company that only has a Web site and an e-mail address. These stores can be quite unreliable. Make sure the store has a phone number and a physical address, not just a post office box. Be sure to call before placing an order and make sure that a salesperson at the store answers, not an answering service.

Make Sure the Item Is as Advertised

Electronic stores have gotten a bad reputation in the past for being less than honest about the merchandise they offer. Make sure the item will be shipped in a sealed box exactly as it came from the manufacturer.

Order over the phone if an item is expensive or urgent. With an online order no one is accountable if there is a glitch. When you make a phone order, you can get the name of the salesperson, verify that the item is in stock, and ask about the return policy.

A Low Price May Not Be a Low Price

After making sure that you are buying from an authorized dealer and that the store has a good reputation, there is still more work to do. A listed low price should only be the start of your search for the best deal. Shipping

and handling can add considerably to the cost. Handling is a vague category that retailers use to tack on an extra charge. Bear in mind that if you have to return the item, shipping and handling generally will not be refunded.

Also, some stores that have very low prices may not have the item in stock. There are horror stories on the Internet of buyers who paid for a camera but then had to wait weeks before it was delivered.

FACT

If you are in a hurry, some stores will ship via overnight or two-day air for the same price as ground shipping. Fast low-cost shipping could be another consideration in your decision of which store to buy from. Always check the handling price in addition to shipping. Some retailers charge almost nothing for handling while others charge a lot.

When to Use an Online Retailer

An online dealer may not be the best choice with all the potential problems, delays in delivery, and additional shipping costs plus return-problem headaches. Perhaps the best reason for using an Internet seller is that it gives you the option of buying a camera you cannot find locally. Virtually any camera that is available for sale can be found on the Internet, along with cameras that are no longer being made.

Buying from a Brick-and-Mortar Store

While the Internet can seem attractive and may offer a slightly lower price, the best and safest deal may come from a local store. There are many more stores that offer digital cameras than you may realize. Call around to see if your chosen make and model is available on the store's shelves.

Buying Locally

Buying from a store in your town means you can try out the camera before you buy, since most stores have demonstration cameras that you can look though and test out. Also, when you buy in your local area, you can

see whether the box containing your camera was sealed by the manufacturer and was never opened. And returning a camera to a local store is generally much easier than returning one to an online retailer.

Where to Look Locally

Even in small areas there should be plenty of stores to choose from:

- Large discount department stores such as Wal-Mart, Kmart, and Target typically carry the most popular brands and lines of digital cameras. They also may carry a number of accessories.
- Electronics stores such as Circuit City and Radio Shack should have a good selection.
- Office supply stores often have an excellent selection of cameras, accessories, cases, software, and books on the subject. Check out your local Staples, OfficeMax, and Office Depot stores.

Click and Mortar

Local chain stores often have an online catalog. You can order online but return the item to the store if there are any problems. As long as you return the item within the return period, there may not be a restocking fee.

Buying via an Online Auction

There are probably hundreds of sellers at eBay and other auction sites that sell cameras and photography-related equipment. In your search for information and for the best price, checking out auction sites is not a bad idea. However, buying from such an outlet may not be worthwhile. Seriously weigh the pros and cons before you make a decision. In some cases, it may be your only choice or even the best option.

Check the Auctioneer's Reputation

With auctions you should always check comments about the seller before considering doing business. The Internet is quite anonymous, and disreputable sellers abound. Yet if you buy from a seller who has been with

eBay for a number of years, who has received virtually no complaints, and who has been given a top grade by eBay with a designation such as Power-Seller, you should not have any problems.

Check the Policies

Just as with an Internet retailer, you should check the auctioneer's return policy, shipping costs, and shipping speed. She may not take charge cards directly and charge payments may be through a middleman such as PayPal.

Why Buy from an Auction Site

EBay, for example, offers many used items that may not be available anywhere else. If you want a camera that is no longer being made, or accessories for such a camera, then eBay and other auction sites may be the best place to search.

Some retailers sell refurbished cameras as new. This is not only unethical but also illegal. While refurbished models may work well, they should be clearly labeled and sold at discounted prices. Always read the fine print. Reputable dealers state that you will receive your new camera in an unopened box as it came from the manufacturer.

Is It Time to Buy?

Buying electronics can be very frustrating. After months of agonizing over what to get, you can make a decision and plunk down your money only to find weeks later that a more feature-laden camera has come out for a lower price.

Digital Cameras Are like Computer Technology

Buying a digital camera is a lot like buying a computer: it's hard to know whether you should buy one now or hold out for a while. Should you pick

from the models that are currently on store shelves or wait for technology, which is constantly evolving, to come out with a model that has even more bells and whistles and probably carries a lower price tag as well?

Don't Be in a Hurry

Electronics keep getting cheaper. In 1965, Gordon Moore, who was then research and development director for Fairchild Semiconductor and who later went on to become one of the founders of Intel Corporation, predicted that the density of transistors on a chip would double every two years. As the ability to put more and more transistors on a chip increases, the cost per unit of computing power declines. Today, Moore's Law, as his prediction came to be called, has turned out to be extremely accurate. In the past three decades or so, the number of transistors on a chip has grown from 2,300 to 28 million.

The same expansion of technology applies to digital photography, meaning that if you wait about six months, you'll be able to buy an even better camera for less money. And if you plan to keep up with the rapidly changing digital world of photography, you can count on replacing your camera system every two to three years.

When to Make the Plunge

There are a number of reasons for buying a camera right now and not waiting:

- Do you have an immediate specific use for a digital camera right now?
- Do you need the camera right now to accomplish what you want?
- Do have accessories that you can use with the camera, such as an expensive memory card?

When you know exactly what you want to do with a camera, it is the right time to buy. You can always buy an inexpensive camera initially and trade up later. Do not be in a hurry to buy if you are unsure of how you will use the camera. Also, don't buy if you will not have twenty hours to test out the camera immediately after buying it.

Camera Discounts

If you are the kind of person who is always looking for good deals, you can find them with digital cameras just like anything else—if you know where and when to look.

Watch out for unbundling. Unscrupulous retailers may sell only the camera and charge extra for the other items such as lens caps, battery chargers, memory cards, and software that are supposed to be included in the basic camera packages.

Refurbished

If you want to save big bucks, consider buying a refurbished model. Refurbished cameras have been returned to the manufacturer, often for some minor defect, repaired, and then thoroughly tested before being resold. These cameras should sell at a substantial discount from the new price. Manufacturers often sell refurbished items. To find them, search for the word 'refurbished' on the manufacturer's Web site.

Floor Models

Any camera you put your hands on at a store may be sold at a substantial discount as a floor model. You may even be able to bargain with the management for a 50 percent or more reduction in price.

Discontinued Models

As an electronics salesman once said, "All electronics are discontinued eventually." Don't be afraid of last year's model just because it is no longer being made. If you can live slightly behind the times, you can save a bundle. Discontinued models are often sold at the end of the yearly product sales cycle. With digital cameras this is in late winter and all during the spring. Look especially for sales on President's Day in February when many electronic products go on sale.

Gray Market Products

Gray market cameras have been imported from a foreign manufacturer directly, bypassing regular channels. Although legal to sell, gray market cameras are not meant to be sold in the United States. They sell at very low prices but usually without the extras normally included in the initial package and without a U.S. warranty. Because of these problems, always make sure that the product you are buying is not a gray market item.

Extended Warranties

Most consumer experts do not recommend buying an extended warranty. These can add considerably to the cost of an item, and the cost of the warranty is often about the cost of the repair if a repair is ever needed.

FACT

You may have extended warranty protection and not be aware of it. Some gold or platinum credit cards will extend the warranty of an item bought with that card. In many card agreements, the warranty is doubled, for example. See your credit card agreement for details.

Expect a Sales Pitch

You will often be given the hard sell, as stores make a lot of money on these warranties (which are really more like insurance policies). If you try out your new camera immediately, you will know if your camera is working properly. If you give it a thorough workout, it is unlikely that anything will go wrong during the extended warranty period, which usually starts right after the normal year-long warranty ends.

Why You Don't Need an Extended Warranty

Generally, an extended warranty kicks in after the manufacturer's warranty ends. If your camera has worked well during the original warranty period, it is very unlikely that it will fail in the next year. In addition, repairs

can take longer under an extended warranty. While there are always exceptions, most consumer experts agree that you will save money by avoiding these warranties.

After the Sale

Once you have made a purchase, your work has only just begun. Since you have a limited time to return the item, you should check out every feature and capability. Plan to spend many hours testing it out.

Do not fill out the manufacturer's warranty card until after the store's return deadline. Many stores will not accept a return if the warranty card has been filled out or mailed. If you have mailed it, problems with your camera will be handled by the manufacturer and not the store.

Test and Read the Manual

After buying your new camera, try out everything that the camera does. Make sure you have about twenty hours to devote to testing. Read the manual cover to cover. For example, identify on the camera where all the exposure modes are located. Take test shots and try out the picture review software. Connect the camera to your computer and download photographs. Then view them on your computer. Compare the view in your computer to the view on the camera's LCD monitor. Do not be surprised if the LCD view is brighter, as this is normal, but make sure that the LCD gives you an accurate view.

Advantages to Testing Out Your Camera

When you give your new camera an immediate run-through, you will identify any problems that might require a return or exchange, and you will gain a good overview of how your camera works. You will learn all the ins and outs of your camera and be able to use the features whenever you need to. Many people have had cameras for years and were not aware of the basic capabilities. This won't happen to you if you test out your model.

LCD Screens and Viewfinders

If you have never used a digital camera before, the first thing you will notice is the LCD monitor at the back. This feature brings an entirely new capability to photography. It can be used in a variety of ways to make sure you get those important shots. Gone are the days when you used to moan "My pictures didn't turn out," when your heart sank after you picked your photos up from a one-hour photo shop and realized they were duds.

LCD Screens

LCD screens do not give you a full-blown view of your photograph but rather offer a tiny view of the picture in the camera. Typically, an LCD screen will display about 200,000 pixels for viewing a picture that is maybe 5 megapixels in size. What this means is that the picture you see on the back of your camera is an approximation; it is a very good approximation, but it will nevertheless differ in some respects when you view the same image on a computer monitor. Yet for quick viewing purposes, it is excellent.

Adjusting the LCD Monitor

In addition to providing a small, crisp image, LCDs allow you to adjust the brightness of the screen to suit both your needs and the lighting conditions of your situation. For example, in very bright light, you might need to pump up the light on the screen to view the image properly. In very dark light, you may also need to adjust the screen to see details that can be hidden in the shadows.

A True-to-Life View of the Image

When previewing a scene, the displayed LCD image is a true rendition of the image. This means it is not distorted; rather, it is a true TTL image and does not suffer from any parallax problems since it displays the image that the camera sees. It also gives a good sense of focus.

While the LCD provides an accurate display of the focus and depth of field (the range of focus), this can be hard to judge on a small screen. Reduced images tend to look sharper. With practice you will learn how to accurately preview the sharpness of an image on the LCD monitor.

Using the LCD as a Viewfinder

As good as the LCD is, many photographers do not use it as a viewfinder for a number of reasons. The camera must be held out at a distance so

that the screen can be viewed properly. This is an awkward position, and it tends to make the camera shake, which can result in blurry pictures.

In some situations, however, the LCD monitor becomes the viewfinder of choice. If you are in a crowd and need to hold the camera up, high above your head, the LCD screen makes this kind of photography possible. The picture displayed is the picture the camera sees, so there is no distortion or parallax, which can occur in close-up work. This means that for macro photography the LCD screen can be perfect for viewing the shot.

Why the LCD Monitor Is So Important

The flexibility of the digital camera has allowed a new mastery over photographic imagery. Things that were impossible with film or that took a very long time to learn are now quite easy thanks to the LCD monitor.

What the LCD Monitor Does

The LCD allows you to take control in some valuable ways, including:

- Preview of the image before taking in real time
- Accurate TTL rendition of the image
- Good depiction of the color of the scene
- Ability to adjust color balance in real time
- Improved display of focus
- Ability to instantly review the last image taken
- Ability to make corrections within seconds after a picture is taken
- Ability to rapidly change settings in quickly moving situations
- Ability to review all images taken in a session

The Big Digital LCD Advantage

Many people assumed that it was the ability to manipulate electronic images or to send them as e-mail attachments or post them on the Web that made digital photography so popular. Yet at least as attractive are the greater enjoyment and the higher skill level made possible by the instant feedback of the LCD screen.

Photography.com commissioned a detailed survey about the advantages of digital photography. The response showed that photographers overwhelmingly valued the increased control over the picture-taking process more than any other aspect. This control included the immediate feedback of the LCD monitor and the ability to manipulate and correct images at the time of shooting. And because of this control, the survey respondents said that photographers could now work with a precision that was previously not available.

How the LCD Helps with Picture Taking

The LCD monitor/viewfinder shows the camera operator what the image looks like in real time before the picture is snapped, and moments later it allows a review of the photo just taken. For the first time in the craft of photography, the picture taker can obtain a good idea of the quality of the image that was just captured. This has a number of advantages for the photographer. She can rapidly make adjustments if a picture is not right; she can quickly learn how to take pictures in unusual situations; she can delete pictures that she doesn't like; she can review a series of shots to make sure she covered all aspects of a picture opportunity. In addition, she can show pictures, as they are taken, to her subjects to get feedback and keep everyone happy.

An excellent example of this new control and flexibility is how the LCD screen works with the camera's flash. Flash lighting has always been very hard to predict. Yet with the LCD monitor, a few test shots will soon reveal the best settings for the flash and even allow some complicated setups such as bouncing the flash (see Chapter 6), which can provide a much softer and more natural look.

How the LCD Provides Important Information

In addition to providing feedback, most LCDs allow a constant display of critical photographic information such as the particular automatic or manual exposure settings, the amount of charge left in the battery, the number of pictures left in the memory card, the picture resolution, the color balance setting, the metering configuration, the flash setup, and the focus mode.

Some photographers find that this can be too much information. Many systems allow the camera operator to shut off some of the displays so that only the most critical data is shown. As if that were not enough, the LCD is also used as a mini computer monitor that allows the changing and setting of a number of parameters via a menu system.

Previewing, Reviewing, and Deleting

The LCD monitor allows you to get a good idea of the picture before you even take it, to see exactly what you just took, and to delete pictures you don't like. Being able to get a sense of the place, atmosphere, and available and ambient light before even taking a shot is a photographer's dream. You can even walk around before an event happens and try out different angles you might use for shooting.

Previewing

Before you take a picture, the LCD screen allows you to see what the camera sees in real time. This means that before you even take a shot, you can judge, for example, the lighting, the depth of field and focus, and whether you will need a flash.

Different light sources can fool even the most experienced photographer because light-sensitive material records each light source with a characteristic color. Mixed lighting is notoriously difficult to work with. Yet the LCD preview in conjunction with the color balance control will quickly reveal the best setting for a particular situation.

ALERT!

The computer image will generally be darker than a standard setting on the LCD. However, you can adjust the brightness setting of the LCD so that its display is the same as the picture on the computer monitor. Look at the same image on your computer and on your camera to make the necessary setting.

Reviewing

The real power of the LCD monitor shines in the review mode. The easiest and most basic review control is to hold the shutter after taking a picture. In many cameras this allows the picture that was just shot to be displayed as long as the shutter button is held down. This control can give immediate feedback for every single picture taken if a photographer chooses. Smart photographers do this almost as a matter of habit because it allows a quick review of pictures as they are taken and can avoid mistakes that might crop up.

After the photographer takes a number of pictures or encounters a lull in activities during a picture-taking event, he can review the pictures he just took. Many cameras offer a picture-by-picture display in the sequence shot plus a quick thumbnail view that allows the photographer to rapidly find a particular picture and then switch to a full LCD screen display of that picture.

Zoom controls also allow a photographer to look at enlarged sections. A high zoom setting will allow the photographer to view the picture full size, but he will only be able to see a small piece at a time. This view should be enough to judge the quality of the photograph.

Deleting

Memory cards can fill up fast, especially at the higher resolutions. In the review process, the photographer can delete pictures to make room for newer ones. Often, test pictures taken at the beginning of a photo shoot can be deleted along with those that have obvious flaws such as people blinking. And, of course, blurry and out-of-focus images can be deleted as well.

While deleting pictures is important, preventing pictures from being accidentally deleted is also important. Many cameras allow the photographer to lock a picture so that it cannot be accidentally discarded without permission. Typically, your LCD monitor will display an icon, such as a padlock, to indicate that a photo is locked.

Using the LCD Menus

If you think of the camera as being a mini computer, the LCD screen becomes a computer monitor that allows you to make a number of changes and settings with a variety of menus. Typically, the LCD can display a series of menus, called in-camera menus, often in a tree structure like MS Windows, which allow a number of choices. There may, for instance, be one menu for shooting or taking pictures and one for reviewing.

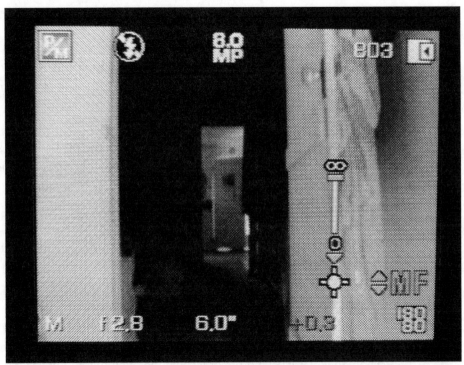

▲ An inexpensive Kodak camera displays a wealth of information on the LCD screen.

FACT

As cameras have evolved, the functions found in menus have evolved as well. Capabilities that were once in menus now might be found as a switch or a button on the camera and vice versa. Each camera will be different and these controls will change as cameras become more sophisticated.

Shooting Menus

Shooting menus confine themselves to controls that you will need to take the picture. These often include setting the picture size (resolution) and quality, the flash setting, and the exposure mode. Still cameras with video modes often put these settings under the shooting menu. Some cameras may even allow you to shoot with special effects, such as taking pictures with a sepia tone or in black and white.

Reviewing Menus

While each manufacturer is different, and more expensive models will have more features, reviewing menus usually allows you to view what you have just shot, delete pictures, tag pictures, protect pictures from being deleted, mark pictures for printing, rotate pictures, set auditory beeps, and resize pictures.

Many cameras allow you to see a thumbnail view of the images stored on your memory card. A quick scroll through these images can help you find pictures. Some reviewing menus will allow you to select pictures and then print directly from the camera. Some cameras even have basic editing capabilities that allow you to change brightness and color and even crop photos. This is most useful if you want to print an image directly from the camera as quickly as possible.

Unless you are in a hurry to print a picture, it makes more sense to edit a picture on the computer where the software will be much more sophisticated and you will have a better view of the photograph, rather than use the in-camera editing tools and the tiny LCD display.

LCD Limitations

LCD monitors give photographers more power than ever before to work with the photographic art form. However, they are not perfect, and—like many things in photography—they have their own limitations. When you understand these limitations, you will be able to get the most from your camera.

Judging the Actual Picture Size

LCD screens often show a bit less than the full picture displayed on your monitor, typically 97 percent of the actual picture. This discrepancy between the preview picture and the final picture has plagued photographers for some time. Virtually no film cameras ever gave a full view of the image through the viewfinder, for example. If you shoot pictures with precise framing and no cropping, you will want to be aware of how much extra will show in the actual photograph. Of course, with digital photography it is very easy to crop just a bit if you need to.

LCD monitors also use a lot of battery power, so if you are trying to conserve batteries most cameras allow the option of turning the LCD off. If your camera has an LCD viewfinder, you may be able to shut that off as well.

Judging Sharpness

Small, reduced images appear sharper. Until you gain some experience, it may be hard to judge the sharpness of a picture. Most LCD screens have a zoom control that will allow you to look at a blow-up of a section. An extreme enlargement should reveal any streaks of camera movement or blur due to the camera being out of focus. As always, you should realize that this enlargement is only an approximation of what the image might look like full size on a computer monitor.

QUESTION?

What is the difference between the LCD image and the computer image?
Compare one of your images displayed on the LCD screen of your camera with the same image on your computer. Contrast the size of the image, the color, the brightness, and the sharpness.

Judging Color

Color is also tricky for a number of reasons. First, the camera will interpret the color of light sources differently than you do with your naked eye. Experienced photographers are used to this, but novices may find this

variance troubling. The LCD screen, in turn, will display the color image with some differences from the actual photograph. Generally, the difference will not be great but it will be noticeable.

Viewfinders

While the LCD screen can be used as viewfinder, many people use an eye-level finder, either optical or electronic. The photographer can then keep the camera close to her body and shut off the LCD screen to save battery power. These viewfinders are included in the design along with the LCD screen.

Conventional Optical Viewfinders

Many cameras are equipped with tiny viewfinders that are like those that used to come with the old Brownie cameras of the early twentieth century. These have a number of advantages and disadvantages.

Basically, the viewfinder is an optical device that allows you to frame the picture. These finders typically have guide marks that the photographer uses to enclose the picture area. A finder usually shows more than just the picture area, so it allows the shooter to see outside the frame and anticipate actions. The best optical viewfinders are coupled with the camera's zoom so that the viewfinder zooms in synchronization with the camera's lens.

The optical finder has an advantage over the LCD display: there is no LCD delay or digital rewriting of the screen, which some people find distracting. Also, since an optical finder doesn't use any electricity, it helps conserve battery power.

These finders work especially well in bright light when the LCD can be hard to see, when battery power needs to be conserved, and in dark situations when LCDs can be hard to use. These finders do not work well in close-up situations, when trying to view the point of focus or depth of field, or when trying to frame a picture closely within the rather imprecise frame lines.

Electronic Viewfinders

In addition to the LCD screen and optical viewfinders, there is a class of viewfinders known as electronic viewfinders. These often show a much

coarser LCD display along with shooting information that is displayed on the larger LCD screen. These are used at eye level, so the photographer can avoid the problem of holding the camera out at a distance. They are also much easier to use in bright sunlight than an LCD screen.

Some viewfinders have diopter adjustments that will allow the photographer to use the viewfinder without wearing glasses. These deliver an undistorted image, but they also drain battery power.

DSLR Viewing Systems

DSLR digital cameras generally have a prism system that allows the photographer to see exactly what the lens sees with an optical (not electronic) viewing system. Since DSLRs also allow the photographer to change lenses, he will always see an accurate display of what the picture will look like. The DSLR design allows a true TTL viewing system. This means that any picture can be taken without distortion. It is for this reason that DSLRs have become the camera of choice for serious photographers; they give the professional photographer the crucial control of accurately framing a picture.

Parallax Problems with Viewfinders

The conventional optical viewfinder will suffer from parallax problems at close range. Basically, this means that the optical viewfinder sees a different picture than the camera lens sees because the viewfinder is offset from the camera lens. The greater the distance between the viewfinder and the camera lens, the greater the discrepancy will be.

Viewfinders That Make Corrections

Some sophisticated optical viewfinders will correct for parallax to a point by adjusting the optics to take in a more accurate view at close

distances. However, even this tactic does not work at very close range. For most people this is not a big problem except at close range. Typically the problem will start to occur at five feet or less.

FACT

If you like to work close to your subject and have an optical viewfinder camera, you can determine precisely the amount of shift that occurs with your viewfinder and at what distances: Compare the viewfinder view (you might even draw a picture) with the LCD view, which will be accurate.

Close-Range Parallax Problems

The problem gets worse the closer you get. At very close range the difference between the camera's taking lens and the viewing lens will be pronounced, and the resulting picture will shift markedly from what the photographer saw when she was taking the picture. When parallax becomes a serious problem, the photographer can switch viewing to the LCD monitor, which offers a view of exactly what the taking lens sees.

CHAPTER 5

Lenses

The lens is a primary component of your digital camera. The lens is made of optical glass or plastic that has been designed to gather light reflected from the subject and project it onto the light-sensitive computer chips in your camera. The lens serves as your camera's eye, determining what your camera can see and how well what is seen is conveyed to the camera's image sensor. No matter how many megapixels a camera has, if it has a low-quality lens, the picture quality will be inferior.

Understanding Focal Length

Every lens has a focal length. You are probably familiar with the terms *wide-angle lens*, *normal lens*, and *telephoto lens*. All of these refer to the focal length of the lens. By changing focal lengths, you immediately change the lens's angle of view and its magnifying power. The term *angle of view* describes how much of a scene the lens captures. A short lens has a wide angle of view, meaning it can capture a wide expanse of a scene. A long lens (telephoto) has a narrower angle of view so it will isolate small sections of the scene.

35 mm Equivalent

Because many people are familiar with 35 mm, digital cameras state their focal lengths in 35 mm equivalent terms. On a 35 mm camera, a lens with a focal length of less than 35 mm is known as a short, or wide-angle, lens. One with over 65 mm is considered a long, or telephoto, lens. And lenses with focal lengths between 35 mm and 65 mm are considered normal. The 50 mm lens is the most common lens.

Focal length is a primary tool in the photographer's tool box. A wide-angle lens, for example, can produce very distorted images when objects are close to the lens. This can be a great artistic effect or a terrible mistake depending on your intentions. Telephoto lenses magnify backgrounds and bring them up to appear closer behind a subject.

Magnification

Magnification goes hand in hand with angle of view. A short lens, with its wide angle of view, requires all the objects in a scene to be reduced in size in order to fit into the image sensor. It has the effect of pushing the subject away from you. Conversely, the long lens, with its corresponding narrow angle of view, will have the effect of pulling objects in a scene close to you, causing them to appear larger.

Variable Focal Length

Today most cameras come with a zoom lens, which is a variable focal length lens. Inexpensive ones may have a 3x zoom, which means that the longest focal length is three times the shortest. More-expensive cameras may have a 10x or more zoom range.

While choosing a digital camera, the first question to ask yourself is how you plan to use your camera. If you want to photograph landscapes, buildings, and interiors, you will want wide-angle capability. If you are interested in shooting portraits or nature scenes, telephoto capability should work. A middle ground would be a normal lens setting between 35 mm and 65 mm (35 mm equivalent).

Working distance is the distance between the photographer and the subject. A telephoto lens, for example, allows more working distance and therefore is better for portraiture. A subject will feel more comfortable when the camera is not up close. A wide-angle lens, on the other hand, allows very little working distance when taking a picture up close.

This is a wide-angle shot of a person standing on a dead-end road. ▶

▲ This telephoto shot is taken from the same place as the previous wide-angle and normal shots.

This shot is taken with a normal lens from the same position as the previous wide-angle shot. ▶

Focal Length and Shutter Speed

To take a sharp picture, use the right shutter speed for the particular focal length. For example, because a telephoto lens is magnifying an image, it is also magnifying any camera shake. A good rule of thumb is that the shutter speed should be about the same as (or higher than) the focal length in a 35 mm equivalent. For example, a 1/30 of a second shutter speed is good for a 35 mm lens, 1/60 of a second for a normal or 50 mm lens, 1/125 of a second for a zoom of about 100 mm, and 1/250 second for a zoom of 200 mm.

To control shutter speed, change the automatic exposure setting to shutter priority, which will allow you to pick the shutter speed. To control aperture or depth of field (described later in this chapter), change your exposure setting to aperture priority, which will allow you to pick the f-stop.

Determining Focal Length

How is focal length determined to be wide, normal, or long? This is an actual measurement that varies with the camera format and can be quite confusing. The longer the focal length, the less the camera sees, as with a telephoto lens; the shorter the focal length, the more the camera sees, as with a wide-angle lens.

How Focal Length Is Measured

On film cameras, the focal length is the measurement of the distance between the center of the lens (technically the optical center) and the film (technically the film plane). On a digital camera, the focal length measures the distance between the lens and the image sensor. In both cases, focal length is measured in millimeters.

To understand focal length, make a hole with your thumb and forefinger. Bring this hole very close to your eye. At this distance the view is like a wide-angle and the distance (focal length) from the hole to your eye is short. Move it out about two inches for a normal lens view and out six inches for a telephoto.

35 mm Equivalent Focal Length for Digital Cameras

The same parameters determine the wide-angle, normal, and telephoto lenses of digital cameras as of film cameras. However, for quite technical reasons, the actual measured focal length of a digital photography lens is different from 35 mm. To make matters even more confusing, focal length for the same angle of view can vary from digital camera to digital camera depending on the size of the image sensor array. Therefore, to make it simpler for photographers to understand, references to digital cameras' lens focal lengths are generally referred to with the corresponding 35 mm equivalent lens. For instance, the spec sheet for the PowerShot S300 Digital ELPH camera describes the lens as being 5.4 to 16.2 mm with a 35 mm film equivalent of 35 to 105 mm.

Maximum Aperture

When taking a picture, you press the shutter release and the shutter opens to allow light from the scene to be focused onto the image sensor. To get the ideal exposure, just the right amount of light must strike the image sensor. If there is too much or too little light, you'll need to make an adjustment. One way to do so is by opening or closing the lens's aperture, an adjustable opening that regulates how much light passes through the lens. "Stopping" down the aperture makes it smaller so it lets in less light. Opening it up lets in more light.

F-stops

The size of the aperture is measured in f-stops. Each f-stop lets in half as much light as the next larger opening and twice as much light as the next smaller one. From largest opening to smallest, standard f-stops are as follows: f/1, f/1.4, f/2, f/2.8, f/4, f/5.6, f/8, f/11, f/16, f/22, f/32, and f/45.

F-stops are a little confusing because the larger the f-stop, the smaller the amount of light that is let into the camera. The easiest way to think of f-stops is in terms of fractions: just as 1/16 is less than 1/8, an f-stop of f/16 is smaller than—and lets in less light than—f/8.

The word *'stop'* is also often used in photography to indicate half or double the light in a scene.

You won't find the full range of settings on any one lens. The standard lens on a digicam may be in the f/2 to f/16 range. However, the maximum aperture is often an odd in-between number such as f/1.8 or f/3.2, which means that the largest opening is about one half stop more than the next higher f-stop number.

Determining the Maximum Aperture

The maximum aperture of a lens determines how much you can open it. The maximum aperture is also referred to as the maximum iris, or the speed of a lens. Although lenses are referred to by their focal length, the specifications of a lens also carries a second number, such as 2.0 or 3.5, which indicates the maximum aperture of the lens. The maximum aperture is usually inscribed on the front of the lens after the notation "1:." So, for example, maximum aperture of 2.8 will usually be noted on the lens as 1:2.8. Larger maximum apertures, such as f/1.8, let in more light than smaller apertures, such as f/3.2, allowing you to take better shots in low-light situations.

Again, the human eye can show you exactly how the aperture or camera iris works. Our eyes have an iris, which opens and closes depending on the amount of light. In bright light the iris stops down and is very small, and in dark light the iris opens up to let in more light.

Depth of Field

Closely related to an understanding of the aperture is depth of field. This concept refers to the amount of sharp focus around the subject that the camera is focused on. While most people think of sharpness as always being

desirable, this is not true. Experienced photographers use depth of field to produce stunning images, often with areas deliberately out of focus.

F-number, Focal Length, and Depth of Field

There are several important things to keep in mind with depth of field:

- The higher the f-number (the smaller the opening), the greater the depth of field.
- The lower the f-number, the shallower the depth of field.
- The shorter the focal length, the greater the depth of field.
- The longer the focal length, the shallower the depth of field.
- The farther the camera is from the subject, the greater the depth of field.
- The closer the camera is to the subject, the shallower the depth of field.
- A higher f-number will be sharper in terms of focus but requires a corresponding drop in shutter speed, which may cause blur.
- A lower f-number will always have less in focus but requires a corresponding increase in shutter speed.

▲ The maximum aperture used in this close shot allows much of the tablecloth to be in focus.

▲ The minimum aperture used in this close shot causes much of the tablecloth to go out of focus both before and beyond the point of focus.

Using Depth of Field for Artistic Effect

In portraiture, an out-of-focus background will often provide a soft setting for a sharp picture of a person's face. This can be achieved using a portrait lens of about 100 mm (35 mm equivalent) and a lower f-number. In another example, under low light with a slow shutter speed, a hand-held camera may produce a slightly blurred subject, yet that subject can appear quite sharp when contrasted with an out-of-focus background.

With experience, depth of field can be judged in the review mode on the LCD screen. Take a test picture and then view what you shot. Look first at the point of focus (the subject) and then the sharpness in front of and behind the subject.

Focusing Methods

Most digital cameras use some form of autofocus, while fixed lenses on low-end cameras are only sharp beyond a set distance. While an automatic feature like autofocus is wonderful for quick shots, it can have some serious limitations resulting in blurry pictures. Top-of-the-line cameras will offer alternative methods for focusing. Low-end cameras will have fewer options.

Autofocus

An autofocus camera offers a more precise and versatile system than a fixed-focus camera. Cameras with autofocus automatically adjust the focus depending on the distance of the subject from the camera. Sometimes an autofocus camera will also offer focus lock. This feature lets the photographer stipulate exactly what object the camera should focus on. Usually this is accomplished by centering the subject in the viewfinder, pressing down the shutter button halfway to lock the focus, then reframing your shot and taking the picture.

Some high-end digital cameras allow the photographer to set the focus point a specific distance away, such as one foot or four feet. When taking a shot of a scene with many elements, this can be a useful feature. For instance, if you are shooting a picture of a woman standing in front of a statue, the autofocus may lock on the statue rather than on the individual.

Manual Focus

Some cameras have a manual focus that permits the user to adjust the focal point for three different distances, which allows for more creative control. Typically, the settings are macro mode (extreme close-ups), portrait mode (for subjects about twelve feet from the camera), and landscape mode. Other high-end cameras have a manual focus that allows focusing at any point at any distance.

Autofocus in low light often does not work. In this case, it really helps to be able to manually override the automatic feature. Never assume that in dark situations the autofocus is working properly. Check each image carefully to make sure that you are getting the results you are after.

Fixed Focus

A fixed-focus lens is a simple lens with no moving parts; the lens cannot be adjusted. The camera captures sharp images of any subject within a certain distance from the lens, usually from six feet to infinity. Objects outside that range will appear out of focus. Usually, objects that are too close to the camera will appear blurry because the focus is adjusted for a specific distance from the camera to infinity.

For many years most simple cameras, like the Kodak Brownie, had fixed-focus lenses. Millions of people took pictures and were happy with their snapshots, and since the pictures were seldom enlarged they provided acceptable quality.

Today, low-end digital cameras (and cell phones) typically are equipped with fixed-focus lenses. If you're a beginning digital photographer, you may want to start with a camera that has a fixed-focus lens. However, you should note that fixed-focus lenses provide the photographer with fewer options and, therefore, fewer creative possibilities.

Types of Lenses

Lenses are generally categorized as zoom, interchangeable, integrated, and macro. Zoom lenses are the most expensive, offering a range of focal lengths. Interchangeable lenses usually fit on expensive DSLRs and can be either zoom or a fixed focal length. Integrated lenses are part of the camera and cannot be switched out. Macro lenses are specialty lenses for close-up work.

Zoom Lenses

A zoom lens has a variable focal length, meaning it allows you to adjust the focal length over a variety of ranges. The range of focal lengths a zoom lens covers usually is specified by its magnification. For instance, a 3× zoom lens will enlarge or reduce the subject in an image by three times.

Zoom lenses are optical or digital or both. An optical zoom lens truly changes the amount of the subject falling on the image sensor. This results in every pixel in the image containing unique data, providing a final photo that is crisp and clear. The advantage of an optical zoom is its ability to take more detailed pictures of faraway objects. An optical zoom's magnification level is measured in degrees, such as 3× or 10×.

A 2× optical zoom means that if the camera's minimum focal length is 50 mm, the lens has the ability to take photos up to 100 mm.

FACT

Because of the nature of optics, the maximum aperture (f-stop) of a zoom lens will be different from one end of the zoom range to the other. The lower zoom range will allow a greater aperture opening and the telephoto range will lead to a smaller maximum aperture.

A digital zoom takes a part of the normal image and enlarges it to give the appearance that you have zoomed in on the subject. The digital zoom adds new pixels to the image using interpolation software. Many cameras have an optical zoom combined with a digital zoom that only kicks in after the optical zoom has reached its maximum point. If you are given a choice,

you should always choose the optical zoom over the digital zoom. The digital zoom lens is not really zooming. By enlarging part of the image with software it is only giving the appearance of having zoomed in on the subject. With an optical zoom, you are varying the focal length. When you zoom in, the focal length increases. When you zoom out, the focal length decreases.

Interchangeable Lenses

High-end DSLR cameras allow lenses to be changed on the camera body. An interchangeable lens can be detached from the camera and replaced with another lens having the same type of mount. Professional photographers rely on interchangeable lenses to create desired effects depending on the situation they are shooting. If you are considering purchasing a digital camera with an interchangeable lens, be sure to investigate the number and types of lenses that are available.

Integrated Lenses

An integrated lens is part of the camera and is not detachable. Some integrated lenses allow you to add supplementary lenses. Typically, supplementary lenses screw onto the lens barrel thread or slip over it with a friction mount. A supplementary lens changes the viewing angle of the lens or allows it to focus more closely than it would in macro mode. Many integrated lenses are zoom lenses.

Macro Lenses

Some digital cameras can focus as close as one or two inches (or even closer) from the subject. This capability will be appreciated by the nature photographer hoping to catch the opening buds of wild orchids in the spring or tiny crabs scampering down a beach. A macro lens can come in handy even around your own home. With a macro lens on your digicam, getting down on your knees for a close-up shot of your new kitten can provide delightful results. See the color pages for macro shots of agate, soap bubbles, flowers, and leaves.

While there are dedicated macro lenses, many cameras with zoom lenses now have a macro setting. Typically the camera must be zoomed

back to the shortest focal length and then a button pushed to go into macro mode. Some noninterchangeable lens cameras also have a macro mode. Check your camera's manual for specifics.

Since DSLR cameras allow changing lenses, you can buy a lens just for macro photography. There are even telephoto macro lenses that allow the photographer more working distance, which can be important in extreme close-up photography.

▲ Looking closely at ordinary things, such as this embroidery, reveals a world of picture possibilities.

Taking a Closer Look at Macro Photography

The world is a marvelous place, especially when viewed close up. A small area suddenly becomes huge when you think of all the close-up shots you could take. Yet macro photography is quite different from normal photography for a number of reasons. There is a limited depth of field. Working very close causes its own set of problems, such as the creation of shadows, and a special lens must be used.

Macro Photography Pointers

To get the best effects from your macro photography, keep the following tips in mind. Check your camera's manual to see what the range is for your macro mode. It can vary from a few inches to as much as eighteen inches. Then stay within that range. In fact, read everything in your manual about the macro mode, because this feature may require special settings.

ALERT!

If you are planning to take a lot of close-up shots, be sure to check the minimum focusing distance of any camera you're thinking of purchasing. The minimum focusing distance specifies how close to the subject you can place the camera. That is, it controls your ability to take close-up shots.

For a variety of reasons you're better off setting up your shot with the LCD screen. Both depth of field and parallax become serious problems with macro photography. However, the LCD monitor should show you true focus in review mode and also correct framing, which a viewfinder will not. Take a test shot before tackling any serious work. Because macro lenses focus so close, depth of field is critical. If your digicam has an adjustable ISO setting, set the sensitivity higher. This increases the depth of field, bringing your macro shot into focus. Using your onboard flash may or may not work. Usually the flash is designed to work farther than the macro range, but it doesn't hurt to try a shot or two to see what you get.

Tips for Macro Photography

It's essential to keep the camera steady. Use a tripod or set the camera on something solid like a table or a stack of books.

If your camera offers a manual focusing feature, use it to take a great close-up shot. Some people find it easier to set the focus manually then move the camera to the point where the subject is in focus. This is because focusing in the macro mode can be very difficult unless you are experienced.

Virtually all digicams offer autofocus. Sometimes an autofocus camera also will offer focus lock. This feature lets you stipulate exactly what object

the camera should focus on. Usually this is accomplished by centering the subject in the viewfinder, pressing down the shutter button halfway to lock the focus, then reframing your shot and taking the picture. Review the playback to make sure the focus was exact. Note that this feature usually also locks in the exposure. If the object you use to focus on produces an incorrect overall exposure, you will have to rethink the shot.

FACT

In addition to shooting close to the subject, the macro mode allows you to use your camera like a scanner to make digital images of illustrations, film photographs, and other objects that could otherwise be scanned on a flatbed scanner. Make sure that the back of the camera is parallel to the illustration or the resulting shot will be distorted.

Evaluating a Lens

When purchasing a digital camera, many folks forget to consider an important component of the camera: the lens. Along with the image sensor, the lens is the part of the camera that will most critically affect the quality of your photographs. A high-quality lens will make a huge difference in the quality of the pictures, no matter how many megapixels the camera records.

A lens can be made of glass or plastic elements. Glass tends to provide higher optical quality and greater resistance to scratches. Lenses are coated to cut down on reflections that can occur on the surfaces of lens elements, causing a blurring of the image. Read reviews of lenses to determine which ones are of highest quality.

Consumer Questions

The following tips will help you judge the lens on the camera you're considering purchasing.

- **Who made the lens?** If it is a manufacturer known for making high-quality optics, such as Nikon, Canon, or Olympus, this is an indication that your images will be crisp and colorful.

- **Does the lens use plastic or glass optics?** Glass lenses are far superior to plastic lenses.
- **Can you attach filters to the lens?** Even if you don't want to use filters, you may want to buy a clear one to protect your lens from scratches, so being able to attach a filter is important.

Consumer Testing

Test drive a zoom lens. Stand ten or twelve feet away from a group of people, look through the lens, and zoom all the way out to wide-angle. How many people are in the shot? Try out the telephoto end the same way. Remember to consider the types of shots you'll be taking. The goal is to get as much original image data into the camera as possible.

Is the zoom lens motor driven? Or can you zoom manually? If it's motor driven, you'll use up your batteries faster. You also will want to note how long it takes to zoom.

Lens Accessories

One drawback to less expensive digital cameras is their lack of interchangeable lenses. However, if a camera has a screw-thread ring inside the front of the lens barrel, it can probably accommodate supplementary lenses and filters. When shopping for a digital camera, you may want to look for one with an interchangeable lens capability, especially if you plan to take many different types of photos.

Filters

Photographic filters are used to correct the color of light or provide a special effect. Some important filters are as follows:

- **UV (ultraviolet):** A UV filter removes ultraviolet light, which commonly shows up in the background of distant shots as a bluish haze. A UV filter is also a great tool for protecting your camera lens.
- **Polarizing:** Polarizing filters remove glare caused by reflected light and tend to improve color saturation. A polarizing filter will darken

a blue sky (which is usually needed in most digital shots) and add richness to colors.

- **Neutral density filters:** When taking pictures in brightly lit situations, a neutral density (gray) filter will reduce the light coming through the lens so that you can use a wider aperture to get less depth of field.

Lens Hood

A lens hood or lens shade hinders unwanted light from striking the lens and creating flare. It also affords your lens some protection from knocks and bumps.

Lens Cap

Look for a camera with a protective lens cap that automatically covers the lens when the camera's power is turned off. Barring that, attach your lens cap to the camera with a string to help prevent your losing it.

Keep your lens free of dust and grit in order to protect the glare-reducing coating and the glass itself. A lens cleaning kit with a blower brush and lint-free tissue is a must. Protect your lens by keeping a UV filter on it at all times.

Try to hold onto the lens cap that came with your digital camera; because the digicam lens caps are so small, it's hard to find replacements. If you do come across a lens cap that fits your digital camera, it might be a good idea to invest in a spare.

CHAPTER 6

Lighting and Flash

Light is what makes photography happen. In fact, the word *photography* comes from the Greek and means light (photo) drawing (graphy). The more you know about light, the better your photographs will be. Working with the existing light often creates the best and most natural photographs, but frequently there is not enough light or the light is too harsh and you may need to use a flash. This chapter explains the technical side of lighting. Chapter 11 discusses the artistic use of light.

Shooting with Available Light

Most photographs are taken with the light that exists in an environment. Experienced photographers learn to judge and work with this light because it produces the most natural results. Flash, by its nature, makes subjects very aware of the photographic process, and the look of the flash lighting is often artificial.

def·i·ni·tion

Available light: This common term is not really a technical or clearly defined concept. It means the light in a room or at an arena or on a city street at night. It can mean light bulbs or window light or floodlights or a combination. Some photographers also use the term *ambient light*.

Take a Lighting Inventory

If you want to work with available light, become aware of the different light sources. In addition to its color, each light has its own intensity, direction, and shadows. Also, lights combine to create an overall effect.

For example, there may be table lamps, window light coming through a curtain, and halogen lamps that are pointed at the ceiling and bounce light down onto the room to add a general softness to the scene. In addition, the color of light takes on colors in the environment. For example, sunlight coming through a red curtain will take on a reddish tone; light bounced off a blue ceiling will take on a bluish tone. Every scene will be different.

Work with the Available Light

Just because a light is on or off does not mean that a photographer cannot change that. If a photographer arrives early for a shoot or finds herself in a room where the lighting could be improved, she can open blinds or close them, adjust lamp shades, and turn on overhead lights.

Outside, if you can move your subject around, look for open shade such as the shade under a tall tree. Such shade will create a more even and pleasing light.

Finding the Best Angle

If you move around the room, you will often find an angle that will produce the best pictures because the light is better at that angle. If you are taking pictures of people, for example, get them to turn toward you or to move so that you take advantage of that angle.

Available Light Limitations

With available light, you are stuck with what exists on the scene. While you can tweak it a bit, you will be limited. Typical problems are dark shadows on a person's face, incorrect exposures, black shadows where nothing can be seen, and odd color.

Your Exposure System Can Be Fooled

Avoid bright lights behind your subjects, for example, because that will produce backlighting, which can fool the automatic exposure meter in the camera and create a dark, underexposed photo. Also avoid bright-colored backgrounds because they can fool your metering system as well.

Direction of Available Light

House lighting can be quite directional, producing deep and sharp shadows. A portrait will often have heavy shadows, and areas of the scene where there is no light may go completely black. In this case, try to turn on some more lights to illuminate the dark areas.

def·i·ni·tion

Detail: This very general word usually refers to the clarity, exposure, and sharpness of different areas of a photograph. For example, a blurry close-up picture of a leaf would have no detail in the leaf. If you see nothing but black in a shadow, then the shadow has no detail.

Color Problems with Available Light

The color of indoor light can be quite difficult for the white balance setting on your camera to read, and mixed lighting sources that are evenly matched can be especially difficult. Fluorescent light is often cold and blue even when corrected with the white balance setting on your camera. Odd-colored lights like neon usually cannot be corrected with the white color balance.

ALERT!

Many photographers believe that mistakes in picture taking can be corrected later with software. While this works much of the time, it often does not. A very bad white balance is often hard to correct, for example. Your pictures will always be better if you get them right at the time of shooting and not later in the digital darkroom.

White Balance or Color Balance Setting

The white balance (WB) setting on your camera sees the principal light source as white light. In color photography this is especially important, as every light source is different and has a characteristic color. Each light has a color temperature (measured in degrees Kelvin). When your camera sets the WB, it sets it to the color temperature of that light.

Most people have seen photographs taken indoors that were very orange. This happened because the WB setting was set incorrectly and the house lamps (known as incandescent or tungsten) caused the picture to become orange. By changing the WB setting correctly, the camera would have seen and recorded the orange light as white light and the picture would have looked normal.

You've probably heard the expressions *cool colors* and *warm colors*. In fact, different light sources really do have different color temperatures, which means they are made up of varying amounts of red, green, and blue light.

Adjusting Color Balance (Color Temperature)

Normally the human eye compensates for different lighting conditions and we are not aware of differences in the color of light. Most digital cameras automatically adjust for the correct color temperature. However, there are times when you will want to override the automatic setting or even set the WB to a wrong setting for a special colorful effect.

If the balance is not too far off, it is easy to compensate for color balance of a digital image by using image-editing software. However, you will suffer some loss of definition during the editing process.

FACT

Color temperature is measured in degrees Kelvin. For instance, a 100-watt incandescent bulb measures 2,850° Kelvin, noon light measures about 5,500° Kelvin, and average daylight is approximately 6,500° Kelvin. Higher temperatures such as daylight are bluer, and lower temperatures such as house bulbs are red or orange.

Typical WB Settings on a Digital Camera

Here are some typical settings you will find on mid-level cameras:

- Automatic Recognition
- Daylight
- Cloudy
- Shade—outdoors
- Incandescent Light
- Fluorescent Light—Daylight
- Fluorescent Light—Warm White
- Fluorescent Light—Cool White
- Custom

Why Custom WB?

Some high-end digital cameras allow you to override the automatic color balance system. Why would you want to adjust the color balance manually?

You do this because you can sometimes achieve a desirable effect. For example, say you're shooting a candlelit dinner scene. By overriding the color balance feature, you'll be rewarded with a moody image exhibiting a warm glow. In other situations, the color balancing system does not remove all unwanted colors. By choosing a different color balance setting you may be able to correct such problems, making colors appear truer.

Setting the White Balance

Many cameras allow you to zoom into a subject—say a person's face—set the color balance, and then zoom back. A custom setting will be more accurate than trying to set the white balance for the entire scene, which may be a mix of light. In this example, since the person's face is what you care about, you can tailor the lighting for the best effect.

Flash

Just about all cameras come with a flash. Flash is like carrying around your own light source no matter how dark a situation might be. Flash used to make people self-conscious with the bright burst of light, but now people are more used to a flash going off, although several flashes in a row can be annoying. See the color pages for a flash photograph of a musician as he is performing.

The flash guide number (GN) will tell you the power of the flash for a particular ISO. The higher the number, the more powerful the flash. When comparing flashes, make sure that the ISO reference is the same, as a more sensitive ISO will result in a higher GN.

Flash Speed

Flash is extremely fast, from 1/1,000 of a second to as little as 1/10,000 of a second. With a flash, the main purpose of the shutter is to open long

enough for the flash to go off and then to close. The automatic exposure calculates the exposure based on the flash lighting and not the room lighting. In a sense, the normal shutter speed is overridden in a flash shot because the brightness and speed of the flash overpowered the light in the room.

Because flash is so fast it can create wonderful (or unwanted) effects. For example, if you can take flash pictures of someone bouncing up and down on a trampoline in a room with low light, you will get an unusual shot of a person frozen in mid-air with every hair on his head standing up. It can also capture an unwanted effect and catch a person in the middle of blinking her eye, for example, so that her eye is half closed and she looks a bit sinister.

Other Flash Options

While most people will use the flash mounted on their camera, there are other choices:

- **Dedicated flash:** This flash is sold by the manufacturer of the camera and is designed to work with a particular brand. If it works with the camera's automatic exposure system, it can produce very pleasing and sophisticated results. Typically it slides into a hot shoe on the top of the camera, a mounting device with an electrical connection that enables the addition of a flash unit.
- **External flash:** Some high-end cameras allow any brand of flash to be attached to the camera via a connector that plugs into the camera. You can move an external flash off of the camera, which solves most problems with flash lighting. Generally you must also purchase a bracket that screws into the tripod screw hole at the bottom of the camera and holds the external flash securely to one side. This side lighting is much more pleasing than the straight on-camera flash lighting and also avoids the red-eye problem.
- **Slave flash:** Slave flashes are triggered by the main flash and fire at the same time. You may not be able to use the red-eye reduction flash setting with slaves, however, as the initial low-power flashes that occur with the red-eye reduction setting will trigger the slaves long before the main flash.

Flash Settings

Less expensive cameras will have less powerful flashes. More expensive cameras tend to have more power and a variety of settings. Some come with a number of exposure settings that let you mix flash with available light.

FACT

Light increases and diminishes very rapidly as distance changes. Double the distance and you need four times as much light. Halve the distance and you need a quarter as much light. To say it mathematically, the intensity of a light source varies with the square of the distance.

Common Flash Settings

Most flashes will come with several of these settings. Do not expect them all in a basic camera. However, a dedicated flash may have a number of other settings in addition to these listed.

- **Automatic flash:** This setting simply computes a value for the flash exposure for the particular light situation and fires the flash. If there is enough light, the flash will not fire since the camera thinks that the scene does not require a flash.
- **Fill flash:** If you want the flash to fire in a daylight situation, use the fill flash setting. This will add the flash to the existing lighting and remove many harsh shadows caused by sunlight.
- **No flash:** Some cameras will automatically fire a flash when they detect that there is not enough light. If you do not want the flash to fire under these circumstances, turn the flash off.
- **Red-eye reduction mode:** In this setting an initial flash or flashes are used to cause the pupils in people's eyes to close before the main flash fires. This can help reduce the problem of red-eye. In many cases this setting does not work. However, red-eye is not hard to correct in the digital darkroom with image software.
- **Slow-sync flash:** Flash in nighttime situations often result in a brightly lit subject with a black background. To add detail to the background

and to bring the existing available light to the scene, steady the camera with a tripod when using the slow-sync flash setting. This mode will allow the subject to be lit properly with the flash but then also expose the picture for available light, often for a very long shutter speed. For creative effects, mixing the very fast light of the flash with a slow exposure can result in unusual images.

Different Flash Levels

Some expensive cameras will let you choose high, medium, or low flash intensities. This gives you much more control over the light and also allows the flash to recycle faster and conserve battery power at the low setting.

Bounced Flash

A flash lighting that is reflected off a wall or ceiling or other surface is called bounced lighting. You need to have a flash that you can direct toward a ceiling while you aim your camera lens at your subject. This technique allows you to capture flattering pictures without the harsh light of a direct flash. It tends to be quite even, with mild shadows. The angle of the shadow will be the angle of the bounce and the bounce surface will absorb some light. In addition, the light will take on the color of the bounce surface. To further complicate things, the distance the light travels will be the total distance to the bounce surface and then back to the subject. For this reason, trying to bounce a flash off of a high ceiling will not produce good results. Calculations can be tricky, but with the LCD review, adjusting settings and determining the bounce angle should not be hard. To make things very easy, bounce cards can be attached above a flash for bouncing. These often provide quick and easy flash lighting for most situations. You simply attach the card to your flash and it will direct the flash.

ALERT!

There is no substitute for experience. Try out different exposure settings and compare results. Experienced photographers learn to try a number of different options before understanding which will work best in a given situation. Flash is particularly difficult and is an art form in itself.

Understanding What Your Flash Will Do

You will need to experiment a bit to see what your digicam's flash can and cannot do. Most built-in flash units are small and are designed to light up subjects close by. Take a series of indoor shots with your subject standing or sitting at different distances from your camera. Take shots of your subject in front of a light source, such as a window, with and without the flash to see how a flash can "fill in" darkened areas.

Principal Flash Limitations

While flash is the all-purpose light source that will work in many situations, it does have plenty of drawbacks. Never take a flash shot and expect it to be perfect unless you have had a lot of experience. Flash can get very technical, but it allows you full control over lighting.

Coverage

Typically, when shooting indoors, the flash will work adequately if the subject you're shooting is within ten to twelve feet. Beyond that you may be out of luck. However, when zooming in on a subject more than twelve feet away, some sophisticated flashes will zoom with the lens so that the light will go farther and be more concentrated. Most flashes are designed to cover a normal lens angle of view, so if your zoom is set to wide-angle you may find that the edges will not get lit properly.

On-Camera Flash Is Harsh

Flash pictures often look a bit staged due to the directionality of the lighting and the harshness of it. Since most cameras have an on-camera flash mounted on the top of the camera, flash produces a severe lighting, much like having the sun directly behind you. Pictures taken with an on-camera flash tend to look similar, since the flash produces a flat light that minimizes surface textures. There are several solutions to this problem. For example, a dedicated bounce flash or an external flash that is moved to the side solves this problem.

Red-Eye

Direct on-camera flash of people often produces an effect that is called red-eye. When a person's eye is open in low light, the flash reflects off the retina and produces a horror-movie red-eye look. The solution is to use the red-eye reduction flash setting, to not have the subjects look directly into the camera, to move the flash off the camera, or to bounce the flash.

Some people put a white handkerchief over the flash to soften the light. While this works well in close shots, it reduces the power of the flash so that it does not work in all situations. Also make sure that the fabric is really white, as the flash will take on the color of the cloth.

The bad news is that red-eye reduction is not always totally successful. The good news is that if your subject does end up with red eyes, you can correct the problem with image-editing software. If you do a lot of portrait work, you will want to buy an auxiliary flash that, when used properly, will not produce red-eye.

Red-eye occurs because most flashes are on axis with the lens. This means that the flash and lens are lined up together. When the flash fires, the light enters a person's eye and bounces around, taking on a reddish tint before coming back directly to the lens. If you move the flash off axis you will generally get rid of the problem.

Blinking and Unexpected Flash Results

Everyone has seen flash shots, where people blinked and it looked as if their eyes were shut. You will not be aware that a person has blinked because you cannot see the picture when the flash fires on the LCD monitor, although you can see it through an optical viewfinder.

Additional Flash Limitations

Unfortunately there are even more problems with flash lighting. To be able to control this lighting effectively, you need to know all the things that can go wrong.

Hot Spots

Because flash is close to some things and farther away from others, you many find brightly lit or overexposed areas close to the camera. These are often called hot spots. The solution is to make sure that there is no piece of furniture or a plant or anything else between you and the subject of the photograph.

Experienced photographers use one eye, such as the right eye, to compose the scene with the viewfinder and then switch to the other eye, such as the left eye, to monitor the scene when the flash fires. They do this because many camera viewfinders, such as LCD monitors and those on DSLRs, black-out just as the shot is taken. To see the effect of the flash, photographers must look at the scene with their naked eye.

Photographs of Groups

When you are taking a photo of a scene with multiple subjects at different distances from the camera, the exposure cannot be correct for all of the subjects. Usually those closest to the camera will be properly exposed. The farther the subjects are from the camera, the darker they will appear in the picture.

Flash Will Eat Batteries

Flash requires a lot of electricity. The more powerful the flash, the more juice it will use. Taking nonstop flash pictures will run through your batteries much faster than photographing in available light. If you do a lot of flash photography, make sure that you carry plenty of extra batteries.

Flash Recycling

Flash stores electricity and then releases it in one powerful burst. Most flashes can take a while to recharge—ten seconds or more—so rapid sequential shooting is not possible with flash. Some flashes will fire before they are fully charged, which will result in underexposed pictures. You should always wait for the flash ready light to come on before taking the next shot.

Focal Plane Shutters

High-end DSLR cameras use a focal plane shutter. Most of these shutters have a maximum shutter speed that can be used with a flash. For very technical reasons, at faster shutter speeds the shutter curtain gets in the way of the picture and only a portion of the frame will be exposed.

Since it is so easy to review shots with the LCD monitor, it is a good idea to review all your flash shots immediately after taking them. If you have a group of people together, don't let them go until you are certain that you got the shots you want; getting them together later may be difficult or impossible.

Flash and Available Light

Often the best solution is to mix available light and flash. This can give you the best of both worlds. It minimizes the harshness of flash lighting and combines it with the more natural light in an environment.

Daylight Mix

Using the fill flash setting, you can remove the dark shadows that are present in sunlight. For example, the shadows of a woman's hat on her face can look bad. A fill flash will lighten those shadows. Fill flash is also great for backlit shots and for a portrait of a person with a sunset sky behind her.

Available Light Mix

Fill flash that is balanced with available light often produces soft, pleasing results with few deep shadows. Mixing the color of flash with house lighting, window light, and light that is bouncing off the walls can create a warm and friendly tone.

Nighttime Mix

If you can hold a camera really steady or if you can keep the camera steady on a tripod or a table, slow-sync flash can produce very nice and often striking results at night. A well-lit person can stand against a dark but lit night city scene, for example.

Additional Light Sources

You can add your own light to the scene. For example, reflectors have been used by photographers for over a hundred years, such as in the early days of the silent movies. In addition, you can bring a myriad of lights that you can set up in a photo situation.

Some photographers will bring their own bright bulbs that can be screwed into standard house lamps. These can be standard house bulbs (called incandescent or tungsten) or specially color-balanced photo bulbs. However, if the wattage of the bulb is too high for the lamp, the bulb could start a fire.

Reflectors

Photographers have always used large collapsible reflectors. In sunlight, for example, these bounce light back into the face of subjects so that the daylight does not produce characteristic deep shadows.

Video Lighting and Light Stands

If you have a video camera, you can use the light that comes with it for your digital photography. You can also purchase a variety of studio lights that clip to stands or that are bounced into a silver reflecting umbrella.

Be Creative

You do not have to buy all your equipment at a photography store. You can improvise and save some money. At an auto parts store, for example, you can buy large folding reflectors that people put in their windshields to keep the sun from heating up their cars. These same inexpensive and portable items can be used in photography to reflect light onto a subject. If you do a lot of lighting, you should carry a roll or two of duct tape. Tape down extension cords and the bottom of light stands to keep people from tripping over or upsetting your equipment.

Shooting at Night

Night photography is a special world that can be quite difficult but also quite rewarding. Photographers who accept the challenge of this kind of photography often create some of the most striking images because of the bright colored lights and deep shadows. See the color pages for examples of night shots.

A World of Contrasts

You may think of night photography as taking pictures in the dark, but that is not true. Night photography has very special demands. While shadows will be deep and dark, bright light abounds. Car headlights, neon lights, store windows, and street lights can quickly overexpose your photograph. The trick is to find a middle ground where you can balance these extremes.

A World of Color

While you may think of night as being black and white, it is often quite colorful, due to the different light sources (and color temperatures) as well as the neon lights. In addition, you will find a myriad of signs and windows that are lit from behind. This kind of lighting is often quite dramatic and not available during the day.

Night Photography and Slow Shutter Speeds

For the spirited photographer, a tripod, night scenes, and slow shutter speeds can add up to an adventure in photography. The lights of a car crossing a bridge will illuminate the entire length of the bridge if the camera is set to a thirty-second exposure, for example. While the bridge and camera do not move, the headlights do move and the total effect is to light a good deal of the bridge. Cars steaming down highways make beautiful night shots. A shot taken with a slow shutter speed makes their headlights look like a flowing river of light.

The only limit to night photography is your imagination. With a little creativity, you can paint with light—that is, let light wash across the picture area. With this kind of photography, you will make many mistakes, but there is virtually no cost because you can erase all your errors.

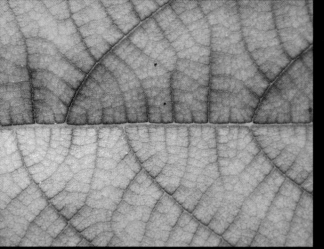

A macro shot reveals the intricate structure of a leaf.

The camera lens was almost touching the petals to make this shot of a rose of sharon.

An extreme close-up with a macro lens created this shot of a small lantana flower.

Rain on this leaf created the shine revealed in this

Anticipation of the gull's movements plus a very fast shutter speed contributed to this shot.

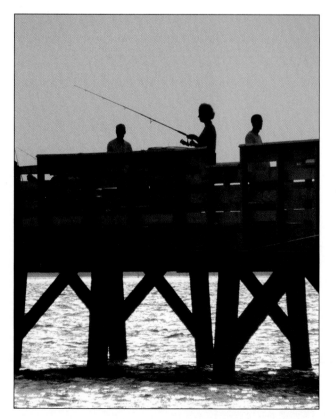

Soft late afternoon light, plus reflected light from the white sand, illuminated this gull.

The sun behind people fishing, along with underexposure, created these silhouettes.
(*left*)

A telephoto zoom allowed the photographer to be at a comfortable distance from this cat. (*left*)

A flash illuminated this Cajun musician in a night club. (*left*)

An unusual camera angle created this composition of an old Buick grill ornament.

This night shot of neon against venetian blinds was taken using a tripod and a slow shutter speed.

North-facing window light on wet shrimp made this close-up shot.

Natural window light behind a thin slice of agate created this macro shot.

Everyday items with contrasting colors, such as these red tomatoes and blue plate, can create a strong composition.

This night shot, taken with a tripod and a timed setting, created this photo of a clock face in the center of Beaufort, NC. (*right*)

An extreme telephoto lens prevented distortion of the Greek column in this photo. (*right*)

This night shot of downtown Beaufort, NC shows how bright light flares and makes a colorful pattern when street lights overload the digital image sensors. (*left*)

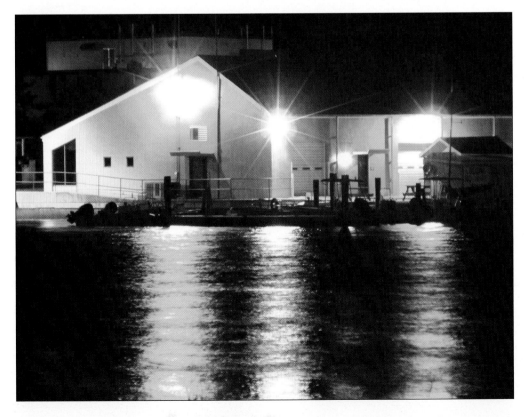

In this long exposure night shot, the reflections in the water take on the color of the lights. (*left*)

The sun and clouds, juxtaposed against water and land, make an interesting composition.

The sunlight turns orange toward sunset in this minimal composition.

A cloud, the sun, the land, and the water stand as separate elements in this photo.

A cloud crosses the sun as the sun silhouettes the land in this extreme telephoto shot.

Batteries and Travel Considerations

Digital cameras are powered by batteries. Part of your job as a digital photographer is to manage your power needs and to have backup. In addition, you may have other devices that work with your digital camera and require batteries. When you travel, you will need to take extra batteries and be aware of how much spare power you have available. You must keep track of your batteries to be a successful digital photographer. If you don't, you'll be out of business.

AA Batteries

Many digital cameras use AA alkaline or AA rechargeable batteries for their power source while others use proprietary rechargeable batteries. As with everything in photography, there are advantages and disadvantages to each option. When you buy a camera, the way a camera is powered should be included in your consideration.

AA Disposable Advantages

Disposables don't require managing. Here are some of the pros:

- AA alkaline disposable batteries are available everywhere.
- They are generally inexpensive.
- If you carry around plenty of extras, you will never be caught short without a fully charged power supply.
- You can use them in other devices you have, such as a flash, that require AA alkaline batteries.

AA Disposable Disadvantages

Disposables can be a nuisance to deal with:

- Good rechargeable batteries will not have to be switched as often as AA alkalines.
- In cold weather, alkaline batteries will die right away.
- You will have to constantly buy and stock dozens of AA batteries to make sure you have enough ready power.
- Rechargeables may be much cheaper in the long run, although they do not last indefinitely.

FACT

Batteries are rated with an mAh (milliamp hour) rating. The higher the rating, the longer you can use the batteries. For example, rechargeables are typically available from 700 mAh to 2,700 mAh. To determine how long a battery will last, divide the mAh by the electrical demand of the camera or device.

Consumer Tips

You can save a lot of money with AA disposables if you know how.

- You can pay as little as 25 cents per battery or as much as a dollar per battery depending on what brand you buy, where you buy them, and how many you buy.
- Buy AA alkaline batteries in bulk because they are much cheaper that way; consider buying twenty or more at a time.
- Lesser-known brands such as Panasonic work just as well as better-known and highly advertised brands; these are often available at Dollar Stores.
- Buying AA alkalines at convenience stores or other such places will cost you an arm and a leg—a dollar or more a battery—yet in an emergency it is nice to know that you can find them anywhere, anytime.

Rechargeable AA Batteries

Battery technology has advanced quite a bit. Rechargeables now claim that they last much longer than AA disposables and that the batteries can be recharged up to 1,000 times. Some manufacturers claim batteries can be recharged quickly, in as little as an hour. You can expect to pay as much as five dollars per battery. However, if you use your camera a lot, the savings over several years could be hundreds of dollars.

With rechargeables you will not have to carry around as many batteries or buy batteries very often. However, you will need to keep your batteries recharged. This requires management; you will need a system so that you know which batteries are dead and which are recharged and you will need to take your recharging device with you.

Also keep in mind these requirements for rechargeables:

- Always charge up your new rechargeable batteries before you use them the first time.
- Your recharger must be compatible with the size of battery and the type of battery you have.

- If you are not going to use batteries for a while, give them a full charge before storing them.

Working Tips for AA Batteries

No matter what kind of AA battery you choose, you need to be aware of some important considerations:

- Never mix old batteries with new batteries; you will go through the new batteries quickly, and mixing can also cause bursting or leaking.
- Never mix different kinds of batteries, such as rechargeables and disposables, or rechargeable batteries with different capacities.
- If you are not going to use your camera for a while (two weeks or longer), take out the AA batteries; when you restart your camera, put them all back together into your camera as a group.
- Have a way of marking or storing your batteries so that you know which batteries have been partially used and which have not.
- If you buy a brand of battery that shows signs of leakage, never buy that brand again.
- When storing batteries, check that the positive and negative ends do not touch.
- When replacing batteries, make sure you put them in the battery compartment in the correct way according to the instructions; placing batteries incorrectly can damage some cameras.

Rechargeable Proprietary Batteries

A proprietary rechargeable battery can have a lifetime of between 100 and 1,000 charge cycles, depending on the materials from which it is made. The types of batteries used in digital cameras generally last from 500 to 800 charge cycles, or about one to three years of average use. These are often quite expensive, as much as $50, and only work with a certain brand of camera.

As large proprietary batteries get older, the information in the LCD read-out about available battery power may not be accurate. Initially you might

see that you have a full hour of power left; instead, the battery might last for only twenty minutes. This is a sign that the battery soon will not hold a charge and needs to be replaced.

In addition, they do have a limited lifetime, so expect to shell out another $50 for a spare battery and then another $50 every year or so.

def·i·ni·tion

Proprietary: This means that a device works only with one manufacturer's products. It is specific to that manufacturer. A proprietary battery, for example, generally will only work with a certain make of camera and may only work with certain models.

Rechargeable Types

There are several kinds of rechargeables and each has its own characteristics. While not the most exciting subject, you should know how your batteries work and how to dispose of them when they no longer work properly.

NiMH

Nickel metal hydride (NiMH) batteries are the most popular batteries for digital camera use because they are rechargeable, nontoxic, and relatively inexpensive. Since they're designed to be used with power-draining equipment, they can offer you more pictures per charge than other types of batteries. According to one manufacturer, NiMH batteries can last 40 percent longer than the same size NiCd battery. In digital cameras, NiMH batteries can typically run three to four times as long as an alkaline battery from a single charge.

NiMH batteries are also preferred because they don't have problems with memory effect. Other rechargeable batteries have shorter life cycles if they are recharged before their power fully runs out. Made from nontoxic materials, NiMH batteries are more environmentally friendly than other types of batteries. Battery retailers recommend NiMH batteries for use in digital cameras.

Li-Ion

Li-Ion (lithium ion) batteries are one of the newer types of rechargeable batteries. They last about twice as long as NiMH batteries, they don't lose their charge as quickly when stored, and they do not have any memory-effect problems. The downside is that they are harder to find and cost more than other types of rechargeable batteries.

NiCd Batteries

NiCd (nickel cadmium) batteries are the most widely used type of rechargeable household battery for portable devices such as digicams, radios, laptop computers, and cellular phones. You can recharge them quickly, and they last for hundreds of charge cycles. NiCd batteries perform well in low temperatures, but they do have a problem with memory effect. Cadmium is an expensive and toxic metal. Consequently, producing NiCd batteries is expensive, as is disposing of them. To combat the increased costs, some manufacturers are actively recycling components of NiCd batteries.

ALERT!

Rechargeable batteries, especially NiCd batteries, run into problems if they are not fully drained before being recharged. Attempting to recharge a battery that hasn't fully lost its charge can result in its not taking a full charge, or not delivering its full capacity, or both. To fix the problem, leave the camera and LCD on to fully discharge the batteries.

Charging Batteries

If you use rechargeable batteries, you will need to add another piece of equipment to your standard camera bag—a battery recharger.

Battery Rechargers

When buying your digicam with proprietary batteries, find out if it comes with a battery charger. The newest battery chargers rely on micro-

processor technology to provide rapid charge to your batteries in about one to three hours. (Otherwise, it can take up to twelve hours to recharge batteries.) Another advantage of a battery charger with microprocessor control is that it can determine when a battery is fully charged. Then it will either begin trickle charging or shut off completely. This prevents overcharging of batteries. Some cameras will recharge the battery in the camera, when the digicam is plugged into an AC wall outlet. If you want a separate recharger, you will have to buy one.

If you decide to buy AA rechargeable batteries, find out if the AA recharger can trickle charge the batteries. Once the batteries have been fully charged, trickle chargers continue to supply a small charge to them. There are differing opinions on the effectiveness of trickle charging. Some battery manufacturers do not recommend it. The best battery chargers send only an occasional pulse charge, rather than a continuous low rate of charge, to a battery that is already charged. Excessive trickle charging tends to dry out the electrolyte that makes a battery work, thereby ruining the battery.

Recharger Tips

Here are some things to consider when choosing a battery charger:

- Can it charge both NiMH and NiCd batteries?
- How long does it take to charge a set of batteries?
- Can it condition NiCd batteries?
- How many cells can it charge at one time?
- Does it have an optional 12 V power cord so you can plug it into your car's cigarette lighter when you're on the road?

Conserving Battery Power

Managing your power was something you never had to think about with traditional film. If you are new to digital photography, you will learn that you must be aware of how much power you have available.

Staying on Top of Your Power Needs

You can get more shots out of your camera if you turn off or turn down power-draining features. First, always be aware of how much power you have left. Many cameras offer a readout of estimated battery time. However, this information is at best only an estimate. To be safe, you should assume that you have much less time than the camera tells you. If a battery does not last as long as it should, mark that battery with a notation, such as an asterisk, to indicate that the camera cannot read that battery's level correctly.

In many cameras, you will get a low battery warning that flashes on the LCD monitor or viewfinder. Depending on the camera, you may be able to take up to ten more shots. So if you need to take a crucial shot when the warning starts, go ahead and take the picture; you will probably be okay.

Follow these tips to maximize your digital camera's batteries.

- Turn off the LCD monitor if you are using a viewfinder. If your camera has an optical viewfinder or an LCD viewfinder, turn off the LCD monitor at the back, as it uses a lot of power.
- Turn off the LCD viewfinder if you are not using it. Some high-end cameras have automatic controls that will sense when you have the viewfinder close to your eye and will only turn it on when you are looking through it.
- Turn down the flash. If your flash has different power levels and you don't need all that power, use the lower flash setting.
- Don't use the flash—use available light. Flash eats batteries. The less you use flash, the longer your batteries will last.
- The zoom setting can use a lot of power—avoid zooming in and out if not necessary.
- Recording can use a lot more electricity than playback—put your camera in playback mode if you leave your camera on for a while.
- Many cameras will work with a power cord plugged into a wall. If you are in a fixed situation close to an outlet, use the wall power.

On or Off?

If you are using your camera every couple of minutes or so, leave it on instead of turning it on and off. Leaving it on means that you will be ready for a spontaneous shot. Turning it on and off uses a lot of battery power, so you may not be gaining anything. If you forget to shut your camera off, many shut down automatically after a set period of time.

Never open the battery compartment or remove batteries when the camera is saving a picture to memory. Interrupting this procedure can corrupt your picture file and possibly the memory card itself. A save operation in the camera is often indicated by a flashing light or other warning sign.

Organizing Multiple Charged and Discharged Batteries

If you do a lot of digital photography, you will need many extra batteries. If the batteries are rechargeable, you will need to bring the recharger with you in your camera kit. You will need to keep track of which ones have been discharged and which are fully charged.

Batteries and Aging

As they get old, some batteries may only hold half a charge or less. While you can still use these batteries, you will want to know which batteries are new and which are older. You will need to keep track of these different battery states. The simple solution is to number your rechargeable batteries with an indelible marker. The first one you buy should be marked "1" and the second one you buy should be marked "2." This marking tells you which battery is older, and the numbering also helps you keep track of which is which when you charge and recharge them. If you do not use some numbering or similar system, you will not be able to tell the batteries apart.

Storing Your Batteries

Have a system for storing batteries in your camera bag. For example, you might put recharged batteries in the outside pockets and discharged batteries in the inside pockets. This way you won't get caught putting in a new battery to take a crucial shot, only to find that you put in a dead battery.

Switching Out Batteries while Shooting

If you are in a fast-moving situation, running out of battery power can be quite disturbing. If you photograph in such environments, learn to do this quickly so that you will be up and running in a matter of seconds.

When you replace the battery, you many find that you have to reset settings because they will go back to the default state. For example, if you were shooting with exposure compensation, you may find that you have to reset the exposure to the settings you had before your battery went dead.

Caring for Your Batteries

The batteries you purchase for your digital camera reflect a financial investment. Maybe even more important to a photographer, they must be operating properly or a photo shoot will come to a standstill.

Getting the Most from Your Batteries

For maximum battery performance, follow these pointers:

- Keep batteries clean. A clean battery will make a better connection with the camera. Experienced photographers will rub the ends of each AA battery, for example, on a clean dry cloth before putting the batteries in the camera.
- Use a cotton swab and alcohol to get rid of dirt.

- Do not leave a battery in a charger for more than twenty-four hours. This will shorten the life of the battery.
- New batteries need to be broken in. Fully charge then discharge them several times so that they attain their maximum capacity.
- Use the battery on a regular basis. Usually, a battery needs to be used once in two to three weeks.

Disposing of Batteries

When your batteries wear out, don't dump them; instead, recycle them to help protect Mother Earth. Frequently they can be returned to the store where you purchased them. Many stores gather old batteries together and then recycle them.

Prolonging Battery Life

You may have heard it said that batteries will keep their charge longer if you store them in the freezer, especially if you're planning on storing them for a long time period. The current thought on this subject seems to argue the point. Battery retailers do not recommend storing batteries in the freezer for two reasons:

- Freezing can cause liquid electrolyte to freeze and stress, or perhaps rupture, the seals.
- Most batteries are designed to work between −40° and 100° Fahrenheit, so a freezer will have no impact on the battery's life span.

Extremely high temperatures can have a negative effect on battery life, so you'll want to avoid storing batteries in direct sunlight, but there is no need to put them in the deep freeze. Simply store your batteries in a cool, dry place, and be sure to recharge them fully before using them.

Buying Batteries on the Web

To keep your camera going, you're going to need to keep your supply of batteries well stocked. You may find it easier to track down the batteries you

need for your digicam by jumping on the Internet. Here are a few popular sites that offer batteries for sale online:

Batteries.com
www.batteries.com
Quest
www.questbatteries.com
Battery City
www.battery-city.com
Warehouse Battery Outlet
www.warehousebatteryoutlet.com

Travel Considerations

When you travel, you will need to plan for power considerations. Domestic travel may give you more options with Internet access and compatible power connections, but nevertheless you will have to plan carefully. Foreign travel may require a good deal of planning.

Domestic Travel

You will need to ask yourself these questions:

- How often will I be able to recharge my batteries when on the road and how often will a power source be available?
- What is the longest I will need to take pictures without being able to recharge my batteries?
- Can I find stores along the route that will sell disposable batteries at a reasonable price? Will these stores be easy to get to or will they be out of the way?
- How long will I be on the road or away from home?

Other considerations to keep in mind include:

- When you travel you should take all the power cords, rechargers, and downloading cables that came with the camera. If you are

bringing a laptop computer, make sure you have all the cords for that as well.

- If you are using disposable batteries, it is always a good idea to stock up on high-quality inexpensive alkaline batteries in bulk as you cannot count on finding a good deal in your travels.

- If you are using a flash, you will need to bring batteries for that device as well.

- In addition to batteries, you may need to carry an extra memory card or two, depending on your needs. If you stay in a place with a fast Internet connection, you may be able to upload your most important pictures to a free picture-album site on the Internet.

Foreign Travel

If you are traveling out of the country, you will need to plan even more carefully. You will need an adapter, for example, to accommodate the electrical specifications of the foreign country.

FACT

Electrical compatibility is a major problem when traveling outside the United States. Before leaving, use the Internet to find out what problems you might encounter and what devices and adapters you will need. If you can correspond with someone who has been to your destination, you might be able to find out exactly what you need to know.

If you take a recharger, you must make certain that it can handle the power requirements of the foreign country and that you have the correct plug for that country's electrical outlets. If you use AA disposables, you should probably take a full supply as well. You should not assume that you will be able to buy AA alkalines readily or at a low price.

Image Sensors and Resolution

8

A chip is composed of rows of tiny light sensors called photosites that capture color and light and then convert them into electrical charges. Most cameras have millions of image sensors. A processor inside your camera analyzes and translates the electrical charges into digital image data. The brighter the light, the stronger the resulting charges will be. The more sensors there are, the higher the resolution. Yet you may find that you often do not need the highest resolution.

Image Sensors and Color

Different image sensors register red, green, and blue (RGB) light. Each receptor senses the brightness of the light for its particular color. Three receptors in your eye correspond to each of these colors. A digital picture is actually composed of tiny dots (pixels), but when you look at it your brain processes the information to form one multicolored image.

FACT

The human eye has about six million cone cells that are sensitive to color. They see images in a way that is similar to an RGB digital photography image sensor system. In addition, there are 90 million rod cells, which see brightness but do not see color. These work in low light and essentially produce black and white images.

CCD Versus CMOS

Digital cameras use image sensors to capture pictures. There are two types of image sensors: CCD (charge-coupled device) and CMOS (complementary metal oxide semiconductor). Not long ago, the only image sensors used in cameras were CCDs. Both types capture light in essentially the same manner, but they differ in the ways they are manufactured and how they process images. CCDs are created using a special manufacturing process that enables them to transport a charge across the chip without distortion. CMOS chips are made using the same processes as microprocessors.

Image Sensor Differences

Because of differences in manufacturing, there are several differences between CCD and CMOS sensors. But what do these technical differences mean to you in practical terms? Here's how they stack up:

- CCD sensors create high-quality, low-noise images. CMOS tend to be more susceptible to noise (small defects in the image).
- The light sensitivity of a CMOS chip is lower.

- CMOS sensors typically consume little power, while CCDs use a special process that consumes lots of power.
- CMOS chips are less expensive to make than CCDs.
- CCD sensors tend to have higher-quality pixels and a greater number of them.

Images Sensor Problems and Advantages

Because of these differences, CCDs are commonly used in cameras that create high-quality images with lots of pixels and superior light sensitivity. However, CCD chips have a problem with blooming, meaning they tend to produce undesired halos around very bright highlights. Blooming can occur when there is an area of concentrated light in your frame. It can happen in very bright daylight in studio light, or if there is a bright source of glare in your scene. For instance, if you're shooting a picture of the relatives gathered at the Thanksgiving table, the glowing candles on the table can cause blooming. The camera's CCD sensors will overload, then the charge from the overexposed pixels will seep into adjacent cells, causing a colored halo to form around bright or shiny objects, or causing random flashes of light. See the color pages for two night shots where the street lights cause blooming to occur.

CMOS cameras currently offer several advantages, including lower price tags and great battery life. Also, CMOS chips are better at capturing highlights than CCDs, making them a better choice for shooting objects such as jewelry or capturing the glint of sunlight on the ocean.

While CCDs have dominated the market, CMOS technology has kept developing. Popular camera maker Canon has used CMOS technology for several years in a number of its cameras. Expect more CMOS cameras in the future, with big names like Canon and Kodak leading the way.

Image Sensor Resolution

When you take a photo with a digital camera, each of the pixels is captured by a single photosite on the image sensor. A computer or printer uses the pixels to display or print photographs.

Bit-mapping

To create the image, the computer divides the screen or printed area into a grid of pixels. Then it uses the values stored in the digital photograph to specify the brightness and color of each pixel in the grid. This process is called bit-mapping, and the resulting digital images are called bitmaps.

Once a digital image is printed or displayed on a screen, its quality is determined in part by the number of pixels used in creating the image (its resolution). The number of photosites on the image sensor determines the maximum number you are able to capture.

Aspect Ratio

The aspect ratio is the ratio of image width to image height, and it varies among image sensors. The ratio of a square is 1:1 (the width equals the height), and the ratio of 35 mm film is 1.5:1 (it is 1.5 times wider than it is high).

The aspect ratio determines the shape and proportions of your digital images. When an image has an aspect ratio that differs from the device on which it is being displayed or printed, the image must be cropped or resized to fit. It's a bit like trying to fit a square image on a rectangular piece of paper. The aspect ratio of a camera can be calculated by dividing the larger number in its resolution by the smaller number. For instance, if a sensor has a resolution of 1536×1024, you would divide 1536 by 1024, for an aspect ratio of 1.5.

FACT

Aspect ratio is something you encounter every day but may not be aware of. For example, the switch from a regular TV screen to a wider high-definition screen is a change in aspect ratio. Because movie screens are wider than TV screens, they also have a different aspect ratio than your TV.

Color Depth

Although resolution is an important determinant of the quality of an image, another equally important factor is color depth. Color depth is the term used to refer to the number of colors in an image. It is also called pixel depth or bit depth. Older computers have displays that only show 16 or 256 colors. Today's computer systems display what is known as 24-bit true color. The term true color is used because the systems display 16 million colors, which is about the same number as can be discerned by the human eye.

ALERT!

Digital photography is generally harsher and brighter than film, with higher contrast and less exposure range. The look is a bit colder. It is also less forgiving than old-fashioned film. Film has a softer, pleasanter look. Yet with experience, you will find light and environments that work well in digital format.

Frame Rate

How quickly a series of photos can be taken in succession is known as the frame rate, shot-to-shot rate, or click-to-click rate. If the frame rate is not quick enough, the photographer can miss a desired shot.

Shutter Lag and Recycle Time

Digital cameras experience two delays that affect the photographer's ability to capture fast-action shots. The first delay, just a second or two, occurs once you have pressed the shutter button and before the camera actually captures the image. This delay is known as the shutter lag. During this small delay, the camera is preparing to take the picture by clearing the image sensor, setting the white balance to correct the color, setting the exposure, and focusing the image. Last, if needed, the camera fires the flash, then takes the picture. An average shutter lag time is about one and a half seconds. The second delay, called recycle time, takes an average of three seconds. That's when the captured image is processed and stored.

Burst Mode

Some cameras offer a burst mode, which lets the photographer take photo after photo while holding down the shutter button. To increase the frame rate, these cameras often decrease the resolution used to capture the images. Some even divide the image sensor into sections and store a single low-res image in each section, then process them all at once. Some digital cameras reduce recycle time by temporarily storing a series of images in the camera's RAM until they can be processed. A camera with burst mode enables the photographer to easily capture action shots.

Image Sensitivity or ISO

If you've purchased film for an analog camera, you have encountered the ISO number, which appears on the film package. This number, such as 100, 200, and 400, represents the speed, or sensitivity, of the film. The higher the number, the more sensitive the film is to light. The ISO numbers indicate that the film speeds are doubling as the numbers increase.

Image Sensor ISO

Image sensors are also rated using ISO numbers, which are meant to be approximately equivalent to film ISOs. The lower the ISO of an image sensor, the more light is needed for a good exposure. A camera with a higher ISO will allow a higher shutter speed and shooting in low light. Image sensors' ISOs can range from 50 to 6400. Many cameras have an auto ISO setting in which the camera sets the ISO according to the lighting conditions.

ISO and ISOE

ISO stands for International Organization for Standardization. The ISO number is a standard way of stating the sensitivity of film or digital image sensors. Some people use the term ISOE—ISO Equivalent—for digital photography. Like many things in digital photography, it is often easier to refer to digital media in the older, more familiar terms of 35 mm, just as car manufacturers refer to the power of their engines in the much older standard of horsepower.

Most digital cameras will allow you to change the sensitivity of the image sensor or the ISO. When you double the ISO, you double the sensitivity. However, after doubling the ISO, you must make a shutter speed or an aperture change to maintain a correct exposure. You can change the shutter speed to double the speed or set the aperture to a setting that lets in half as much light. Photographers increase the ISO when they need a faster shutter speed or more depth of field. Yet, as with many things in photography, it is a tradeoff. A higher ISO image is often a bit coarse or grainy.

def·i·ni·tion

Noise: When you shoot with a very high ISO in digital photography, you will often find that the image contains a lot of noise. Noise in this context means that a pixel here and there was recorded incorrectly. Some cameras are more prone to noise than others.

Understanding Resolution

Resolution can be quite confusing. For a camera, the highest number of pixels it can record is the highest resolution. For computer monitors, however, the image size must match the monitor display settings (the monitor resolution) for the photograph to be shown properly. Understanding resolution is a numbers game, but the concept is simple. You need to match the camera image size to the output size. With basic calculations this is not hard to do.

Pixel Count

Each image has a set number of pixels, which is called the pixel count. This number is the total number of pixels in a particular photograph and is computed by multiplying the image's height in pixels by its width in pixels. For instance, the lowest resolution setting on a digital camera (and cell phones) often creates images that are 640 pixels wide and 480 pixels tall (which is perfect for e-mail). In this example the pixel count of a 640×480 image is 307,200.

On the opposite end, a high-resolution image might have a 3072-pixel width and 2304-pixel height. This photograph has an exact pixel count of

7,077,888 but this number is usually rounded off and written as 7.1 megapixels. When buying a camera, the highest pixel count will be listed with the camera's specifications. So, for example, the FujiFilm S700 digital camera is listed as a 7.1 megapixel camera.

A Range of Resolutions to Choose From

Virtually all digital cameras (and even cell phones) will offer a number of resolutions that you can choose from. The FujiFilm S700 offers a range of resolutions from low-end 640×480 to 1600×1200 to 2288×1712 to 3072×2304. Most cameras will let you switch back and forth between resolutions as needed. Typically an icon on the LCD viewer will alert you to the specific resolution you are currently using.

ALERT!

Many cameras also offer another file size option, which is often listed as basic (B), normal (N), and fine (F) quality. This is different from resolution and the pixel count of the image and instead refers to the way the image is saved in the camera using compression. Read more about lossy and lossless compression plus TIFF and JPEG file formats in Chapter 18.

Determining the Number of Pixels You Need

High resolution or a high pixel count can be crucial but may be unnecessary in many—if not most—picture-taking situations. The trick is to match the size of the image with the demands of the printer, monitor, Internet, or e-mail service.

There is a simple answer to working with resolution. Shoot at the resolution that is appropriate for your needs but keep in mind that it's often best to set your camera to capture a pixel count at or above what you need for your final picture output. You can always delete pixels later if you want a lower image resolution, but you can't add pixels without risking damage to your image. In addition, you may want a low-res image today for use on a Web site, yet in the future you may decide you want to print the image at a larger size. Then those extra pixels will serve you well.

Printing Pictures

High resolution is very important when it comes to printing quality pictures. The highest resolution, in the example above of 3072×2304, will produce an excellent quality print of about 8" × 10" dimensions and a decent quality print of 11" × 14" dimensions. When shooting photographs for large quality prints, always use the highest resolution.

Cropping and Modifying

If you want to be able to crop a picture, then a higher resolution is also helpful. You can cut out a substantial amount and still have a large pixel count.

Computer Viewing

When viewing images on their own computers, many people use a graphics viewing program that may automatically resize an image for viewing so that it will fit on the computer monitor. In this case it does not really matter what resolution the image is. However, the displayed images of a high-resolution photograph will not be a true rendition of the actual image since it has been shrunk to fit the screen.

E-mail

High-resolution images are bad for e-mail for a number of reasons. A high-resolution image can often not be viewed properly online as it is too big for the computer monitor. In this case, high resolution should be avoided and a low resolution such as 320×240, 480×360, or 640×480 VGA is preferred. Also, higher resolution images are much bigger and some e-mail services will not send or receive such large file sizes.

The nature of computers and the Internet is to move to higher resolution, more memory, more storage, and faster connection speeds. For example, the average monitor resolution has increased rapidly over the past few years. As these aspects advance, you will need to adjust your use of image resolution to suit the changed situation.

Internet Web Sites and Blogs

The standard computer monitor resolution is now 1024×768 pixels. Each pixel in a photographic image is displayed as a pixel on the computer monitor. This means that a 640×480 can be viewed easily today, although a bit small, but the next larger standard digital photography resolution of 1600×1200 is too big. The image would bleed off the screen. In this case the 1600×1200 would need to be resized so that it could be viewed properly.

File Size and Resolution

The reason that resolution is so important is that the higher the resolution, the larger the file size of each individual picture. A large file size has a number of consequences. For example, large files can take a lot of storage space.

First, large pictures will fill up your camera's memory or memory card quite fast. For example, a 512-megabyte card can hold 3,995 640×480 photographs or 147 3072×2304 photographs. In other words, the camera can hold more than twenty times the photographs at the lowest resolution as at the highest.

But the news gets worse. If you save your photographs and modify them in a digital darkroom program, you will need to make copies; you should always keep an unchanged copy of the original. After processing in your digital darkroom, you should back up all of your images (the originals and modified ones) on a backup drive.

There are other considerations as well. You may not be able to work with more than a couple of large images at a time in your computer as they may fill up the RAM when you are working on them. When posted on the Internet, large images often take a long time to download so that online viewers may not be happy campers.

Printing Considerations

Printing has its own language for resolution. Generally, a printer prints out the same dots that make up the image, but the printer can place dots very close together. The closer these dots are together, the sharper the pic-

ture will look on paper. Printer resolution is usually expressed as dots per inch or dpi. And quality printer resolution can be 600 dpi and go as high as 2880 dpi. At 600 dpi, for example, 600 very tiny dots will be in one inch. An image of this quality can rival the quality of film photography.

Unfortunately, there are two terms that are often confused—dpi (dots per inch) and ppi (pixels per inch). While closely related, they are not the same. Dpi refers to the number of dots a printer can put on a piece of paper and ppi the number of pixels in a digital photograph. Read more about this in Chapter 20, but suffice it to say, the ppi of an image must be in synch with the printer requirements or the print won't look good.

Printing can do odd things when the pixels in your image do not match the dimensions of your printout. Printers are adjusted to work with images set to a particular resolution. When you try to print an image file that's at a higher resolution than the printer is geared for, some printers will eliminate the extra pixels, causing the printed image to be of lower quality. The reverse is even more true—a low resolution image printed at a higher resolution will often produce a terrible blocky image. Yet there are solutions to both of these problems.

Adjust the dimensions of your image to fit the printer's output requirements. This will give you much more control over the resampling. If you do not make this adjustment, the printer software will do it instead, which often has disastrous results. In other words, using your own image software, resize your image exactly for the printer's dpi requirements.

Adjusting Pixels and Resolution

Adjusting the resolution can be tricky. In order to match the size of your photograph to the proper output size, you may need to change the size of the image, while always saving an untouched copy of the original. If you do this incorrectly, your picture can look terrible. If you forget to give your new modified image a new file name, it will overwrite the original, which will be lost forever.

Resampling or Resizing

You can enlarge or reduce the pixel count by resampling (often called resizing). This is often done by specifying new pixel dimensions—that is, a new height and a new width for the image. You can upsample, which adds pixels to an image, or downsample, which subtracts pixels from an image. Generally, you can get a good quality image by downsampling, since the photograph already contains detail that simply needs to be reduced.

Upsampling is a different issue. In this case, the software is adding pixels that do not exist. Because this can cause a lot of problems, the software performs what's called interpolation, which means that sophisticated calculations are performed to make the enlarged image as close to the original as possible. Bad interpolation can lead to what are called jaggies or aliasing, in which edges in particular no longer look smooth but are jagged and coarse.

Some people have been very successful at enlarging an image using the following technique: they upsample only 10 percent at a time. They do this over and over until they reach the desired size. A number of people have reported that the resulting larger image printed splendidly and that they were quite surprised at the quality.

When you resample you will often be asked if you want to keep the same aspect ratio, which is the ratio of the height to the width. In almost all cases you will want to keep the aspect ratio the same, since changing this will distort the image.

Confusing and Conflicting Terms

There are a lot of confusing terms in digital photography, and even experts and manuals do not use these terms correctly or consistently. Throughout this book the most common usage has been emphasized, but you may read articles where some terms are used differently than the way this book has defined them.

Confusing Terms: A Recap

Some of the most frequently confused terms were covered in this chapter:

- **Resizing:** can mean resampling, but it is sometimes used to mean printing the same image at a smaller size without changing its size—which means that it is now printing at more dots per inch (dpi).
- **Dpi:** (dots per inch) is often used interchangeably with ppi (pixels per inch). See Chapter 20 for more about this.
- **Pixel dimensions:** usually means the pixel height by the pixel width, but some software uses it to mean the pixel count or total size of the image.
- **Interpolation:** is sometimes used instead of the terms *resampling* or *resizing*.

More about Resolution Confusion

The term *resolution* describes more than image quality. It is also used to describe the capabilities of digital cameras, monitors, scanners, and printers.

To indicate the resolution a camera is capable of recording, the terms *VGA* (video graphics array) *resolution* (approximately 640×480 pixels), *XGA* (extended graphics array) *resolution* (1024×768 pixels), and *megapixel resolution* (indicating a total pixel count of 1 million or more) are used. Pixel count is a more accurate method of judging the resolution of a camera.

In a similar way, manufacturers of computer monitors use "resolution" to describe the number of pixels the monitor can display. On most monitors you can choose from display settings of 640×480 pixels (VGA resolution), 800×600 pixels, or 1024×768 pixels (XGA resolution). The ppi of your monitor depends on its physical size, plus the display setting you choose.

Monitors are commonly set to display 96 ppi. Older Macintosh monitors are usually set at the factory to display 72 pixels per inch. Fortunately, the math for image display on a monitor is simple, as they are both measured in pixels. One pixel in an image will display as one pixel on a monitor. So, for example, a 640×480 picture will display just fine—with room to spare—on a monitor with a resolution of 800×600.

Just like digital cameras and monitors, scanner capabilities also are described in terms of resolution. Luckily, scanner resolution is usually spoken of in the same terms as image resolution. A low-end scanner commonly captures a maximum of 300 or 600 pixels per inch.

Overview of Resolution

Resolution can be confusing, so it is important to remember the main points. Don't drown in a sea of technical terms; just remember the important ideas and do a little math as needed. Here is a resolution cheat sheet, which includes all the points you should keep in mind:

- Match the image size to the output size. This means that smaller images work better for e-mail and the Internet and larger images for printer output.
- Always save your original photograph. When modifying a picture or resizing, rename the new image with a different name so that it does not overwrite the original file.
- Enlarging an image often will produce poor quality results. In this case, shoot a photograph at a higher resolution so that it does not have to be enlarged.
- Reducing the size of an image is almost always successful, so when in doubt use a higher resolution setting at the beginning.
- Change resolution settings as needed in your camera and use the onscreen display to let you know the particular resolution you are currently using.
- See Appendix C for a resolution table.

Creative Controls and Other Features

While photography can be quite technical, the creative aspect is the fun part once you have learned the technical side. For example, many cameras offer different exposure modes, which allows you to make the most of photographic effects such as depth of field and various shutter speeds. If you have a good understanding of photography, you might want an expensive camera that allows total creative control with all manual settings.

Creative Controls

Way back in the dark ages of photography, automatic exposure controls cost a lot more than manual controls. Now the opposite is true. Manual or semi-automatic controls cost more. Lower-priced cameras have fewer exposure controls, more-expensive ones have more. If you want full photographic control over your images, you may have to buy a DSLR or a high-end pro-sumer camera. Yet less-expensive cameras have a number of controls that with a little tweaking can be used to exercise considerable control over the creative process.

How Exposure Works

Exposure is a combination of shutter speed and lens opening, the f-stop. The meter in the camera reads the light in a scene and then selects these two settings. In any given scene there are usually many choices that could be made for the same scene, but with automatic you have no choice; the camera makes those decisions for you.

def·i·ni·tion

Reciprocity: When a shutter speed is doubled or cut in half, the corresponding lens opening must be cut in half or doubled to keep the same exposure and vice versa. In other words, letting in light for a shorter time means that you must also let in more light through the lens to compensate.

How Creative Controls Work

With creative controls, you can now be the creative artist and decide how much depth of field you want or how fast you want the shutter speed for an action shot.

With semi-automatic controls you can set either the shutter or the lens opening and then the camera will do the math for you and change the corresponding other control so that the exposure remains correct. With manual control, you can put both settings anywhere you want, even settings that might otherwise be seen as incorrect.

Autoexposure

To take advantage of creative controls, you must understand how autoexposure works. Then you can understand when and why you should override its settings. Autoexposure is the most common exposure mode and the main one for point-and-shoot cameras. In this setting, the camera makes all the decisions for both the shutter and the aperture. You have virtually no choice. Generally speaking, the camera will select a shutter speed fast enough for hand-held shots and a select a corresponding lens opening.

A Bit of Creativity with Autoexposure

Many cameras will let you lock in an exposure by pressing the shutter button down halfway. You can point the camera to a certain area and use that for your exposure settings. You should pick an area that is the same distance away as your subject, since the camera may also lock in the focus.

A simple technique with autoexposure is to point the camera down at the floor or ground that the subject is standing on. Find an area around his feet that is evenly lit, lock in that exposure and then bring the camera back up. This exposure will avoid problems with strong lights in the background or a bright sky.

Understanding Autoexposure

Depending on your camera, the LCD monitor or viewfinder may give you a readout of the settings that are being selected. In this case, at least, you know what you are working with. If you do not like the settings, even basic cameras will often let you go to the next level of control, such as shutter priority or aperture priority.

Metering Systems

A digicam uses built-in light meters to measure the light reflecting off the subject. There are different ways in which the camera's metering mechanism

calculates exposure. The metering mode you choose will depend on the particular shot you're taking.

Matrix Metering

This exposure system works by dividing the frame into a grid or matrix. Then it analyzes light at different points on the grid and chooses an exposure that best captures both the dark and light sections of the scene.

Center-Weighted Metering

This method measures light throughout the scene but gives greater importance (weight) to the center of the image area, assuming that that is where the primary subject is located.

Bottom-Weighted Metering

This arrangement measures light throughout the scene but gives greater importance to the bottom of the image area.

Spot Metering

This gives you the most control and almost allows the camera to operate like a hand-held meter. It measures the light only at the center of the image. This means you can meter a person's face while completely ignoring the light of a bright window behind her for an accurate exposure.

It can also be used for manual exposure calculation. This lets you get specific readings for a person's face, the background, and the shadows, for example, and then to make a decision as to the final exposure.

FACT

Some cameras have several autoexposure choices, called program exposure modes. For example, there may be one setting for action shots that would always select a fast shutter speed. There also might be a program mode for landscapes or portraits. In this case, the camera automatically makes the settings based not only on the light but also other factors appropriate to the shot.

Exposure Compensation

To gain creative control of exposure, you can use exposure compensation, also known as exposure value (EV). This allows you to increase or decrease the exposure from what the autoexposure setting typically delivers.

If your pictures are coming out too dark (underexposed) or too light (over-exposed) and you are taking a series of pictures in the same lighting, then adjust the exposure up or down to compensate. You should never assume that you can take pictures with the wrong exposure and fix them later with software because you may not be able to.

How Exposure Compensation Works

The settings are different from camera to camera, but usually they appear as +2, +1, −1, and −2, with zero representing the default autoexposure setting. To obtain a brighter image—for example, in a backlit situation—you "dial up" using a positive value to increase the exposure. For a darker image, choose a negative value, thereby decreasing exposure. Exposure compensation lets you choose the exposure that is most likely to produce the results you're seeking.

When to Use Exposure Compensation

It takes a lot of practice to get to the point where you know when to lighten or darken a scene. One feature of a digital camera that makes it easier: the LCD screen. Because it lets you preview your shot, you don't have to guess whether or not the exposure needs adjusting.

Bracketing

One way to avoid a poorly exposed image is to use a trick that professional photographers often employ. It's called bracketing. The bracketing process means that you take three shots: one at the recommended exposure setting, a second shot that's lighter, and a third shot that's darker, thereby

bracketing the recommended exposure with two additional shots. By taking a series of shots at different exposures, you're far more likely to obtain one that's to your liking.

▲ This shot of a ship was underexposed.

▲ This shot of the ship was overexposed.

Examples of Exposure Compensation

Exposure compensation control lets you correct exposure. Here are some typical settings and how they are used:

+2: Used when there is high contrast between light and dark areas in a scene

+1: Used with side-lit or backlit scenes, such as snow scenes, beach scenes, sunsets

0: Great for evenly lit scenes

–1: Good for scenes where the background is darker than the objects in front of it, such as when an individual is standing in front of a brick wall

–2: Used when the background is very dark and takes up a large portion of the image, and you are striving to maintain detail in the brighter areas of the scene

Aperture-Priority and Shutter-Priority Modes

When the depth of field is most important, photographers choose aperture priority to make quick changes in the f-stop. This setting allows maximum focus for landscapes, for example, and out-of-focus backgrounds that work well with portraits. When shutter speed is most important, they chose shutter priority—for action shots, for example. The operation of both modes is very similar.

How Aperture Priority Works

After selecting the aperture-priority setting, the photographer pushes a button mounted on the camera body (in many camera designs). By pushing the button, the photographer changes the aperture either up or down. The LCD readout informs the photographer and keeps her on top of and in control of the changes she is making. However, every change in f-stop causes a corresponding change in shutter speed, so the photographer needs to keep an eye on that as well. If the shutter speed gets too slow, for example, the picture will be blurred and all that wonderful sharply focused depth of field will be lost in the blur of camera shake.

▲ The automatic setting of the aperture makes the background in this photo too sharp.

▲ Choosing a minimum aperture in aperture priority throws the background out of focus, which makes the banana stand out more in the photo.

Judging Depth of Field

With most digital cameras it will be very hard to judge the depth of field before taking the picture. The preview image on the LCD monitor is usually the view of the scene at the largest lens opening (and least depth of field). However, after taking the shot, the photographer can view the resulting shot and use the LCD review and the LCD zoom review feature to judge the quality of the focus. Some very high-end cameras offer a depth of field preview, but this is not a common feature.

How Shutter Priority Works

Setting the shutter priority setting is similar to setting the aperture priority. After selecting the shutter priority setting, the photographer pushes a button mounted on the camera body (in many camera designs). This changes the shutter speed to faster or slower. The LCD readout informs the photographer and keeps her on top of and in control of the changes she is making. However, she needs to consider how the change in shutter speed will affect the corresponding change in f-stop.

▲ The autoexposure setting chose a shutter speed that was too slow, causing the head of the cat to blur.

▲ A faster shutter speed, in shutter priority mode, allowed a sharp picture of this cat.

When the photographer controls shutter speed, she can shoot fast-action situations so that the pictures are sharp and clear or use a slower speed to give the action a slightly blurred but dynamic look. She can also use very fast speeds to make waves on a river look like hard ridges of ice or choose a slow shutter speed to make the same river look like soft clouds of foam.

def·i·ni·tion

Readout: In shooting mode the LCD monitor and/or the LCD viewfinder will display critical information such as shutter speed, aperture, exposure mode, etc. This is called a readout. Especially in the heat of a photographic moment, it is important that the photographer be able to see this information without having to take his eye away from the viewfinder.

Total Manual Override of Automatic Exposure

Photographers who are comfortable with making exposure calculations and who know what effect they want to achieve prefer manual controls. In this case they set both the shutter speed and aperture based on either the meter (or metering systems) built into the camera or a separate meter, a device that has been used by photographers for more than 100 years.

Hand-held Light Meters

With the sophisticated technology of digital photography built into the camera, most people will not even consider a hand-held light meter. However, such a meter can be useful when taking product shots or wedding portraits. A hand-held meter allows you to measure the light falling on a subject, for example, not the light reflected from a subject, which is all that the built-in camera meter can do. It also lays out the full range of choices for shutter speed, f-stop, and ISO exposure in a given lighting situation.

Gray Cards

Photographers use gray cards, available in camera stores, to help get correct exposures. Place the gray card in front of the subject so that it is in

the same light as the subject. Move in close to the card so that all you see in the viewfinder is the gray card. Tip the card so that it appears as bright as possible and has a slight glare. Then tip it again to eliminate the glare and read the camera meter to find the proper settings.

Photography of TVs and computer monitors can be tricky. With a normal shutter speed, a scan line will cut across the screen. You must use a tripod with a slow shutter speed such as 1/8 second or 1/15 second instead. Review your shot with the LCD on your camera. If the scan line still shows, select the next lower shutter speed.

Autofocus

As discussed earlier, most digital cameras with noninterchangeable lenses are either fixed focus or autofocus. A fixed-focus lens is not adjustable. The camera with a fixed-focus lens captures sharp images of any subject within a certain distance from the lens. Objects outside that range will appear blurry.

Focus Lock

Sometimes an autofocus camera will also offer focus lock. Using the focus lock, the photographer can center the subject in the frame, lock the focus, then reframe and take the shot. When taking a shot of a scene with many elements, this can be a useful feature because it allows you to specify which object you want to be in focus.

Manual Focus

You can focus manually with more expensive digital cameras. In this case, autofocus is turned off. Some of these cameras only allow you to focus at certain preset distances, while others let you focus through the entire range. Manual focus is critical for photographers who take night photographs, as autofocus systems are notoriously error-prone in low light.

Continuous Mode and Panoramic Mode

With some digicams you can snap an entire sequence of photos. These images can be used to make short movies for a Web site or an animated GIF. There are several ways digicams allow you to capture a series of photos.

Different Methods for Shooting a Series

Taking a series of pictures is almost a different kind of photography, in between still photography and movies:

- By depressing the shutter, a digital motor drive or burst mode lets you snap picture after picture.
- Time-lapse photography is achieved by taking a sequence of photos at designated intervals.
- Video recording mode allows you to take low-resolution video in MPEG format.

Continuous Mode Limitations

Most cameras cannot take high-resolution images in video mode. You may be limited to 640×480 or slightly larger, but high-resolution images generally will not be possible. Some cameras offer sound recording. However, if your main purpose is to take video, you should buy a digital video camera.

Still pictures in series can be put together in an animated sequence. There are a number of simple-to-use software programs that can take still images, crop them individually or all together and move different frames one pixel width or height at a time. These mini-movies can play from start to end or in a looping and continuous-play mode.

How the Panoramic Mode Works

Panoramic mode enables you to take snapshots that are wider than they are high. Digital cameras frequently include panoramic mode. With a little skill, a 180-degree or even a 360-degree image can be created.

Some digicams simply capture a band across the middle of the image sensor, leaving black (unexposed) bands at the top and bottom of the photo. The preferred method is to create multiple-image panoramas. This is achieved when you take a series of images while slowly turning in a circle. Then the camera uses special panoramic software to "stitch" the images together, forming one 360-degree panorama. Many digicams come with this panoramic stitching software. This software provides a handy tool when you want to shoot three or four photos and stitch them together to form a city skyline or a coastline scene, for instance.

Panoramic Software

Some software programs for panoramas are quite simple and consist of only three main screens. You can use them to stitch together from two to thirty-six pictures, vertically or horizontally. Such a program combines overlapping photos to create virtual reality panoramic images up to 360 degrees. The panorama can usually then be output to a graphics file or a movie format such as QuickTime. The QuickTime VR (virtual reality) format allows a person to view the panorama at various angles. It becomes part of a virtual reality movie with which a user can interact by moving the mouse to pan and zoom over the scene.

Self-Timers/Remote Controls

These two devices can be used for a number of purposes and are essential for some photographers.

Why Self-Timers and Remote Controls?

A self-timer mechanism delays the shutter release for about ten seconds, allowing you to jump into a picture before the shutter releases. This is a useful feature when you want to take a self-portrait or include yourself in a group shot. Wireless remote controls make it a little less stressful, allowing you to walk—not run—to get in the shot. Once you're situated, you simply click a button on the remote and the camera snaps the image. Of course, that leaves you with the question of where to hide the remote.

◀ The camera's self-timer allowed this self-portrait to be taken.

Other Uses

Many photographers use a self-timer for rock-steady long exposure photographs. If a photographer pushes the shutter button, there is a chance that the camera will shake a bit, thus causing blur and resulting in an unsharp image. A self-timer allows the camera time to stop moving after the button has been pressed. A remote removes the person from the camera so that he cannot shake the camera.

Experimental Photography

Digital photography is an experimenter's dream. If you flub a picture, you can just delete it and it has cost you nothing. The quick display of the LCD monitor allows the photographer to quickly judge how to modify his settings. Experimentation by its very nature requires constant feedback, which is exactly what digital photography provides.

Learning to Experiment

Experimentation is a learning process in which each picture leads to the next. The photographer learns to make adjustments as he goes along based on the last picture. A photographer will make lots of mistakes, but will slowly zero in on a new and exciting effect, which, once mastered, can be used over and over.

In the old days of film, experimenting was costly and there was a huge time lag between taking the picture and seeing the results. This made the process very cumbersome and slow. What can now be accomplished in a matter of hours with digital photography often took weeks with traditional film.

In a sense, experimenting encourages and allows you to take pictures that are wrong. Experimental pictures are often ones that you would normally avoid. Use blur, camera shake, and noise, for example, for artistic effect. Use odd color balance to achieve an unusual look. Unusual camera angles and framing can also be productive.

How to Start Experimenting

Some fruitful areas for experimentation are:

- **Slow shutter speeds:** Using a slower than normal shutter speed can produce quite unusual images that have a smeared effect.
- **The "wrong" white balance:** You can get very colorful results using an inappropriate color balance.
- **Flare:** When light enters the lens directly, it often does odd things. The effect will be different depending on the aperture. For example, a backlit portrait in which some of the backlighting is allowed to flare might produce interesting results.
- **Night photography:** Everything is different at night. The colors, contrast, shadows, and light sources are all different. There is lots of room for experimentation.

- **Self-portraits:** Digital photography allows you to judge immediately how you look. Some cameras even have an LCD that swivels so you can easily take pictures of yourself.
- **Very slow shutter speeds:** Experiment with minute-long exposures at night.
- **A high ISO:** High ISO settings will produce a lot of noise, but noise might be colorful in some situations.
- **Mixed lighting:** Very colorful effects can be found and produced by using a variety of light sources or setting the camera's white balance to the wrong setting.
- **Underexposure:** Severely underexposed pictures can produce unexpected and dramatic results when lightened and color-corrected in a digital darkroom.
- **Camera shake:** Shaking a camera as you take a picture might create unusual patterns.
- **Camera movement:** Panning the camera, walking with a camera down a street with a slow shutter speed can produce exciting effects.
- **Slow-sync flash:** The razor-sharp speed of flash can be mixed with the very slow exposure of slow-sync flash for quite surprising results.
- **Odd camera angles:** Shoot from the floor or from a stepladder. What does your apartment look like?
- **Odd framing:** Frame so you see only part of a person's face or part of a person walking out of the frame. How does the framing feel?

There are no limits: Experiment with all the ways that light can register on light-sensitive material. Some people have even thrown their cameras into the air while taking a shot, just to see what would happen.

CHAPTER 10

Taking Great Pictures

With automatic exposure and focus, just about anyone can take a usable picture these days. But taking a truly great picture requires skill. It's not the camera that's important—it's you, the photographer. With camera in hand, you will choose what scenes to shoot, and when and from what vantage point to shoot them. If you take advantage of creative controls, you also can choose the amount of focus (depth of field), the focal length (zoom setting), the shutter speed, and whether to use a flash.

10

Getting Ready to Shoot

Let's assume that you've just purchased your camera. You're eager to get started, but you're not sure where to begin. Once you feel confident that you know how to operate your camera, take a moment to consider the basics of snapping a picture.

Tripping the Shutter

There is a trick to snapping the shutter. To learn the feel of your particular camera, trip the shutter a number of times. Notice how much play (an area of no resistance) there is in the shutter button before you hit a hard point. Try to hold the camera at this hard point without pressing the shutter further. When you press beyond that hard point, the shutter should go off. This can take practice, as first-time users may have trouble finding the precise point where they can lock in the settings but not trip the shutter. Take time to learn how to do this. Afterward you can delete any pictures that you took.

With many cameras, pushing the shutter partway locks in the focus and the exposure. After doing this, there will be almost no lag when you snap the shutter since the camera does not have to make any calculations. If you can hold the button at that hard point, you can also reframe the picture with those settings locked in.

Once you have mastered the delicate play of the shutter, learn to carefully trip the shutter. When taking a picture, learn to move the shutter button, but not the camera itself. This is a subtle but crucial distinction and can make the difference between blurry and sharp pictures. If you move just the shutter button, pictures will be clear; if you push the shutter button and also move the camera, you will get blurry pictures.

Keeping Steady

Other movement can also ruin a picture. If your body is not squarely positioned, you may sway a bit, which will cause blur. When you go out

into the real world, you'll want to always stand with your feet planted firmly. Some people like to lean up against a wall or pole to steady themselves. Gently take a deep breath and hold it, then slowly squeeze the shutter. When you can hand-hold a camera at slow speeds, you will find that you can take a variety of pictures that were not possible before, such as candids of your children in low available light.

To learn your limits, take a number of shots using the shutter-priority mode to see at which point the picture becomes blurry. That point is now your shutter speed threshold for that focal length. With practice you will find that you can learn to hold the camera steady at even slower speeds.

Most blurry photographs are due to camera movement. The photographer did not hold the camera steady, so the picture is not as sharp as it could be. When in doubt you should always use a higher shutter speed than a lower one. With experience you will learn your own personal shutter speed limits.

Focal Length and Shutter Speed

The shorter the focal length, the slower the shutter speed needs to be for a sharp picture and vice versa. You can hand-hold with a shutter speed that is roughly equal to the focal length equivalent in millimeters.

- A wide-angle lens of 30 mm (35 mm equivalent) can be hand-held at 1/30 second.
- A normal lens of 50 mm (35 mm equivalent) can be hand-held at 1/60 second.
- A mild telephoto lens of 100 mm (35 mm equivalent) can be hand-held at 1/125 second.
- A long telephoto of 200 mm (35 mm equivalent) can be hand-held at about 1/250 second.

Stabilization control removes camera shake at moderate shutter speeds and allows a steady photographer to shoot at a speed as low as 1/4 second. If you like to shoot in available light, choose a camera with this feature as it will allow you to take clear pictures in dim environments.

Slow Shutter Speed Photography

No one can hand-hold a camera steady at very slow shutter speeds. In this case, the photographer must find a way to steady the camera. Long exposures are almost a different kind of photography, as they require special equipment and even a new way of looking at a scene.

Tripods

A tripod has been standard equipment for photographers since the beginning. Light, portable, and flexible, this three-legged device can be carried and positioned virtually anywhere. You can adjust each leg to accommodate almost any terrain, and a movable tripod head allows you to make fine adjustments to the camera's position. Tripod head movements include swiveling, tilting, and raising and lowering.

If a tripod is securely positioned, it is possible to take very slow exposures of many seconds, minutes, or even hours. These kinds of exposures are often quite useful for landscapes and architecture. See the color pages for shots of buildings at night taken with a tripod.

Types of Tripods

There are a number of different types of tripods to choose from:

- **Standard tripods:** You can find a variety of tripods, from flimsy to robust, and there are a variety of adjustments available.
- **Tabletop tripods:** These tripods are quite steady when positioned on a table or a bookshelf or a rock wall. You can carry these small tripods outside your camera case. A cable release, which screws into the shutter button and allows you to gently press a plunger at the end of a long cable to avoid moving the camera when the shutter is tripped, makes it easy to get that shot once your camera is set up.
- **Monopods:** As the name suggests, a monopod has only one leg. Seasoned photographers use these because they allow maximum camera movement while providing some stability. These are often used in candid situations such as high school football games. However, the photographer must be careful to keep the camera steady, as the

monopods do not have the stability of tripods. It is pointed at the end so it can be stuck into a soft surface, but the base is not broad enough to allow the monopod to stand independently.

◀ This "bad" shot of a computer monitor was taken with a shutter speed that was too high. Use a slow shutter speed to get decent shots of a TV or computer monitor.

QUESTION?

How do you take a fifteen-minute exposure?
You use the B setting (or bulb setting). This very basic control can expose your image for seconds, minutes, or hours. It opens the shutter and keeps it open until you release the shutter. To make an accurate exposure you will need to use your watch.

Deliberate Camera Movement

While many photographers work hard to remove any kind of camera shake or movement to prevent blurry pictures, sometimes camera movement can be used for artistic effect. For example, camera movement combined with an appropriate shutter speed can produce very dynamic effects that give a sense of movement much better than a still-frozen shot.

Panning

We are used to the concept of panning in movies. The camera moves to follow a person walking down a street, for example. However, this technique has not been used as much in still photography. In photography movement is relative. If a photographer follows a person running down a football field at the same rate the person is running, the photograph of that person will be sharp while the background may be blurred.

Other Creative Camera Movements

A camera can also be moved through an environment. You have probably seen videos of streams of lights rushing by as a person drives down the highway. You can accomplish this same effect in still photography by mounting a camera to the top of the dash of your car, setting the camera to a slow shutter speed (several seconds), and then driving down the road.

How to Judge the Quality of Your Photo

Photographs are often ruined because they are fuzzy and not clear. This is usually due to one of two things: blur due to camera movement or fuzziness due to the camera not focusing properly. Of course, sometimes the fuzziness is caused by both factors.

Reviewing Your Photos

While the LCD screen can help, it takes a while to learn how to judge the quality of a photograph. Because the LCD displays a small image, the photo will look much sharper than the picture when it is viewed full size on your computer monitor. Beginning photographers are often surprised when a picture that looked good at the time turns out to be less than sharp when printed or viewed on the computer.

When you are still learning a new camera, you should take test shots of a scene and then carefully review those shots using the zoom feature in the camera's review mode. The zoom feature will blow up a section of the photo to a very large size. While you will not be able to see the entire picture this way, you can judge the sharpness of crucial points, such as a person's

face. Yet even this takes some practice to learn. At extreme enlargements, nothing will be completely sharp. At these maximum blow-ups, you are, in a sense, looking at the finest details in your picture with a microscope. If you can see good detail at this point, the picture is as sharp as it can be.

FACT

Small pictures always look sharper than larger ones. This is true for images on LCD monitors at the back of digital cameras, LCD viewfinders, and thumbnail pictures viewed on the camera or in an image editing or browsing program. Even small prints generally look sharper than large ones.

The Difference Between Blur and Out of Focus

If the picture is not sharp, the extreme zoom in review mode will help diagnose the problem. Camera movement or subject movement will cause a streaking as though the details were smeared. If you moved the camera, the entire picture will be smeared; if the subject moved, then just that person will be smeared and the rest of the photo will be sharp. If the problem is due to focus, points of color and light will appear to be growing larger but will not be streaked or smeared.

Preventing Blur Due to Movement

Camera movement is caused by a number of factors—how you press the shutter button, how steady your entire body is, and the shutter speed you choose. If you cannot find a firm place to plant your feet, for example, select a higher shutter speed to compensate. If you are in a strong wind that is moving the camera, use a higher shutter speed. If you are taking a picture of a still object like a bowl, you might be able to use a slow shutter speed. Set your camera on a table and then carefully press the shutter button.

In addition to camera movement, subject movement can be a problem. When taking pictures of people, movement is always a factor. A good rule of thumb is to shoot at 1/125 or higher when people are involved. With action shots you might start at 1/250 of a second. Use the shutter priority control.

Time and Its Effect on Photographs

In a sense photography is all about time. The instant the shutter is snapped determines the photo. Photographs are moments frozen in time. The photographer chooses the moment to capture, whether it is the fading light of sunset or the look of defeat on the face of the high school football quarterback.

◀ This photo was made possible by anticipating where the runner would be in relation to the pier.

Action Shots

Another way that time influences a photo is when the photographer freezes the action or captures movement. Action shots bring to mind pictures taken at sporting events, but you can record any movement or action to create a memorable image. If you've ever captured the action of your son's football game, you've experienced the relationship of time and photography.

Time and Nature

When we view serene scenes of the natural world, we are seeing the effects of time on the environment. Photos taken in different seasons remind us that although seasons change and the landscape changes with them, the serenity of the natural world remains. Look out the window to discover seasonal changes in your own yard or take a walk to a nearby park. As a photo-

▲ This action shot of gulls was a bit confusing.

▲ After reviewing the previous gull shots, the photographer made adjustments to create a better composition with the flying gulls. See the color pages for another action shot of a single sea gull in full flight.

graphic exercise, you may take a series of shots of the same outdoor scene to record how it changes with the seasons.

Time and People

Since time affects people too, we glimpse time when we view pictures of children, teens, adults, and seniors. When subjects of different generations are photographed together, we are especially struck by the cycle of life. During the course of our busy days, we don't often stop to reflect on the ways in which time changes us. Seeing a photograph can make us pause and consider the passage of time.

Taking the Picture

Exploring digital photography should be a joyful experience. After all, photography gives us the opportunity to express our feelings. If you are pursuing photography, you've felt the satisfaction that comes from producing a photograph that works. Effective photos move people. They can make us feel uplifted or dispirited, nostalgic or repulsed, regretful or homesick, serene or

agitated. Every picture conveys a message. The trick is to make it the message you intend.

Photojournalists take a number of shots from different distances or zoom settings. The three basic shots are a close shot, a medium shot, and a long shot. Together these tell a story. Photographing a series like this is also a good learning experience, as it forces you to see the same scene in different ways.

Practice with Digital Feedback

As with other skills, your skill as a photographer will increase the more you practice, practice, practice. Using a digital camera makes it even easier to learn by trial and error. First of all, you can preview your shot in the LCD screen. If you don't like what you see, you simply delete it and try again. Second, you can benefit from the instant feedback and make adjustments in lighting, angle of view, and composition as necessary. Finally, you don't have to spend money on film and processing in order to create dozens of images.

Understanding How the Camera Will Record the Photo

The first step to being a good photographer is learning to see the world as the camera sees it. When we look around us, we automatically and unconsciously screen out a lot. Clutter seemingly disappears from our view. Not so with the camera; it will record everything in a scene. As we look at the world, we are viewing it in three dimensions. The camera produces a two-dimensional image. Our eyes adapt to the lighting, but the camera's does not. The photographer learns to recognize and make alterations for these differences.

Take a look around you right now. What do you notice? Good photos can be taken anywhere. Although it would be a grand adventure to travel the globe taking pictures, it is not necessary to venture far from home to capture intriguing images.

Previsualization

An important skill for the photographer is previsualization: the ability to imagine how the photo will look. This only occurs when the photographer understands how the camera "sees" and how it will capture the image. Previsualization for the digital photographer requires an understanding of composition, light, and the mechanics of your digital camera.

FACT

The camera sees the world differently than you do. Colors are different; highlights white out or detail in shadows disappears. It takes a good deal of experience to understand how the real world translates into the world of pixels. After a while, however, you will be able to look at a scene and understand how it will look as a photograph.

Where to Find Picture-Taking Opportunities

Start with your passion. Besides photography, what else do you enjoy? Perhaps you love to play sports, listen to music, or collect antiques. Maybe in your spare time you like to read a bestseller, shoot hoops with your kids, or dance the night away at a local club. You can combine other interests with your passion for photography, especially when you're using an easily portable digital camera. Next time you're heading out to the club, take along your digicam. You'll be rewarded with great action shots of people on the dance floor. Bring your camera with you to the next flea market or antique show, and you'll have a means of recording the treasures you decide to bring home plus the merchandise you left behind.

Recording Everyday Life

Don't wait for a special occasion. Start carrying your camera with you wherever you go. You'll get more practice, which will help you move faster toward your goal of being a crackerjack photographer, plus you'll end up with some engaging images you never would have dreamed of.

What about carrying your camera to work with you? Even an ordinary workday holds plenty of potential. Don't wait until you reach the office to start shooting. There's no reason you can't take pictures from your seat on the bus or train. If you're commuting by car, you'll need to keep your attention on your driving, but you might be able to shoot out of the car window when you're stopped at a red light. Maybe during your tedious commute you've already entertained yourself by framing certain shots in your mind. Pack your digicam in your briefcase tomorrow, and you can start turning those imaginary images into the real thing.

Familiar Faces

Most of us take snapshots at the holidays, but consider taking pictures of your favorite people on a regular basis. Your kids, friends, and relatives are all potential subjects. Maybe taking portraits will even become your specialty.

Don't force yourself to choose a specialty. Just experiment and see where your photography leads you. When you see something striking, take photos even if you don't understand your attraction. This is about being creative and having fun, not fitting into any particular mold or following any rules.

Capture your loved ones while they are carrying out their daily routines. What about a picture of the baby having her nightly bath? Your preschooler would be delighted to have you look over his shoulder while he finger-paints his next masterpiece. And your Aunt Isabel would probably be flattered if you asked to take a photo of her in her garden next to her prize rose bush.

Developing a Personal Style

Sooner or later, most photographers find that they are drawn to a particular subject, such as portraits, landscapes, travel photos, and so forth. As you take more and more photos, you will develop a personal style that will become increasingly apparent in your images. Although it is helpful to notice the styles of other photographers, it is not necessary to imitate them.

Your own style will develop naturally. Don't force it. Just enjoy the process and you are bound to find your individual approach to digital photography.

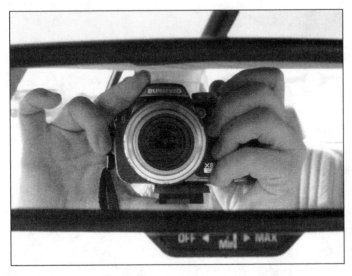

◄ Personal-style photos can be just about anything you want, including a sense of humor.

Make Your Own Gallery of Favorites

You can find millions of photos on the Internet. With image search engines, you can locate photographs of your favorite subject matter. For example, a quick search in Google images for football photos yielded more than 700,000 images. If you want to restrict your images to photographs, add the word "photographs" to your search. When viewing photos it helps to have a high-speed Internet connection. When you find an image you really like, bookmark it. Periodically go through this collection of images, study them carefully, and try to pinpoint what you find striking.

Image Search Engines

As millions or perhaps billions of images are put onto the Internet, search engines have evolved to help find particular subjects.

Google Image Search
images.google.com
Yahoo Image Search
images.search.yahoo.com

MSN (choose image search)
www.msn.com
PicSearch
www.picsearch.com

Image search engines are still evolving, so periodically do a search in a standard search engine for "image search engines." New ones should be coming online regularly.

Online Classes and Workshops

There are dozens of online digital photography courses. Some are free!

MorgueFile.com
www.morguefile.com/archive/classroom.php
MorgueFile offers a free ten-lesson course online as well as free images that you can download and use as needed.

BetterPhoto.com
www.betterphoto.com
BetterPhoto.com offers over a dozen courses on digital photography, including ones on Photoshop, and many more online classes on different aspects of photography.

Photography workshops are held all over the world. It's a great way to turn some vacation time into an experience of learning about and practicing photography. You'll get immediate feedback from the instructor, plus you'll benefit from the opportunity to interact with others who share your passion. As digital photography grows in popularity, more and more digital photography workshops and classes are springing up.

QUESTION?

Why do you find a photo striking?
Some pictures get your attention but you may not know why. Study them carefully and soon it will be obvious: It could be the composition, the moment in time, the lighting, the color, the subject matter, or the emotions, but something makes the shot stand out.

Common Mistakes

There are a number of initial mistakes that almost everyone will make when learning. With the advantage of digital photography you can overcome these and start taking striking photos.

Take Time to Compose Your Shot

Like traditional analog photography, good digital photographs rely on basics such as good composition. Many of the techniques of film photography apply to digital photography as well. Strive to get the best possible shot; don't expect to correct your mistakes later with image-editing software.

Get Close

Most photos miss the mark because the photographer did not get close enough to his subject. Your objective should be to fill the frame. This will result in photos that are better composed and provide more visual information to work with when you edit your images with your computer. Walk nearer to your subject or zoom in for tight framing. A closer shot creates a greater sense of intimacy. When shooting vertical images—people, buildings, trees—turn the camera for a vertical orientation and avoid empty space at the edges of the frame.

Beginning photographers often think they are close enough when they are too far away. This is because they concentrate and in a sense mentally zoom in on the subject instead of understanding that the picture will be exactly what is framed in the viewfinder.

Keep It Simple

Avoid clutter in your photos. To do so, change the angle of view or move closer to your subject. Aim for one strong focal point in your composition. Rely more on close-ups and simple compositions, and you will be pleased with the improvements in your photographs.

Experiment with Lighting

Try shooting at different times of day to see the effects on your subjects. Just be sure you are never shooting directly into the sun.

Plan Ahead for Action Shots

One way to avoid shutter lag is to prefocus the camera. If you can determine a spot where the action is apt to take place, such as the area around the goal at the end of a soccer field, you can prefocus on that area. Push the shutter button halfway down and wait for the action to occur. When you snap the photo, the shutter lag is reduced to only two- or three-tenths of a second.

FACT

On a digital camera, there is a delay after you press the shutter button (shutter lag) which can last as long as a full second. This lag is the result of the time used by the digicam to focus on the subject, calculate exposure, and adjust for proper color balance.

Avoid Stiff Portraits

When taking snapshots of a group of people, you'll get better results if they are involved in an activity or interacting with each other. Allow people to sit or lean against something so they will feel—and look—more relaxed. Be sure you are not catching them squinting into the sun.

- Use flash outdoors to eliminate shadows.
- Avoid wide-angle distortion.
- Do not center all your pictures in the frame. Use the focus-lock feature to avoid this problem: Focus initially on people at the center but then move the camera to create a better composition.
- Partial images can be very dramatic. Shoot close-ups or crop to provide interesting images.
- At night, turn off the autoflash and use a tripod for better images.
- Image-editing software is a great tool, but it will never replace a good photographer. Think about the composition when setting up a shot.

CHAPTER 11

What Makes a Photograph Memorable

The more experience you have as a photographer, the better your pictures will be. While taking a basic shot is simple—just point and shoot—taking a really striking picture requires that you understand a number of variables and be able to put them together in fast-changing situations. This sense of timing is so important that Henri Cartier-Bresson, the famous French photographer, called the moment that the shutter is snapped "the decisive moment." This is the moment where movement, expression, light, and composition come together to create a photograph.

Overview of Picture Elements

Virtually all types of photography require a photographer to act quickly and decisively. A landscape can change rapidly as the sun changes or clouds fill up the sky. Even a portrait requires a photographer to capture fleeting but revealing emotions on the subject's face.

Picture-Taking and Skill

As you can see, it takes a good deal of practice to quickly organize the elements of a photo and take a stunning picture. Yet with time you can learn to do just that. It is a little like learning how to dance. At first the steps seem awkward and unnatural. Yet gradually you get a sense of how the dance progresses and you add more moves. Eventually you go effortlessly from one foot to the other while changing steps and staying in tune with the music.

The Photographer's Toolbox

In order to take photographs that capture the viewer's attention, you need to know the elements that combine to form visual impact. These include light, angle of view, framing, shape, line, pattern, texture, composition, color, depth of field, lens focal length, and shutter speed. Just as an artist uses paint and canvas to create a painting, a photographer has tools at his disposal to create memorable pictures.

Light

Light is the most important element in a photograph. Photography is the action of capturing light on light-sensitive material. Photography is the art form of light. Without light, you have nothing. If the light is not right, it does not matter what apples or children or pets are in front of the camera; the picture will not work.

Each light source will create its own set of shadows. They add a dimension that can give a photograph depth and substance. Very intricate and subtle shadows can be recorded within textures, for example. It is these two elements, light and shadow, that are the beginning of a stunning photograph.

Understanding light is crucial. Experienced photographers learn to judge the quality of the light first, then analyze shapes, lines, patterns, and textures later. To have the desired effect, light must reveal or show the shape properly.

Like many things in digital photography, you can learn about light much faster than you can with a film camera. The LCD screen can immediately show you the quality of the light and also how the light appears after being recorded on the light-sensitive computer chips (image sensors).

Overview of Light

Light has many qualities. It can be soft with light gray shadows or bright and harsh with deep shadows. A scene might be evenly lit or have areas of directional lighting like spotlights. The direction of the light is very important. The light can come from behind the photographer, from the side, or from behind the subject. Photographers can control this by positioning themselves in relation to the light.

The angle of the light is another element. Lighting from above is very different than lighting from below, for example. Lighting that is at a low angle to a surface will reveal minute details in a texture, even the weave of cloth, while lighting from the front will show very little texture.

Each light source has its own particular color, which can be recorded quite distinctly in a photograph. Again, experienced photographers are used to this aspect of light. Digital cameras have a white balance control, which will see one particular light source as white light.

Each light source has a distinctive color. Incandescent bulbs, halogen lamps, sodium street lights, florescent lights (many kinds), mercury lights, camping lights, and even kerosene lamps and candles have their own colors. In addition, there are strongly colored light sources such as neon lights and stage lighting.

Multiple light sources can cause problems or be used for artistic effect. A photographer will have to choose which light source will be seen as white while the other light sources may have noticeable colors. These can pose a number of problems. First, each source will have its own direction and create its own shadows. Second, the different sources may have very different colors, so the photographer will have to choose which source will be considered the "white light" using the white balance control. The other light sources may create odd colors in the scene, a bit like colored lights at a rock concert.

◀ Light creates images in photography. It is the fundamental building block of the art.

Different Moods of Light

A photographer uses light in the same way that an artist uses paint. Light is the source of all color. All colors combine to form white light. When light strikes an object, some colors are absorbed and others are reflected. For instance, a fire truck looks red because its surface is reflecting red and absorbing all other hues. An object appears white when its surface reflects all colors and black when its surface absorbs them.

The sun is the most common source of illumination. During the course of a day, the sun's light shifts from dawn's soft radiance to harsh midday bright-

ness to the delicate rosy glow of sunset. Once the sun has set, the night is filled with cool tones. When shooting a city skyline at sunset, you'll find the buildings tinged with the pinks and lavenders of the twilight sky. But under a noonday sun, those same buildings will be starkly lit. Bright, sunny days are good for capturing brilliant images. Overcast days produce subtler color combinations. Seasons, too, will change the effect of light upon a subject.

FACT

Sunlight not only changes throughout the day, but also from season to season. By studying these changes, you will learn techniques for effectively tackling the challenges presented by different lighting situations. You will also discover new ways of using your digital camera as a creative tool to express your unique message.

A great photograph requires great lighting. Time of day and the resulting angle of light affects form, contrast, texture, and color. Professionals know when the best times to shoot are.

How Daylight Changes

Here is an overview of how light changes throughout the day:

- **Predawn:** Pink, dreamy light; ideal for shooting bodies of water and landscapes
- **Dawn:** Crisp, golden light reflects on subjects facing east
- **Early morning:** Soft light
- **Midday:** Harsh sunlight; best for shooting monuments, buildings, and urban streets
- **Late afternoon:** Warm, golden light; ideal for people and landscapes
- **Sunset:** Beautiful skies, especially twenty minutes before and after the sun sets
- **Dusk:** A purple glow in the sky; does wonderful things to skylines
- **Night:** If you're willing to experiment, night offers some interesting effects

Contrast is a key element in any photograph. A good photograph should have a full range of tones from black to white. For example, even though an image might have primarily light pastel tones, a true black should exist in the deepest shadows. Contrast becomes especially important when a picture is printed in a publication or converted to black and white.

Angle of Light

The angle of the light determines a lot about its mood and quality:

- **Front lighting**, such as taking a picture with the sun behind you, provides an even illumination of your subject and tends to produce natural-looking colors. However, since shadows are cast behind the subject, it can appear rather flat, lacking depth and volume. You can turn this to your advantage when you are shooting to emphasize patterns and when you prefer that forms appear as two-dimensional shapes.
- **Side lighting** will better convey a three-dimensional form. For most photos, side lighting is the most effective type of illumination. You can use side lighting to emphasize texture, especially when the light crosses the surface of your subject at a low angle. It can also be used to emphasize the roundness of shapes.
- **Back lighting**, lighting that comes from behind a subject, can be difficult to use correctly, but properly executed it can produce dramatic results. With strong light, the subject will turn into a silhouette. With weaker light that is balanced by other light from the front or side of the subject, back lighting may produce what is known as rim lighting. Rim lighting refers to a slightly darker than normal subject that is circled by a halo of light.
- **Lighting from above**, such as the light emitted by the noonday sun, tends to produce unflattering shadows on both people and scenes. However, sometimes it can be utilized to produce drama, such as when shooting images of urban buildings.
- **Lighting from below** is typically used in horror movies because it produces deep sinister shadows. As a result many photographers avoid this kind of lighting, but in the right situation it can be quite useful.

- **Even lighting**, such as that on overcast days, provides soft light that reveals more subtle colors and detail. When shooting on a sunny day, you can sometimes capture subjects in open shadow for diffused light that reveals vivid color usually lost in harsh, direct light. Open shade often has a bluish tint, so make sure your camera properly sets the white balance.

The use of light is an artistic tool. Mixed lighting might be a problem for one photographer and an artistic effect for another. The same can be said of overlapping shadows from multiple light sources or a bright light that flares directly into the lens. Use your creativity to make light work for you.

Angle of View

By changing your camera angle, you can change the viewpoint of your photos, along with their tone and impact. A scene will change dramatically when it is shot from above or below as opposed to eye level. You may need to get down on the ground or sit high up in the stands at a football game to achieve the results you're seeking.

QUESTION?

When do I use high or low angles of view?
High or low angles of view can be used to reveal patterns and textures not normally perceived at eye level, simplify a composition, isolate a subject against the sky or a plain background, or eliminate a cluttered environment.

Different Points of View

Because we usually view the world from eye level, photos taken at a normal eye-level angle communicate realism. We can give power to objects by shooting them from below, so that they appear to tower over us. By shooting from above, objects become diminished, but the arrangement of objects often becomes more discernible.

The angle of view can have a dramatic impact on open landscape images. When you shoot from a low angle, more sky is revealed and the spaciousness of the landscape is emphasized. When you shoot from a high angle, the horizon is positioned near the top of the image and the land may seem to stretch out to infinity. Photos of children are often much better when shot from a child's point of view rather than an adult's. Experienced photographers often stand on a table or go up to a balcony to get an overview shot of an event.

Experimenting with Angles of View

Try taking a series of pictures of the same scene from different angles of view. How does the angle of view affect the emphasis of the picture? What is being communicated by each image? As Ansel Adams, the famous photographer, said, "A good photograph is knowing where to stand."

The LCD monitor allows you to hold the camera high above your head for unusual high shots. While this takes some getting used to, this ability gives the digital camera additional power over traditional film cameras when it comes to camera angle and point of view.

Framing

To create a photograph, photographers frame a picture with the viewfinder or LCD monitor on their camera. We have become so accustomed to rectangular viewfinders and pictures that we tend to forget that we are creating art within that frame. Yet a good photograph has to fit comfortably within its right angles and oblong shape.

A given situation can yield many pictures. Photographers are, in a sense, cutting out a slice of reality from an entire scene. Amateurs can take boring pictures at an event where experienced photographers often create stunning photos.

▲ Trees frame the rising sun. Framing often creates a photo.

A Window to Your World

Good photographers make the elements of the picture work within the frame, so that the subject of the photo seems to exist naturally within the rectangular format. Photographers often have a number of controls that allow them to adjust this framing until they get it just right, including techniques such as zooming in or out, changing the angle, moving backward or forward or left to right, or adjusting the depth of field.

Framing is at the heart of photography. In a fast-moving situation a photographer must be able to compose quickly. This takes considerable experience when events are changing rapidly. Experienced photographers learn to shoot without being distracted by the hustle and bustle around them and yet at the same time they stay aware of how the situation is progressing.

Shape and Line

As a photographer, you can create dramatic impact by emphasizing shape. One way to do this is to make a single shape the focus of your image, capturing it against an uncluttered, contrasting background. To do so, you may have to get in close to your subject or change the camera's angle to rid your picture of distracting details. Lines define shapes. Our eyes follow lines. Lines lead the way, showing us direction and distance.

How Shapes Appear

In more elaborate compositions, shapes become the building blocks of your image. They can mirror each other in form or provide contrast to create balance or tension. Shapes can overlap and disappear in shadow.

Shapes are subtle. They are usually defined by edges and by lighting that separates them from the rest of the things around them. Yet often only part of a shape will be seen, leaving the viewer to imagine the rest of it.

◄ This is the powerful and distinctive shape of a blue marlin.

Kinds of Shapes

There are many kinds of shapes, from manmade to natural, from hard-edged to soft-edged. The human body is one of the prime natural shapes that photographers work with. Photographers often play with a viewer's understanding of shape by placing a shape against a background that alters it. For example, a scallop shell looks very different on a sandy beach, where it merges with the sand, than on a table of dark wood, where it stands out.

Line

Line can convey action or force. One of the most important uses of line is to lead the viewer to the center of interest in the photograph. Lines are a tool the photographer uses to create depth in a photograph. A flat, two-dimensional image takes on life when parallel lines recede to a distant point, creating a sense of perspective and beckoning the viewer to the far-away point.

You can utilize hard-edged lines to create impact, while curving lines suggest a softer, more graceful feeling. When composing a picture with several elements, lines can be used to direct the eyes of the viewer from one form to another. They can link objects usually considered unrelated, and they can provide information about the action in the picture. Frequently, the opposition of curved and straight lines is used to express action.

ALERT!

Lines can be easily changed in a photograph. The photographer simply has to change her camera angle. A billboard shot from the front will be flat and rectangular. Shot from the side and close up, it will create a trapezoid that recedes into the distance.

▲ The line of the pier pulls this composition together.

S-Curves

The S-curve is one of the most common and graceful lines used in composition. An S-curve often draws the eye past several points of interest. S-curve compositions typically produce a feeling of calm. Look for an S-curve when composing a shot.

Other simple geometric shapes can enhance your photo compositions. The strongest of these is the triangle. A triangle in your composition can add effective visual unity to your image. A V shape typically accentuates perspective and pulls the viewer's eye to the focal point of the picture. The C-curve can be useful for framing the main element or drawing the viewer's eye into the picture.

Pattern and Texture

Patterns are formed when lines, shapes, or colors are repeated. Typically, a photographer uses patterns to create a sense of harmony. At the same time, other feelings can arise from photographs that show patterns. Texture appeals to our sense of touch. When used in a photo, texture adds a feeling of realism to the image.

The Power of Patterns

Because of their strong visual impact, even the slightest suggestion of a pattern can catch our eye, especially when the elements join together by chance. Look for patterns in your own world, and begin experimenting with them to see what effects you can achieve. For example, vertical lines are everywhere. Try to find places where these lines repeat in some kind of progression. Bear in mind that a pattern alone can make for a dull photo. Be sure that a pattern is strong enough to stand alone before you make a photo of only pattern. Often, you'll want to include additional elements to provide visual interest. For example, you can pose a person against an interesting pattern.

Patterns and Rhythm

When repeating picture elements are used effectively, they create a visual rhythm, a kind of visual music. This can add energy and activity to a

static picture. This rhythm can be the subject matter of the photograph or it can be the background.

Texture

You can utilize texture to portray the nature of a surface: rough, smooth, jagged, bumpy, and so forth. Texture gives a three-dimensional sense to an image, causing the elements to be seen as forms. It helps the viewer perceive the heaviness and bulk, softness or hardness, and roughness or smoothness of the objects.

Feeling the Texture

Even though there is an interesting texture in your photograph, it may not photograph properly. With texture, lighting is critical. Front lighting hides texture; side lighting reveals it. Also, the light might show the texture in one part and not show it in another.

▲ A curtain yields a distinctive pattern that could be part of a composition.

▲ Texture is just about everywhere, even in this breakfast cereal, and it is an important part of photographic imagery.

Composition

As a digital photographer, you need to build, or compose, your image using the light that reveals visual elements. Unlike a painter, you cannot simply pick and choose your objects, colors, or placement of each (except when you combine elements using image-editing software). But you do have certain options that impact the composition of an image, including the ability to move closer to or farther away from your subject, to choose how you angle your camera, and to decide whether to shoot from above or below your subject. The photographer then combines the visual elements—shape, line, pattern, and texture—to create a picture. He may decide to isolate one element or use a combination of any or all of them.

The Power of Composition

Learn and experiment with the guidelines for good composition discussed later in this chapter. See how the resulting images change as you change your approach to a scene. Although it is important to know the rules, don't be afraid to break them when it is advantageous to do so. There is no single "right way" to take a photograph.

Your goal is to create an image that quickly and clearly conveys your intended message. Composition is not a haphazard matter. You will need to analyze the elements in a scene, then adjust them for the effect you seek. Sometimes you will isolate a single element for a simple but striking image. Other times you will use a combination of elements to tell your story. You may decide to go for a symmetrical, harmonious picture or you may deliberately choose to convey a feeling of disharmony and uneasiness.

Perhaps you will choose one main element to dominate the picture, with lesser elements supporting the focal point. The main element may be larger in scale or brighter in color than other elements in the picture.

Before taking a series of pictures, walk around the room or the backyard where your picture session will take place. Experienced photographers will do a full 360-degree walk-through and even get up high or down low if the situation permits to find the best point for taking photographs.

▲ These three gulls form an interesting composition.

Balance and Imbalance

Although you may think that it is desirable to arrange the elements in a picture symmetrically by placing the main subject in the center with other elements spaced evenly around it, this is exactly the sort of composition you'll want to avoid. A perfectly symmetrical image can appear rigid and uninspiring. To pique a viewer's interest, an image typically contains two main attributes: tension and movement. Balance in a successful image comes from the less obvious: the visual weight given to various elements in a picture. You can obtain this type of balance by using contrast, such as bright colors balanced by muted ones, dark objects balanced by lighter backgrounds, or very detailed objects balanced by open areas.

The Rule of Thirds

One formula for achieving balance is known as the rule of thirds, and painters have successfully employed it for hundreds of years. As you peer

through the viewfinder, imagine lines dividing the image into thirds, both horizontally and vertically. Subjects placed near one of the four intersections formed by the lines gain immediate off-center emphasis. On the other hand, elements situated at diagonally opposed intersections seem balanced. When subjects are located at three of the intersections, they can form a striking triangular composition. In other pictures, the imaginary lines divide a scene into pleasing two-thirds/one-third proportions.

The rule of thirds can be utilized when photographing all subjects, but it works particularly well when you are shooting a relatively small subject photographed against a large expanse or a plain background. Another way in which the rule of thirds can prove useful is helping the photographer decide where to place the horizon. You can easily arrange the composition by placing the horizon along one of the frame-dividing lines.

Color

Color determines the mood of a picture. As a digital photographer, you can manipulate color, both when shooting and when working with image-editing software after you've captured the image. While shooting, simply by moving around and changing your angle of view, you may be able to combine colors to better express the story you want your image to tell.

ALERT!

When framing your shot note where colored objects are located. Bright patches of color in less important parts of the scene will draw the viewer's attention there. Don't overload your images with colorful objects; the result can be a busy image that leaves the viewer feeling slightly uneasy.

Warm and Cool Colors

Color determines the mood of a picture. When the predominant colors are warm ones, such as yellow or red, the mood is bright and cheerful. Cooler blues, lavenders, and greens can convey a calm and tranquil mood, suggestive of a mountain brook or a leafy glade. Contrasting colors create drama,

while dark grays and black evoke a somber mood. See the color pages for a variety of colors and overall tones that make a photograph successful.

You can choose to effectively combine many colors in your image, use a controlled palette of just one or two colors, or utilize just a splash of lively color for impact. Another way to use color in photography is to compose your picture to include a brightly colored object against a subdued background. The color will draw the viewer's eye to the bright item and make it a focal point, even though it may be relatively small in size.

Color versus Black and White

Some photographers will need black and white pictures on a regular basis for newsletters or publications. Black and white is very different from color and involves only shades of gray. Don't assume that a good color picture will work in black and white. Experienced photographers learn to see the world in color or black and white depending on the need. Some cameras will let you see the picture in black and white on the LCD viewfinder.

Focus (Depth of Field) and Focal Length

Higher f-stops create sharp focus in front of and behind the subject; lower f-stops do the opposite. Out-of-focus areas can be quite subtle. A slightly out-of-focus background will draw the viewer's attention to the main subject that is in focus. A wildly out-of-focus background, often created with a telephoto lens, can resemble an abstract painting with merging colors and even bright colorful circles of light. Focal length and depth of field often work together to create a strong image.

Depth of Field Effects

A busy and unavoidable background, for example, can be controlled quite easily by using a lower f-stop that puts it out of focus. Portrait photographers often use this trick to emphasize the person in the portrait and to abstract and blur the colors in the background. In a landscape, however, you might want everything to be in sharp focus from very near to very far. In this case, you would use the very highest f-stop.

How to Control Depth of Field

The way to control depth of field is to change the exposure setting on your camera from automatic to aperture priority. In this mode, when you change your aperture the metering system will automatically make the corresponding change in shutter speed.

Lens Focal Length

A zoom lens has the effect of bringing you closer or taking you farther away so that you don't have to move. At the same time it is changing the focal length. Different focal lengths have different characteristics and are another very helpful tool in the photographer's tool box.

Wide-Angle Lenses

Landscapes and interiors, where as much as possible in the scene needs to be included, often require a wide-angle lens to encompass everything.

▲ This wide-angle shot taken under a bridge is sharp from just a few feet away to infinity.

Wide-angle lenses can also be used in close-cramped rooms to take in all the activity. These lenses are also noted for distortion. Objects close to the lens often look unreal. A portrait of a person close to the lens, for example, will look out of proportion.

Normal Lenses

Normal scenes such as an office party in a large room usually require a normal lens such as 50 mm. A normal lens has a perspective that appears normal and natural.

Telephoto

Experienced photographers like to use a mild telephoto setting for portraits such as 80 mm to 125 mm. A close shot with a normal lens can distort a face, but a person's face appears normal with a mild telephoto. A telephoto lens has less depth of field, and putting a background slightly out of focus is often a useful technique with portraits. Longer telephoto lenses can make the background go completely out of focus and also magnify the background behind a subject so that it appears much larger than normal.

▲ This extreme telephoto shot was taken from the same position as the previous shot.

Shutter Speed

If you want a sharp, clear picture, it may not matter what shutter speed you use, as long as there is no camera shake and resulting blur. In many—if not most—picture situations, shutter speed does not really play a part. At the same time, there are a variety of shutter speeds from fast to very slow that can produce dramatic effects, if the photographer understands how to use them.

Slow Shutter Speeds

Shutter speed can be used for creative effect in a number of situations. Blur, motion, and smearing effects often depict action much better than still frozen shots. For example, a telephoto shot of a football player running down the field at a slower shutter speed will show a streaked background that gives a strong sense of motion. In this case the photographer would pan the camera and move it in sync with the football player. The slower shutter speed (say 1/30 of a second with a telephoto lens) would make the background a bit blurry while the player would appear relatively sharp against this background.

Fast Shutter Speeds

High shutter speeds can be used to create very dramatic effects, such as that of people jumping up and down with their hair flying off into the air. A fast shutter speed will freeze that hair, giving it a surreal look.

Previewing Does Not Work

Experimenting with shutter speeds can yield a number of creative effects. However, in this case the LCD monitor cannot really provide a preview. You must take the picture first and then review it to see the effect you have captured.

CHAPTER 12

Types of Photographs

Some photographers enjoy taking specific types of photos, including portraits, landscapes, still lifes, nature scenes, and urban streets. In addition, many will want to experiment with digital photography, since digital technology allows experimentation as never before. While this chapter discusses each of these types of photographs individually, they can be combined in any number of ways. For example, a portrait, a landscape, and a sunset could be combined to create a powerful image. Candid pictures of children playing with pets can produce wonderful results.

Portraits

Portraiture requires people skills. If you like working with people, then you can be a good portrait photographer. Some people rate having their picture taken on a par with getting their teeth drilled. They will stand in front of a camera with a forced smile, hoping to quickly move on. The photographer must put the subject or subjects at ease, yet be in charge at the same time.

When starting out, try different types of photographs. To understand what really excites you, you need to become involved. You may not realize, for example, how much the roar of the crowd at a football game gets your heart pumping and leads to stunning images. Or you may find that, instead, you enjoy the quieter personal touch of portraits.

Getting Subjects to Relax

While everyone has seen hundreds of stiff posed shots, a good photographer will instead get people to relax. Find a place where they feel comfortable, such as a living room couch. Outside you might look for a tree or wall that subjects can lean against.

When shooting indoors, turn on your camera's red-eye reduction mode or the overhead lights or have the subject look at a light before you take the picture. These techniques help avoid that scary red-eye syndrome. With digital software, you may be able to remove red-eye later, but it is easier to do it when shooting.

You need to change the expectations of your subjects. Let them know that your session with them is going to be an enjoyable experience but that to get good pictures you will need to take a number of them. Since they now know the session will take a while, they may relax and real emotions might start to come through.

◀ The author's wife poses for a portrait in her jewelry studio.

Portraiture Techniques

Close portraits of subjects are often most effective. Yet you do not want to have to stand uncomfortably close. Experienced photographers use a zoom setting between 80 mm and 125 mm (35 mm equivalent), for two reasons: this setting allows them to keep at a reasonable distance and it causes less distortion with close shots.

Look for side lighting or even lighting and move around so that when your subjects are facing you the light is coming from the right direction. Avoid direct sunlight and instead look for open shade. Fill flash can also be useful both in sunlight and in shade to prevent deep shadows.

def·i·ni·tion

Subject: The word *subject* in photography refers to the person or persons, building, or anything else that is the principal object or objects of the photograph. The word *subject* is different from *subject matter*, which is a more general term and refers to the category of photography into which the photo falls, such as portraiture, landscape, or still life.

With children you might get the best shots by following them around as they play. You will get much better pictures if you get down to their level and not take pictures from above like an adult. If you can join in their play a bit, they may begin to trust you and allow you to get unposed portraits.

Candids

Candids are often the best and most natural pictures of people, but there are a lot of tricks to putting individuals at ease and to being in the right place at the right time. You might encounter hostility while taking pictures on a busy sidewalk because people might be suspicious. Find situations where a camera is more accepted, such as a sporting event or an outdoor concert. A good zoom such as a 10× is essential, since candids require a lot of working distance. See the color pages for an example of a chance candid shot.

Some people are not going to welcome you taking their picture. Avoid anyone who looks unfriendly, and explain what you are doing if someone approaches you. If you are taking art photos, digital photography makes it easy to show people what you are doing so that they feel comfortable.

Anticipate Events

Try to anticipate events so that you can be there ahead of time. For example, at a sporting event you might leave early so that you can get pictures of people coming out of the exits after the game.

Find Your Own Stage

Another trick is to find a fixed place where people show up at random, such as a well-lit wall that people walk in front of or a doorway. In a sense, this place you have chosen is now a stage. Frame people as they appear and make a composition by working with the setting. Try to find a place where you can position yourself unobtrusively and not be noticed. Taking pictures from above is often a good candid technique, as people rarely look up.

▲ Candid shots often happen by chance and can create exciting unplanned imagery.

▲ Pets are popular subjects for photography.

Pets

We think of our pets as members of our families, so it's not surprising that we love to include their images in our photo albums. Candid shots work especially well, since it is hard to keep your dog or cat sitting at attention for very long. You can try using a squeaky toy to draw their attention toward the camera, or wait and snap a candid shot the next time your child is playing with your dog. Move outdoors for good action shots, such as running at the beach.

Although cats and dogs are the most popular household pets, don't overlook the hamster, bird, or gerbil that calls your house home. Smaller animals can figure in your photography plans. Even fish in an aquarium can produce interesting pictures; take time to play with the quality of light in water.

Landscapes

Landscapes are much harder than you might think. Because the photographer has so much to work with, the vast space can be overwhelming. Landscapes require that you organize the foreground, the background and the sky into a whole that communicates a sense of place. Many of the elements of composition mentioned in previous chapters should be brought to bear.

Special Characteristics of Landscapes

Some scenes will be much more striking at certain times of day. Lines, shape, texture, and pattern should all combine to create an image that holds together. Shadows can be crucial. Many photographers use a close object like a tree or a wall or a small building to help organize the scene, taking the eye from near to far. While landscapes do not move, light can change quite quickly as storm clouds move in or the sun goes behind a mountain. Keep one eye on the weather as you shoot.

Another trick is to frame a scene and then wait for a person to walk along a sidewalk or for a car to come down the road. Most photographers will think of a wide-angle lens and full depth of field as being essential for a landscape. This may be appropriate for some shots, but not all. A wide-angle lens will emphasize the foreground at the expense of the background, for example, while taking in a wide view. A telephoto lens can often pick out an essential detail and also magnify the background considerably so that mountains that might appear far away with a wide-angle lens can appear to be very close with a telephoto shot.

▲ Like portraits, landscapes have always been part of photography.

Sunsets

When the sun gets close to the horizon it moves fast. In fifteen minutes you can take a series of pictures that will all look quite different. It is important to avoid looking at the sun, as it can damage your eyes. The clouds are usually the most colorful part of a sunset, even after the sun has set. Try to use a tree or a rock or a building to help give the sunset a sense of place and organization. The light from a sunset reflected in a window can also be very effective. See the color pages for a series of sunset photos.

FACT

When taking pictures at dusk or dawn, it can become difficult for your autoexposure system to determine the right exposure. This happens because there is an extreme difference between light and dark. Take a series of shots so you'll be certain to get satisfying results.

While most people think of sunsets as landscape images, the sunsets over cities, apartment buildings, and highways can be just as stunning.

Still Lifes

Although fruit may be the first thing that comes to mind when you hear the term still life, just about anything can qualify as a subject for a still life. A still life simply refers to an inanimate object or group of objects, composed and captured in an interesting way. For centuries, painters have used still lifes as a means for exploring and learning about their craft, and photographers can do the same.

Examples of Still Lifes

Many of the photographs used in advertising are still lifes. Open a domestic-themed magazine, for example, such as *Woman's Day* or *Good Housekeeping*, and study them for clues to what works and what doesn't. Notice what draws your eye, paying attention to the use of lighting, color, composition, shapes, and texture. You will see that photographers use

techniques such as patterns (repetition of shapes and lines), a combination of complementary or clashing colors, and a focus on one main object to create noteworthy still-life images.

◀ Cooked shrimp make an interesting still life.

Still Life Techniques

When setting up your own still life, everyday items you have around the house can be used to make a statement if they're arranged well. To make it more than just a snapshot, you will need to consider the texture, theme, and composition of your image. Your choices of subject, placement, and lighting will be the keys to creating successful still life images.

Pick objects of complementary or contrasting color or shape, things that will work together to convey a story, or objects that are found together in nature. Arrange them so that they are leaning against or are placed next to each other. Larger items will become the main focal points of the composition, with smaller objects placed in front of them.

ALERT!

When photographing a still life, you have complete control over the creative process and can experiment with shape, light, color, texture, and composition. Still lifes tend to be more time-consuming because you must first set up the shot. By paying attention to detail and allowing your creativity to surface, you can create a memorable still life image.

Soft, diffuse lighting will give the image a soft quality, like a painting. Stronger light is more appropriate for use with a still life composed of contemporary or angular items. Varying the angle of the light also changes the mood of the shot. Lighting your still life from above will make it appear more grounded. If you light it from below, the objects will cast high shadows and appear larger.

Macro Photography

Close photography could be considered a special branch of still life photography. Often created in the studio, these shots are rarely spontaneous. By their nature they must be carefully set up, lighted, and framed. Close photography has special requirements. You may want to work with it or need to do it more often than you might realize.

If your digital camera has a close-up mode, you can enjoy taking intimate shots of the world around you. Nature offers a limitless array of possibilities, from the elegant butterfly perched on a garden bush to tidal pools hidden among seaside rocks. For technical aspects of this kind of photography, go to Chapter 5 and read the "Taking a Closer Look at Macro Photography" section.

◄ Close-up photos, such as this picture of a grill ornament on an old Buick, make worlds unto themselves.

Silhouettes

Silhouettes are outlines of subjects, like black cutouts. While a silhouette is often of a person or figure, it can be of anything. However, since a silhouette abstracts a subject, silhouettes can be unclear if not carefully composed. See the color pages for a silhouette shot of people fishing at a pier.

Silhouette Techniques

The light must be behind the subject you want to silhouette so that you are, in effect, underexposing the subject. To get the best exposure, turn your viewfinder toward the brightest area of the scene, then lock in the exposure and reframe the shot. If your camera has exposure compensation, take a reading of the bright area, then bracket the shot so you can choose the image with the exposure that you like best.

▲ Silhouettes can make dramatic images like these boats at anchor with the late afternoon sun behind them.

What to Look For

Silhouettes have the most impact when you incorporate an opaque object and a bright background. Look for a bold subject with a simple shape, one that the viewer can easily recognize. The background can be any light-colored expanse, such as the sunset sky, the glittering sea, or even a light-colored building. While the concept is simple, finding a bright and uncluttered background is often not simple. As with other subject matter, move around the area where you are to shoot to find the best vantage point.

Cities

The movement, color, and exuberance of city streets make them an ideal place for taking photos. Amid the urban commotion you'll find eye-catching architecture, captivating faces, lush public parks and gardens, fountains, green markets, and historic landmarks. Even the public transportation—taxis, buses, and subway cars—can be fruit for your digital images.

City Life

If you're new to the area or just visiting, take a walk to really get a feel for the flavor of the city. You'll be part of the street's hustle and bustle, so you'll be able to spot interesting details as you stroll around. Think about what you'd like to shoot. Are you looking for anything that grabs your attention, or do you have a particular subject in mind?

If you're in a city with a long history, look for opportunities to show the old and the new side by side. For instance, if you're visiting Boston's Back Bay, a shot of the Romanesque Trinity Church dwarfed by the contemporary glass behemoth, the John Hancock Tower, would show an interesting juxtaposition of the historic and the modern.

City Angles and Light

For a different perspective on a city, you might want to get above or beyond the action. When viewed from above, streets become lines forming interesting patterns. For a good vantage point, see if the you are in city offers

an observation tower. If you're staying in a high-rise hotel, you may be able to shoot photos from your room.

You may need to get away from the city to get an expansive view. To shoot from the water, take a boat or ferry ride. Even a bridge, such as San Francisco's Golden Gate, can offer a fantastic place from which to photograph a city.

The city can look a little lackluster at midday, but in the evening it takes on a glamorous glow. Try shooting at twilight, when there is a lot of blue light left in the sky, and see how the buildings glimmer. Just before sunset you can shoot from the west to catch the setting sun lighting up the city skyline. Skylines often make breathtaking images, especially when captured in dramatic evening light.

▲ The hustle and bustle of a city can yield a variety of images.

Hot Spots in Cities for Taking Pictures

Open-air markets, with their colorful produce stands, merchandise vendors, and shoppers haggling for the best bargains, can be fodder for your

photographs. City parks can reveal lovely fountains and gardens, while urban skyscrapers can be used to produce striking graphic images.

When visiting metropolitan areas, walk through busy urban areas with camera in hand. Keep your eye open for interesting subjects, such as people shopping or making their way to work, and architectural details that will convey the mood of the city.

Travel Photos

If your trip takes you to a tropical destination, the beaches, luscious flowers, and colorfully garbed people all combine to spark your imagination. When traveling by cruise ship, you'll have opportunities to get photos, both on board the ship and when stopping at ports of call. You can shoot scenery from the deck of the ship, capture the impressions of the island markets, and even record the action at the ship's buffet table or dance floor.

Architectural Details

Although it is fun to capture the magnificence of a famous structure, such as the White House or the Eiffel Tower, many buildings offer subtle architectural details that make exquisite images on their own. Menacing gargoyles, centuries-old weather vanes, and luminescent stained glass windows are just some of the compelling details that can be used to create whimsical photos.

What to Look For

A building's many details combine to give the structure its architectural style. Think of the elaborate gingerbread of a Victorian house, the stainless-steel exterior of an Art Deco diner, and the fluted columns of a Greek Revival courthouse—all details that immediately declare the style of the building. See the color pages for a photo of a Greek column at a courthouse.

Architectural Detail Techniques

The best photos of architectural details are ones that are tightly composed so that the subject fills the frame. Depending on how far you are from

your subject, you may be able to use a normal lens or moderate telephoto. If you are too far away, you'll need a more powerful telephoto lens. Be sure to note the lighting. Ideally, it will be coming from the side so that texture and details will be readily revealed. If you are concerned about capturing color, a hazy day will offer the most saturated hues. For this kind of photography, a telephoto zoom lens is essential because you may not be able to get as close as you would like.

If you're interested in shooting architectural details, begin by taking the time to look for them. Although you may first think of visiting cathedrals and historic structures, remember that even a simple country barn or city diner can offer interesting shapes and patterns. As you begin to become more aware of the details of the buildings around you, you may be surprised at how many can be used effectively in your digital images.

◄ Keep your eyes open for fascinating architectural details, such as this cupola on top of the courthouse in Beaufort, North Carolina.

Good Pictures Are Everywhere

You need not be a globetrotter to take impressive photos. Start in your own backyard or take a walk down the street where you live. The great photographer Edward Steichen took hundreds of pictures of a tree near his home in Connecticut. "Each time I look at these pictures," he said, "I find something new there. Each time I get closer to what I want to say about that tree."

Picture Opportunities Where You Live

Make a list of different places, events, celebrations and seasonal changes that could provide picture opportunities close to home. While many people think that they have to travel to an exotic country to find exiting photography, the best pictures are often taken close to home. Close observation and a good understanding of subtle changes in your own environment will often yield the most powerful shots.

You don't need to go far to witness the effect of time. Simply look out your window or take a walk in a nearby park to discover seasonal changes in your own yard. You might even decide to take a series of shots of a particular outdoor scene to record the ways in which it changes with the seasons.

The Home Court Advantage

When you take pictures close to home, you have the advantage of understanding your situation better than when you are out of town or on vacation. Your familiarity will allow you to see and use elements that others might miss. Also, looking at your everyday world for new picture possibilities has the advantage of making your normal world quite interesting.

PHOTOGRAPHER'S LOG

Details	Picture 1	Picture 2	Picture 3	Picture 4
Date				
Time of day				
F-stop				
Shutter speed				
Focal length				
ISO				
Metering mode				
Place (such as the address)				
Quality of the light				
Weather				
Image resolution				

Details	Picture 5	Picture 6	Picture 7	Picture 8
Date				
Time of day				
F-stop				
Shutter speed				
Focal length				
ISO				
Metering mode				
Place (such as the address)				
Quality of the light				
Weather				
Image resolution				

Photography Log

It is very easy to forget the details of an image that you've taken. Many a photographer has taken a great shot or created a great effect and then not been able to recreate the special feeling of that picture because she did not remember the camera settings.

Essential Information

While you could write down a myriad of details, the log on the facing page should be most helpful.

FACT

Some file standards such as EXIF (Exchangeable Image File Format) contain metadata that is saved within the file. EXIF uses the JPEG or TIFF formats with an added tag structure to save important exposure data about the image, such as shutter speed, f-stop and ISO. For much more information about EXIF data, read the EXIF section in Chapter 18.

Using a Notebook for Learning

Keeping notes is one of the best ways to learn the craft of photography. It is especially useful when you take a series of shots of the same subject at different f-stops, shutter speeds, focal lengths, metering modes, and ISOs. That way you can compare the effect that each change had on the same image. In order to get the most benefits from a series like this, change only one variable at a time.

Memory Cards, Downloading, and Storage

Downloading refers to the transfer of images from your camera's storage medium to storage located on a computer or other device. Downloading is accomplished by connecting the camera directly to the computer using a cable, or removing the medium, usually a memory card, from the camera and inserting it into a special reader. You may have more problems with downloading than any other aspect of digital photography, so understanding the ins and outs of this procedure is important.

Digital Film

Most digital cameras save pictures on memory cards. When you take a picture with a digital camera, the image registers on the camera's light-sensitive image sensors, but then the image has to be saved to memory. For this reason, memory cards have been dubbed "digital film" by digital photographers, since they now serve the same function as film. While the camera may come with basic storage, which is often called internal memory, you will usually have to add a memory card to save more than a few photographs.

Memory cards and the internal memory of the camera use a computer technology called Flash, or nonvolatile memory. This allows a digital device to save ("write") information to memory, and that information remains in memory even when the device is turned off or is not powered. Because memory cards use electronic memory, they are very fast and reliable, as there are no moving parts such as a hard drive has.

Memory cards and the internal memory of the camera are different than RAM memory in a computer, for example, which is temporary—it vanishes when the power is turned off. Memory cards keep everything that has been stored. The cards can be removed, stored, and inserted in other devices with no loss of data.

Memory Cards

As mentioned in Chapter 2, you will almost certainly need to buy a memory card when you purchase a new camera. Each camera requires a specific type of memory card, and if you are shopping for a new camera, the type of memory card required might be one of your considerations.

Types of Memory Cards

There are many different cards. For example, the Secure Digital (SD) card can be used in a number of devices. If you already own a gizmo such as a PDA or GPS, you may be able to use the card you already own for that device in your camera.

There are a variety of memory cards. They go by names such as:

- Compact Flash cards (CF)
- MicroDrive (MD)
- Memory Stick (MS / MS Duo)
- Memory Stick Pro
- Multi Media Cards (MMC)
- Smart Media (SM)
- xD Picture Card (xD)

Different types of cards may cost more than others and their capacities, and cameras' limitations on capacity, can vary.

Memory cards come in a range of sizes, everything from 8 megabytes to 8 gigabytes. As with many things in the computer world, you will often pay much less per megabyte the larger the card you buy. However, memory cards are not perfect and if you have a large card and the card fails, then all of your pictures will be lost. For this reason, many photographers prefer to have several smaller cards so that they don't put all their eggs in one basket.

Memory cards over 2 gigabytes may not be compatible with all devices that normally accept that type of card. The larger capacity cards can require a different kind of computer addressing, which may not be compatible with older gizmos. Check the device manufacturer's Web site before buying.

How Much Does a Memory Card Store?

The picture storage capacity of a memory card can be confusing and hard to understand. Because JPEG images are compressed, the actual size of the stored picture file is often about half of the megapixel rating. For example, a 2-megapixel image will often only have a file size of about 1 megabyte and a 6-megapixel image only about 3 megabytes.

This means that:

- A 128MB card will hold 130 2-megapixel photos or 40 6-megapixel images.
- A 1-gigabyte card will hold about 1,000 2-megapixel photos or 300 6-megapixel images.

The above numbers refer to JPEG files and the corresponding megapixel rating of your camera. If you are saving TIFF files or RAW files, the capacity will be much smaller. Consult your manual for information about the approximate size of these files.

ALERT!

Never remove a memory card while a photograph is being saved. This can corrupt the picture file and even the entire card, making it unreadable. If this happens, recovery software may be able to retrieve some files and/or reformat the card. This type of software works with memory card readers.

Formatting

You may be able to put a card into your camera and be up and running with no need to do anything further. Yet a memory card is very much like a hard drive or disk in that it needs to be formatted so that the camera can read it and write to it properly. Therefore, the first time you use a card it is not a bad idea to format that card just to be certain that the card is correctly configured for the camera. Read the camera manual for instructions on how to do this, as it will vary from camera to camera.

Formatting can be useful for other reasons. If you keep getting error messages when you save pictures to the memory card, reformatting may solve the problem. Bear in mind that formatting will erase all information on the card. For a quick delete of all pictures on your memory card, formatting is also useful. This can be much faster than deleting all the pictures or going through and deleting them one by one.

Caring for Memory Cards

Memory cards normally work well, but there are things to be aware of:

- Never touch the delicate prongs or metal contact areas.
- Make sure the prongs and metal contact areas are clean and clear of any dust.
- Avoid losing the cards.
- Store them in a case that keeps them from getting dinged up or lost.

Memory Card Readers

Instead of connecting your camera to the computer (see the next section) you can insert your memory card into a separate memory card reader. These quite simple devices plug into the USB port at the back of your computer. The computer then reads your memory card pictures like another drive. For example, if your computer has C: as its main hard drive, the memory card reader will now become D: drive. With many people having trouble connecting their cameras and downloading images, the card reader makes the job of transferring quite simple. You will have to install software that comes with the reader before using it.

FACT

Memory card readers are inexpensive and simple to use. This one accessory may solve many download headaches and also can be used with repair and recovery software in case of problems. You can leave the reader attached to your computer and then download images as needed without having to connect your camera.

Cost of Memory Cards and Card Readers

The cost of memory cards, like all storage devices, keeps coming down. Expect to pay about $50 for 1 gigabyte or more and about $10 for 128 megabytes. You will notice that the cost per megabyte is much less for the larger

size. Card readers cost about $10 to $20 for a basic one and more with extra bells and whistles.

PC Card Adapters

Computers that take PC cards, as many portables do, may accept an adapter that allows you to read your memory card. In this case, you insert the memory card into the adapter and then put this combined card into the PC card slot on the computer.

Portable Card Readers

If you are on the road and want to back up your memory cards, there are numerous portable card readers that can transfer data to a portable hard drive. Then, when you get home, you can transfer that data to your computer. These come in a variety of styles and capacities that can range from 20 to 80 gigabytes, and the more expensive ones have an LCD viewing screen for checking that your pictures are on board.

This technology is certain to change quickly, so your best bet is to go to a big online photography company, such as Adorama.com, and go to their Memory Cards/Portable Storage section to see the latest gizmos and prices.

Recovering Deleted Images

If you accidentally delete pictures from your memory card, you can often recover those pictures without a lot of trouble. Computers and cameras don't really delete pictures when you delete them. Instead they mark the space as free, as a space that can be overwritten. Recovering deleted files might be easier than you think if you follow these steps:

- When you accidentally delete a picture, do not take any more pictures on that memory card.
- Put the card in a card reader.
- Use software (see Chapter 17) to bring back the images in virtually any format, including music and video. This software is also useful for formatting, troubleshooting problems with the card, and secure deleting (a full erasure of any specified data).

Downloading Pictures from Your Camera

Once you have taken your pictures, you will need to transfer them to a computer or other storage medium or even the Internet. As long as they remain in the camera, you cannot do very much with them, except scroll through them and view them on the LCD monitor on the camera.

There are a variety of ways to move your pictures from your camera to other destinations, but the most common is via the USB cable. For very fast transfers, professionals prefer a technology called FireWire (an Apple brand name), also known as IEEE 1394, which is another serial bus interface standard via cable.

Cable

Most people will transfer their pictures using a cable. This chapter details how to transfer via USB cable, since that is the most common and the steps involved are substantially the same for any type of cable.

ALERT!

Hot swapping generally only works with USB and FireWire serial connections. It often does not work with older serial configurations. With older connections of this type, you may have to turn off your computer and your camera, connect the two devices, and then turn both devices on. Read the manual for instructions.

USB Connections

USB was designed by computer manufacturers to enable simple high-speed connections between devices. In particular, USB allows hot swapping, which means that the cable can be plugged into a computer without having to turn the computer off and then back on or without having to reboot the computer.

USB was also designed to allow plug-and-play capability. This means that the computer, when connected via USB, automatically recognizes many external devices with little input from the user. This book covers a number

of other USB devices such as external hard drives, memory card readers, scanners, and printers.

If you are shopping for a new computer, buy one that has many USB ports. With so many devices using this input, more is always better. Connecting gizmos using a USB port is the most convenient way to attach external hardware, and since it allows hot-swapping, you can plug and unplug as needed.

USB Problems

While USB works very well and is generally backward-compatible, meaning that old computers work with new standards, there are some problems. Here are the main ones:

- If you are running Windows 95, you may have trouble with a USB connection. Most cameras will require Windows 98SE or higher for the USB to work properly.
- There are two USB standards—USB 1.*x* and USB 2.0. USB 1.*x*, the older standard, will run much more slowly than USB 2.0 but is still relatively fast.

Basic USB Transfer Steps

Since most people will be transferring their pictures via USB, here are the steps involved. In the world of digital photography, there are more problems with this crucial step than with any other. Don't try to wing it. Later in this chapter you will find a detailed step-by-step description.

- **Read the manual:** This can't be said enough! Install the software exactly as required by the manual before connecting your camera.
- **Connect the camera:** Again, follow the instructions exactly according to the manual. Generally, you will connect a manufacturer-supplied cable to the camera and then plug it into a USB on the computer.

Once you are properly connected, there are usually two ways that the computer can recognize the camera:

- Software supplied by the manufacturer will launch automatically. Typically, you will see thumbnails of your pictures on the camera. At this point you can decide what you want to move or copy.
- The computer will see the camera as another drive. For example, if you have only a C: drive, you will now also have a D: drive, which will list the picture files on the camera. At this point you can move, copy, and manage your files with a file manager such as Windows Explorer or with a picture file management program (see Chapter 14).

ALERT!

No matter which software comes up, you will need to decide where you want your pictures to go on your computer. You can choose an existing folder or create a new one. Read this book's suggestions about keeping track of your photos in Chapter 14.

Other Types of Transfers

While USB is the most common type of transfer, there are many other ways to download from your camera. Older cameras also use a variety of other methods.

FireWire (Apple Brand Name) or IEEE 1394

This method of transfer works very much like the USB, only faster. FireWire transfers data between devices very quickly, fast enough for digital camera images and uncompressed digital video. Some people believe that FireWire will become the data transmission standard of the digital world. FireWire is easy to use and is hot-swappable. It permits many devices—such as digital cameras, digital camcorders, music devices, printers, and scanners—to be connected to one port.

Docking Station

Kodak in particular has developed docking stations as a way to simplify digital photography. You place the camera on a docking station that is connected to the computer via a USB port. Then you press a button or two and pictures are transferred to your computer.

TWAIN

TWAIN compliant cameras and scanners can be accessed directly by some computer graphics and file manager programs. While TWAIN works with older operating systems, Windows XP (1.7 or higher), in particular, has built-in TWAIN support. What this means is that your camera and your graphics program can work together so that you can import your camera's photographs into your graphics program—for example, edit them and then save them in your computer.

Older Types of Transfers

Other (generally older) digital cameras use other ways to transfer images. These methods include wireless infrared transfer (IrDA), removable storage such as a floppy disk or a CD, and transfer via the serial port. All of these methods are quite slow. Some may require the original software that came with the camera to work properly.

FACT

The older 1.*x* USBs (usually 1.1 or higher but less than 2.0) will probably need a different driver than the one that comes with a new device. Download the driver off the Internet before the camera can connect properly to your computer. However, the USB should work properly once installed.

Avoiding Problems

After you have figured out how to transfer images without a hitch, write down all the steps involved. This is especially important if you don't download very often, as you will probably forget something.

Take Download Notes

Since computers are very logical, write down the steps in order. Don't leave anything out. For example, if software is automatically launched after you attach your USB cable from your camera, write down that your software showed on the screen and that it took 30 seconds after attaching the camera. The more detailed your list, the better. A month from now you won't be scratching your head wondering why it worked before and why it doesn't work now.

Error Messages

If you get an error message on your computer or camera, make sure that the cable is inserted correctly into both receptacles and that the camera is on. If these check out, make sure that the USB port on your computer is working properly. In Windows, for example (Settings > Control Panel > System > Device Manager), you can look at a list of devices that are installed in the computer and see whether they are working properly.

It's easy for computer users to accumulate a mass of power cords and cables that include various camera cables plus computer, monitor, mouse, and keyboard connectors. Label your power cords and cables each time you install a new piece of hardware to avoid the frustration of figuring out what each one does.

Downloading Checklist

The following detailed checklist can walk you through this most important process in digital photography. While the steps will vary somewhat, the general procedure should be the same.

Step-by-Step Typical Download from a Camera

The process of transferring image files from your camera to a computer can begin with the downloading of thumbnails for each picture. The

thumbnails take the place of a contact sheet, allowing you to view your images. Using the thumbnails, the photographer decides what files to download and what files to delete.

ALERT!

The first rule of computer file management goes as follows: Never automate a destructive command. You might delete something you didn't mean to delete. With an automated process, you may not even understand that you accidentally deleted a file. Instead, you must take control so that if you mess up you can try to figure out a remedy. For example, never select the option 'Delete Files After Transfer' which will automatically delete your camera files. You should verify that the transfer of images to your computer was successful before deleting any camera files.

Generally, the transfer process happens this way:

- Connect your camera with the AC power cord and, if possible, avoid using batteries or use fresh batteries. You do not want your camera to shut itself down in the middle of a transfer operation.
- Connect the camera's USB transfer cable to the appropriate output plug on the camera; connect the other end to the computer's USB port.
- If the software does not load automatically when you connect the USB, use picture file management software on the computer to open the camera's stored photos.
- Go to the list of photo thumbnails that are in your camera.
- Choose the ones you want to transfer to the computer.
- Do not delete any pictures at this time—this means avoid the Move and Delete commands and use Copy instead.
- Select the directory to which you'd like to transfer the files; make sure that none of the names of the new pictures are the same as old pictures already in the folder.
- Instead of selecting a folder, consider creating a new empty folder— this will prevent any accidental erasures since there will be no way new pictures can overwrite old pictures.

- Select the command 'Transfer Selected Images'.
- The downloading process begins. Go get a cup of coffee. When the transfer is complete, continue to the next step.
- Go to the folder on your computer and check that all the pictures you selected for downloading were copied correctly into the designated folder.
- At this point, decide which photos on the camera you want to delete and then do so.
- Make your own checklist similar to this with your own notes for your particular camera, computer, and software.

Displaying Your Image on a Television

Your digital camera can be connected to a television or VCR. This is a quick and easy way to look at your enlarged images and also to share them with friends and family. If your digicam has a video-out jack, as many digital cameras do, then you can connect to a TV using standard input or video-in terminals. This type of connection allows you to view your images on your TV or record them on videotape using your VCR.

When you display your images on a TV screen, you can see them a lot more easily and clearly than when you view them on a computer monitor. Because of the bigger screen, small imperfections become more readily discernible. If you have a group of people who would like to see your images, whether for business purposes or just for fun, this is one way to do it. By recording your images on video you can create your own slideshow, complete with sound if your camera provides the ability to record audio.

Many digicams sold in the United States output video in NTSC format, the format used by TVs in North America. European televisions use the PAL format, so you won't be able to display digital images from your camera on European TVs unless your camera has PAL capability. Some newer digicams offer the choice of NTSC or PAL formats. If you travel a lot and want to use the video-out feature in countries outside the United States, this feature is something to keep in mind.

To transfer images between your digital camera and a TV, typically you connect one end of an AV cable to the camera's video-out or AV-out jack

and the other to your TV or VCR's video-in jack. If your camera has the ability to record audio, you will use a separate AV plug for the audio signal, inserting it into the audio-in jack.

Burning CDs or DVDs

A common way to send and share picture files is on removable optical media—that is, CDs or DVDs. Saving data to an optical disk is called burning, in the language of computers. If burned properly, CDs can be read by virtually any computer because the format has been standardized.

While DVDs hold considerably more data than CDs, the world of computers has yet to settle on a standard format. Therefore, to share data you should always use CDs unless you are certain that the other computer that reads your data can read your DVDs.

Macintosh versus Windows

While CDs can be read by both Macintosh and Windows computers, you may need to save your CDs in a Mac-compatible format (also known as ISO 9660 or the universal format). Your CD-burning software should offer you this choice in one of its menus. When you save in this format, file names will be limited to eight characters. While the software can often take long Windows names and cut them off at eight characters (called truncating), you will have much more control over the naming of your images if you name them yourself. To simplify your task, make a folder just for saving images in the Mac format if you are a Windows user. In this folder, all your image files will be limited to eight characters plus the extension.

Double Checking

After burning a CD, check that your images were burned properly onto the CD. Put the CD back into your CD drive; even better, put it into the CD drive on another computer and make sure that you can read the CD properly.

Archiving Your Photos

Photographs can be some of your most precious possessions. Family snap-shots and personal memories are often irreplaceable. If you want to make sure that your photos will still be around years from now, there are a number of things that you must do.

Storage

Some storage media lasts much longer than others. However, the following media lifetime numbers are often best-case scenarios. Longevity also depends a lot on how the medium is stored. Optical media (CDs and DVDs) are not magnetic and as a result are less vulnerable to temperature and humidity and also to glitches due to magnets or electrical magnetic fields.

- **CD-R:** The best storage medium by far is a CD-R. Under the right conditions, it might last 100 years, although to be certain, you should probably replace or add a new copy more frequently. Some photographers say you should make a new copy every ten years. A CD-R will hold about 650 megabytes or perhaps 200 to 300 large images.
- **DVD-R:** This is projected to have the same life as a CD-R and it holds much more data, as much as 4.5 gigabytes. However, currently there is not a standard for writable DVD-Rs. If you save a DVD-R in a format that becomes obsolete, you will not be able to read it years from now (remember Beta video tape?).
- **CD-RW and DVD-RW (rewritable optical disks):** These disks have a shorter life span than a CD-R or a DVD-R, but they should last considerably longer than the magnetic media listed next. These will hold about the same as the R versions.
- **Magnetic media:** For long-term storage, magnetic media is projected to only last about 10 years. For example, media such as hard drives and removable disks, such as the Iomega Zip disks, are projected to last only about that long. Also, magnetic media can be damaged by magnets and magnetic fields. Clearly these are not a good choice for long-term storage. External hard drives are available in hundreds of gigabytes.

You May Be Able to Use Magnetic Media

However, all is not lost with magnetic media. If you add an external hard drive (which is recommended for backups), keep duplicate copies of your images on a couple of hard drives, and replace or upgrade your hard drive every five to seven years, you can copy your most important photographs every so often to your newest drive. While this might seem like a lot of work, most people upgrade their computer periodically so that copying old pictures to a new drive is simply part of that process.

Storage Conditions

A major manufacturer of optical media states that CDs and DVDs should be stored under the following conditions and limitations to last a long time:

QUESTION?

Where can you find the perfect place for long-term storage?
While optimal storage conditions might seem daunting, a safety deposit box at a bank should work just fine. If you rent the smallest one, the cost should be minimal and it would hold dozens of CDs.

- **Temperature:** The ideal temperature is about 77° Fahrenheit (25° Celsius).
- **Humidity:** The ideal humidity is about 55 percent.
- **UV light:** The optical media should not be exposed to UV light or sunlight.
- **Handling:** The optical disk should not have any scratches or fingerprints.
- **Storage:** The optical disk should be stored in a jewel case.
- **Recording:** The optical disk should be recorded normally and not at a high speed.
- **Labeling:** Do not write on the CD itself; however, you can write on the outside of the jewel case.

Photo File Management

In the old days of film, you had to sort through hundreds or thousands of prints, negatives, and contact sheets to keep track of your pictures. Many people who still work with film have boxes, envelopes, folders, and so on with little idea of how to find a picture or even a clear idea of what they have. With digital photography, all that has changed. Image-cataloguing software (also called image file management or organizing software) makes cataloguing, archiving, tagging, and even modifying pictures quite simple.

How Files Are Named and Stored

When you take a photograph with your digital camera, it is assigned a file name by the software in the camera. In addition, the picture file is usually tagged with the date and time that it was shot. When you download these pictures to your computer, the assigned names will be saved to a folder on the hard drive of your computer.

Never Touch Your Originals

The photographs that come directly from your camera are originals and should never be touched, unless you decide you want to delete some that you don't like. Any you save you should keep in a separate folder that is clearly labeled as holding originals. In addition, before you have too many photographs, devise a clear system that will allow you to quickly and easily find any image.

Basic Filing

To avoid confusion, construct a logical filing system that allows you to do several things:

- Avoid any danger of accidentally erasing any original files.
- Put the pictures under one main folder that you can easily back up.
- Make it easy to find pictures months or years from now.

FACT

No file can have the same name in the same folder. If you save a new file with the same name, it will overwrite and erase the old file, which will be lost forever. Therefore, give your modified file a different name from the original so that there will be no chance of accidentally erasing the original picture.

To start off, choose a basic folder name such as "Photos." You should then create subfolders under this folder. These subfolders, in turn, will have other subfolders. Keep in mind that it can be confusing to go more than

three levels deep with subfolders in the computer tree structure. However, there is no technical reason to stop you.

Your main folder will now have the address on your computer of: **C:\Photos.**

You might have one main folder for originals (with subfolders as needed) such as **C:\Photos\Originals.**

You might have one main folder for photos that you rename and work on in your digital darkroom or image-editing software, such as: **C:\Photos\Best.**

Under the folders Originals and Best, you might have other subfolders as your photo work grows.

Later, when you back up your photos, you can easily back up all of these images in the main folder **C:\Photos** (including all the subfolders) with one simple command in the appropriate software, described at the end of this chapter.

Image Browsing and Management Utilities

The computer world has not really settled on one name for image browsing and management utilities. These can be called image cataloguing software, photo managers, viewing software, photography file managers, or image organizers. Yet all these terms describe the same kind of software.

To make things more complicated, many image browsing and management utilities have also added a number of image editing tools, so that you can make basic corrections in your photographs. Yet image browsing and management software is primarily dedicated to one specialized task, the job of organizing and working with your photographs.

Why Do You Need a Specialized Image Program?

Like all file management software, a specialized image program will allow you to view a list of files in a folder and copy, move, rename, and delete files. Unlike other management software, it can limit the files listed to only image files and can display much more information about each file, such as the pixel dimensions and comments you have made. You can view the files as small thumbnails and in addition see individual files in large

windows within the program as you simply push a down arrow to the next file in the file list. Or you can view them full frame and flip through them by holding down the spacebar. In short, you can scroll through images very rapidly and view them in any mode you choose. This kind of utility also has built-in safety features to help you avoid overwriting pictures with the same name, while you rapidly sort through your photos and organize them with just a few key strokes.

However, if you do not want a specialized organizing program, but instead want software that will do it all, Adobe Photoshop Elements is the most popular all-purpose photo software on the market. It will allow you to organize, edit, share, and print your photos within one easy-to-use program and is highly recommended.

Additional Management Features

A photo management program has many added features for visual file management. In addition to standard file information, it can list the compression ratio, the uncompressed size, and the color depth. Because these programs are specialized for images, they can read and view just about any kind of image file ever made. In addition, they can often convert one kind of file to another with the Save As command. Many even offer batch conversions. This means you can select a number of files that can then be converted all at one time into another picture file format.

ALERT!

Your editing software should definitely include a lossless JPEG rotation feature. This means that you can turn a horizontal into a vertical with no loss in quality. While just about any software can rotate an image, it takes special software to do this so no image quality is taken away.

Additional Image Features

When you are sorting though hundreds of images, it is easy to make mistakes. With image management software, you can set an option so that the program asks you each time you try to overwrite a file while at the same

time offering a full display of both images along with their creation date and size. This way you can be certain that you want to replace an existing file. It will even allow you the option of saving a new file that has the same name with an automatic new name so that you can keep both the old file and the new file. If you don't want this feature, you can shut it off. These programs can also read meta information, metadata, or EXIF info that is encoded into some JPEG and TIFF files. This allows you to keep information such as the shutter speed and f-stop used to take the photograph.

Customizing

Most good programs allow you to customize the look and feel of the software to fit your style. You can view or hide a full listing of details about each file or thumbnail or icon and sort according to each. If you enter a text description, you can sort by the text you included. The program also makes it very easy to set or remove image file associations for picture file formats. Many image management programs even include a batch renaming feature so you can rename hundreds of selected files at a time in any manner you choose.

You can also launch another program from within an image management program so that the selected photo opens in the new program. Additionally, you can drag and drop pictures into another image editing program. For more about combining two programs in this way, see Chapter 15.

File Management Tasks

The following description is based on the ACDSee software but also describes in general how this type of image software works. Image browsing and management software often shows a folder of photographs just as any normal file manager does.

File Viewing

Normally when you open an image management program you see the file window, a hard drive tree structure window, and a window with an enlargement of the selected image. All of these can be resized or completely

repositioned into a horizontal instead of a vertical format. Now comes the fun part. When you click a file name, the picture displays in a window within the program. Generally you can resize the window to suit your needs. If you want to view the image full size, you just press the Enter key for a full screen view. Pressing Enter again will take you back to the file listing.

Hitting the space bar will display the next image when the image is viewed full-screen. Some programs are so fast that you can hold the space bar down and quickly flip through hundreds of images at full size.

You can also set a number of viewing options, such as viewing a picture so that it always fills the screen no matter what size, or so it is resized only if it is too big. If you want to compare two or more images that are in different parts of the folder, you can select just those images and then flip back and forth between them, ignoring other pictures in the folder. You can even create slideshows that display an image for a specified number of seconds and loop through the selected images in the folder.

Thumbnails

Most image cataloguing software can display all the images in a folder or selected folders in small pictures called thumbnails. These can be quite useful when you want to quickly find an image. Depending on the program, you can either save the thumbnails for faster access next time or have the program generate new thumbnails each time. You can pick the size of the thumbnail, create HTML pages with thumbnails, and print thumbnails. You may find it useful to print out your pages in black and white or color and store them in a folder. Once you have done that, you can write notes about which pictures you want to work on, and also make notes as you are working on pictures, such as the specific settings and changes you made to the image.

Altering Your Photos

While photo editing is not the specific job of a photo file manager, most of these programs now come with a full set of tools for photographic modifications. For example, if you are primarily interested in photography and not

computer graphics, you may find that you have enough tools in one of these programs to meet your editing needs.

You will typically find tools to perform these basic and most often needed modifications:

- Cropping
- Lightening-darkening
- Contrast adjustment
- Grayscale conversion
- Flipping
- Color correction
- Sharpening
- Resizing-resampling

Photo Editing

Just about everyone has been bored to death by a family who came back from a vacation and showed every single picture taken on that trip. However, that same family could have created an exciting and fascinating show by editing their pictures.

Selecting Your Best Photos

Editing is perhaps the most important photographic skill after knowing how to take a picture properly. This is because photography is often a percentage game: for every ten or twenty pictures you take, only one will be superb. That's where editing comes in.

Editing means that you spend hours poring over your pictures to select the strongest images. When you have narrowed down your images to about twenty percent of your original images, the very strongest start to jump out.

If you created a folder such as **C:\Photos\Best**, as suggested earlier in this chapter, you can now make a subfolder of Halloween pictures such as: **C:\Photos\Best\Halloween**. Copy your strongest images from your original Halloween photos into that folder, but don't be too critical; save less impressive but still promising pictures to a separate folder.

Zero In on the Best of the Best

Once you have made an initial selection, go through these selected Halloween images again and pick the best of the best. You might want to save them to a second folder called Best_of_Best or rename them so that you can work on them. As a result, you have really narrowed down your choices to the very strongest images. These best of the best pictures will be worth tweaking and spending a good deal of time on in your digital darkroom or with image-editing software to get them just right.

def·i·ni·tion

Editing: In photography, "editing" has two meanings, which can be confusing. In organizing and exhibiting photographs, editing means selecting the best images for public display and not showing the rest. However, when making changes to a specific photograph, editing means modifying or correcting the photograph with image-editing software.

Renaming Your Image Files

Any picture that you work with should be renamed so that you don't accidentally erase the original. In addition, you may want to assign names that make sense. Use the word "holiday" or "vacation" in the file names, for example. When you do this to dozens of pictures, it can turn into quite a chore unless you know how to do it quickly.

There are a number of ways that you can rename your files, and each method will make it easier to find your photos later. Simple names are easier to understand than coded names, but you can decide which you prefer.

If you have a series of pictures, start by deciding on a general name for that series. A simple name can be Birthday or Vacation, for example. If you want to add a year to identify the vacation, you might make it Vacation09. Then decide on a way to number each picture. Many computer gurus prefer the underscore symbol to separate the name from the number of the picture in the series. So for example, pictures 1 and 2 in a series of fifty pictures about your vacation in 2009 would be Vacation09_01.jpg and Vacation09_02.jpg.

As explained in Appendix C, you should add the extra 0 if your series goes up to 99 and 00 if your series goes up to 999 so that your series will sort correctly.

When you work in your digital darkroom, you will often find that you make several versions for a number of reasons. You might not be sure which version you like best and save both of them, or you might want one picture for one purpose and another picture for another purpose.

When you have several versions of one picture, you can add extra notations to the end of the file name, so that you know what is what. Adding a lower case "a" or "b," for example, is a good way to indicate this. For example, if you cropped Vacation09_01.jpg, you might name a second file Vacation09_01a.jpg to indicate that you did something additional.

Some people prefer coding as a way to indicate what a picture is about. In this case you could adopt a series of code letters that always mean the same thing such as: V=vacation, B=birthday, C=cookout.

ALERT!

An underscore character is very useful when working with file names. The underscore symbol clearly separates sections of the file name so that it can be read correctly. Computer geeks find it is less confusing than a hyphen, which can have other meanings. For example, Filename_01.jpg = picture file number one; Filename_01_mod.jpg = picture file number one modified.

A cropped picture could be indicated with a "crp" after the full name, so that Vacation09_01a.jpg would now be: V09_01crp.jpg. If you use a coding system, be consistent and keep notes so that when you have not worked with your pictures in months, you can remember your own code.

Renaming a Series of Photos

There will be many times when it would be nice to name a group of pictures in a series. Fortunately, you do not have to rename each one, but can name them with a batch process. A number of image file management programs offer this feature, and there is also a wonderful free utility called

Renameit (see Chapter 17) that will rename files in just about any manner you choose. For example, after you made a selection of pictures from your originals, you might want to rename them Cookout_01.jpg, Cookout_02.jpg, etc. With a renaming utility, you can choose a name that you want to use with a set of image files (but don't alter the extension). Then typically the addition of variable symbols will allow you to add a number sequence to the tail end of your new file name.

Let's say you have files that were automatically named by your camera as Abcd1234.jpg and Abcd1235.jpg. To rename them, you would first select the files you want to rename. Then choose Rename and type in the file name you want to call all photos in the batch and add two variable symbols for the sequential numbers (such as ##, symbols that are often used). Many programs also allow you to choose the number for the start of your numbering sequence, such as 01 if you want to start with number one.

Now your dialog box for renumbering your dozens of files looks like this: Cookout_##. All files that you have selected—Abcd1234.jpg, Abcd1235.jpg, and so on—will be renamed Cookout_01.jpg, Cookout_02.jpg, etc.

As with all computer tasks, go back and check that your renaming was successful and also that the pictures are now in the correct order.

Changing the Sort Order

It is important to note that your files will be named in the sequence that they are sorted in your folder. If you want to sort them in a different sequence, you will need to add an extra step. If you put Web sites together or make slideshows or PowerPoint presentations, it is often much easier to have files sorted in sequential order. When your photos are sorted in a series, you simply go to number one first, number two second, and so on, and can stop worrying about what each file is.

If you want files to be in a certain sequence, you can manually go into your file management program and add temporary numbers, so that the files display in the order that you choose. For example, you can go in and manually change the order of any group of files (even ones with different names) by simply adding an 01 or 02 to the beginning of each file name.

For example, if you decide you want to view Abcd_1.jpg after Abcd_9.jpg, add a temporary number sequence, such as 01 and 02, to the begin-

ning of the file name, such as 01Abcd_9.jpg, 02Abcd_1.jpg. These will now sort in the order you have chosen. Once you have your sequence the way you want, rename the series again and the pictures will then display in the order that you chose.

Keeping Track and Organizing

There are many ways to keep track of your filing system, your original pictures, your editing settings, and your edited selections. Use the free program Treepad, which uses a simple text-file structure, to make notes. If you develop a cataloguing system that is at all complicated, notate what you have done or you may forget six months from now.

Text is the universal word format that can be read by virtually any word processor or other text program. For a variety of reasons, save your notes in the text file format (.txt) so that you can read them years later or so your great-great-grandchildren can read them 100 years from now.

Backing Up Your Image Files

If you work with digital photographs, you should make duplicate copies on a second drive or on other storage media (a process that is also called backing up). While this seems like a difficult task, it can be quite simple. Backing up involves keeping your pictures in clearly named folders, copying them to clearly named backup folders, and using software that simplifies your task.

Hardware

There are quite a few ways to back up your images. Bottom line: you should have at least one duplicate copy of important picture files on a separate hard drive or other medium. It is important to put your backup copy on a separate device because your primary device can fail. If it does fail, you will not be able to access your data. A separate device also allows you to

move that device to another place if necessary. This adds another measure of safety.

Types of Hardware Storage

The basic means of storage are:

- Optical disks: CDs and DVDs. CDs come in two types, R and RW. The R type can be written to but data cannot be erased from it. The RW is rewritable and data can be erased from it. CDs typically hold about 650 megabytes of data and DVDs up to 4.7 gigabytes.
- Magnetic media: Hard drives and removable disks. You can either install a second hard drive into your computer, which will typically become drive D:, or attach an external hard drive through the USB port. Removable disks are available in 750MB size. External hard drives are available in hundreds of gigabytes, as are internal hard drives.
- Thumb drive or memory card: For temporary backup, these cannot be beat. However, they cost much more than other media per gigabyte and they have a limited capacity.

The best storage for quick and easy backups is an external hard drive. This is true for two reasons: it can be quite large and it can be quite fast. Once you have set up the backup software, it takes only a couple of minutes each night to back up your latest data. With large external USB hard drives costing about $100, it is also cost effective.

Removable media such as DVDs and magnetic disks take longer and fill up quickly. You then must organize and catalog the disks, which adds another chore to your photo storage.

FACT

The capacity of hard drives and thumb drives will go up considerably in the future, and the cost will come down. When the market decides on a standard for writable DVDs, these will become more common and will probably become the permanent backup storage of choice. Stay tuned.

Software

While backing up pictures might seem a difficult chore, it is really quite simple with the right software. There are a number of ways to back up, but the simplest and easiest is to back up your data every day in a form that can be read by any computer.

If you use an external USB hard drive, for example, you will back up your data every session. In the event that your principal hard drive fails, you can simply plug your external USB drive into another computer, which will then have access to all your pictures. As with most software, you might need to spend an hour or so at the beginning learning how to set it up. But after that, all you need to do is press a button or two and your principal hard drive will be backed up in a couple of minutes.

Once you have organized your folders into a simple system, you should make an exact copy of your source (primary) folders. A manual backup is often easier than an automatic one and gives you more control. Simply do it at the end of each session.

How Dedicated Backup Software Works

Here is how typical backup software does its job:

- You select folders on your principal drive that need to be copied on a regular basis. They can be entire folders or subfolders or sub-sub-folders, and you can select a number of different folders at a time. Your principal drive is often called the source drive by the backup software.
- You create a folder on the external drive or removable medium or internal hard drive. This is often called the target drive or the desti-nation drive by the backup software.
- Once you have made a few more choices, you can then simply press a couple of keys and the backup software will quickly scan your source folders and your target folders and make a backup. This

can be done rapidly because the software is looking for only those files that have been changed since the last backup. This ability to quickly locate the recently altered files speeds the backup process considerably.

The software will offer you other choices as well, such as whether you want an exact copy of each folder each time. This means that newly changed files with the same name in the same folder will overwrite old files with the same name in the same folder. You can also decide to keep all your old copies in addition to the new files. Furthermore, you will want to choose whether you want an automatic backup or a manual backup.

The Digital Darkroom

In your digital darkroom, just as in a traditional film darkroom, you can make changes to your photograph that can improve it considerably. Photographers have been adjusting their prints for almost 200 years using a number of time-honored techniques. However, these types of controls are different from computer graphics. This chapter deals with standard photographic corrections; Chapter 16 moves on to the computer manipulation of your photographs.

Darkroom Controls Versus Computer Manipulation

Because computer graphics developed much faster than digital photography and because digital photography uses the same file format as computer graphics, darkroom tools, from the beginning of digital photography, came bundled with image processing tools. While there is nothing wrong with the computer manipulation of a photograph, it goes beyond the craft of photography itself and adds another layer of graphic processing to the photographic image. Yet there are a number of standard tools that photographers have used in the darkroom since the beginning. These controls are quite different from the computer manipulation of an image.

The Difference Between Photographic and Image Tools

Unless you have worked with photographs for years, you might not realize that there is a difference between photographic and image tools. Some of the tools in your photo image editing program are based in photography and others are based in computer imaging.

While it's not a perfect explanation, photographic tools essentially enhance or subdue detail that is already in the photograph. Computer graphic controls tend to add elements that are not in the original image, greatly exaggerate photographic details, or add special effects.

To get the most from your photographs, it is usually best to apply photographic tools and controls first. Regular photographic tools generally involve making adjustments for framing, exposure, and color balance. Then, if necessary, you can make further changes with computer graphics tools.

For example, cutting out a background from around a person and replacing it with a completely different background is quite possible and done often with digital photography. Yet it goes beyond photography and becomes a kind of digital collage. This can be an important consideration. Newspapers, for example, have to be careful not to state that a picture is real when significant elements of that photograph have been altered with image processing tools.

A Straight Photograph

You have probably seen a dazzling photograph where the light was just right and the print had a complete range of tones from dark to light. It gave you the feeling that you were looking at a real scene that had been captured by the camera. This is the lure of photography.

The best photographs often have a complete range of tones. The lightest and darkest tones do not have to dominate the picture, they may only be in small parts of highlights or shadows, but they give the photograph depth. Understanding tonal range is basic to the craft of photography.

In addition, photography has the power to tap into our emotions, in part because we believe the scene to be real. Beyond a well-crafted image, we are often moved by a photo because the quality of the daylight in the image has a special power or because the photographer has snared an elusive moment in the real world. This sense of reality is central to the art of photography.

Photography and Computer Graphics

We see manipulated photographs every day in magazines and on billboards. Computer graphics produce images that are stunning, but they are often highly manipulated and more like the shape and molding of animated movie characters than photography.

FACT

The skin on many models in glossy advertisements and in fashion magazines has been carefully retouched with digital imaging software; that is why they appear to have perfect skin. Subtle flaws such as moles may have been removed. Shadows may have been painted and backgrounds added. The addition of sparkling highlights often completes the computer imaging remake.

While computer graphics can add to the image, they tend to take away the sense of reality so important to photography. While this is not important in some work, it is very important in others. The art of computer graphics is quite different from photography. Understanding this allows the photographer to make both photographic and computer graphic adjustments.

Basic Digital Darkroom Tools

To get the most from your photos, start with the basic photographic tools. These tried and true adjustments to the photographic image will improve your photos considerably and highlight areas of photography that you might want to learn more about.

You can find these tools and controls in the very popular Adobe family of photography products. The company offers a software package for just about every level of interest and experience, from the Photoshop Album Starter Edition for beginners to Photoshop Elements for casual photographers, all the way up to Photoshop Lightroom, Photoshop CS3, and Adobe Bridge for professional and commercial applications.

ALERT!

In technical terms, the brightness control is linear and the gamma control is nonlinear. The brightness control lightens or darkens everything in the image at the same time. The gamma control brightens or darkens parts of the image at different rates. Keep your eye on changes to the shadows and the highlights to get a feel for these controls.

Brightness Control

If your exposure was not perfect, you may need to brighten or darken your image. This is generally the first step in correcting a photographic image. When you use the brightness control, it brightens the entire image step by step all at one time. A good rule of thumb is to brighten the picture until there is detail in the shadows but there is no loss of detail in the highlights.

For example, you may find that there is considerable detail in the shadows that lightening will reveal. However, once an area is overexposed, most detail is lost and darkening may not help. Do the best you can with the brightness control (or the gamma correction) until you have an image with a full range of tones.

▲ This image was brightened to bring out more of the person walking.

▲ The gamma control lightened the person walking without lightening the background as much as the brightness control.

▲ In this digital darkroom adjustment, contrast was increased.

Gamma Correction

The gamma correction is quite similar to the brightness control but generally works better with digital images. When you increase the gamma number, the shadows are lightened faster than the highlights are lightened. This allows you to bring up the shadows while still keeping detail in the highlights. You should move the gamma number up or down (usually it is on a sliding scale) until the highlights start to become a bit pale or begin to seem a bit washed out. At this point you should back off a bit until the highlights are crisp and clear.

Gamma correction works especially well with flash images. It brings up detail in the shadows and makes skin look more natural, yet it does not wash out the highlights. If you want to get the best quality photographs, spend time looking at the subtle differences between gamma and brightness changes. You will often find that an image changes noticeably at a certain point, a tipping point, where the image starts to lose detail. When you find that point, back off a bit and the correction will be about right.

Contrast Control

The ideal photograph has a full range of tones from white to black. It does not matter whether the photo is color or is monochrome. These areas of black and white are often subtle. Use the sliding contrast controls to find the precise spot where the picture has full contrast. Ideally you want a pure black in tiny areas of the shadows and a pure white in the highlights.

You will rarely use the brightness control or gamma correction by itself. After adjusting the image to bring out the fullest range of tones, tweak your image further using the contrast control. Aim for a photograph that catches your attention even when you are several feet away from your monitor.

Dodging and Burning

These two photographic terms refer to darkening (burning) or lightening (dodging) sections of a photograph. In the film darkroom days, burning was often done with a hole cut into a piece of cardboard. A special wand-like tool with a circle of cardboard on the end was used for dodging. Accomplished photographers liked to use their hands. Now you can select tools to carefully and subtly lighten or darken your digital image.

◀ This "bad" job of dodging to the person's face was done to make clear how selective areas can be lightened or darkened.

Cropping, Rotating, and Sharpening

Moving and reshaping your image is part of the standard darkroom tool-box. Slight changes in framing, for example, can make a photograph much stronger. If you shoot at the highest resolution with a digital camera, you will have plenty of room to crop.

Cropping

If only part of your photograph works or if some parts are distracting, then cropping or cutting out a section of the image might improve it consid-erably. In a sense you are cutting out a frame within the frame that you have already created. If you shot the picture originally with a high resolution, then cropping should not affect its quality, even though you will be reducing the size (and pixel count) of the image.

▲ In this computer edited photo, the image was cropped to remove the foreground.

Rotating and Verticals

You can rotate your picture 90 degrees to see how it might look in a ver-tical format. You can also combine this with some cropping to make the

vertical orientation fit with your new format. Many pictures look better as verticals. Some subjects lend themselves to vertical orientation; others look better when taken in the horizontal format. In general, people and buildings tend to look better vertically. Landscapes and groups of people work well within the horizontal format. When buying a photo file manager and browser, get one that will perform a lossless vertical rotation. There is no reason that you should lose detail because you merely have to rotate an image to its true orientation.

FACT

Because landscapes are often shot in horizontal format, such orientation is sometimes referred to as "landscape." And because portraits are often shot in vertical format, such orientation is sometimes referred to as "portrait." When you shoot a bunch of pictures in the portrait orientation, go through your photos quickly after downloading and turn them so they display properly.

Flipping (or Flopping)

If you want to have a person look to the left instead of to the right, simply flip the image. With film photography it was often called flopping, as the negative was flopped to reverse the image. Flipping only works if there is no writing in the picture, since the writing will be reversed.

Sharpening

The sharpening tool allows you to make your image a bit crisper, but it can also add a grainy look to your image. Use the sharpening tool when needed, but don't overuse it.

Color Tools

You can make slight or massive changes in the color of your photos. A picture with cool colors and a bluish cast can be turned into a warmer photo

with a slight reddish tone, for example. Making subtle but important color corrections can take a while to master.

Hue Color Control

This setting changes the overall color of the entire picture. If the overall color is off or the color of the light gives the photograph an orange or bluish tone, use the hue adjustment to change this. It is especially useful for making white balance corrections. You can adjust the hue in very small increments, so getting to the right color can be quite a precise operation.

Saturation Color Control

Saturation refers to the intensity of the color. Bright bold colors, for example, are highly saturated. While highly saturated images can be eye-grabbing, they are rarely natural. Make this adjustment carefully and don't get carried away.

Lightness Control

The lightness control adds white to the color when it lightens the pictures and adds black to the color when it darkens the picture.

RGB and CMYK Color Controls

Many programs allow you to adjust the colors separately. They are usually adjusted on a sliding scale. The **RGB** has three controls: **R**ed, **G**reen, and **B**lue. The **CMYK** control has four: **C**yan, **M**agenta, **Y**ellow, and blac**K**. This control is difficult to learn because it takes a lot of experience to understand the settings or mix of CMYK that produce a certain color or color cast.

Photo-Editing Tips

In the beginning, getting a sharp full-toned image may be quite a challenge. It takes a while for a photographer to develop an eye. Yet if you give yourself time, you will begin to understand what images in the real world look good and will translate properly into a photograph.

Troubleshooting

If you are unable to achieve a crisp image that has a full range of tones from light to dark with darkroom controls, you are probably not exposing your photos correctly to begin with. Take a number of pictures using exposure compensation (see Chapter 9) so that you can experiment with finding the right exposure. Digital photography does not have the tonal range of film, especially color print film. This means that digital photography is less forgiving and highlights can easily be overexposed. Getting a proper exposure is actually more difficult with digital than with print film.

def·i·ni·tion

Tonal range: The range, measured in stops, between light and dark that can be captured on light-sensitive material. Color print film has a range of about eight stops, color slide film and digital photos have about six stops. Once you have a properly exposed digital photograph, however, the range can be expanded with digital darkroom software.

How to Make Darkroom Changes

Use these tips to help with your image editing:

- Many digital darkroom programs have an autocorrection setting. Usually this quickly calculates the color balance, contrast, and brightness all together. If you use this setting and get bad results, it's because the program can only guess at what your image should look like.
- Even though a program may allow you to process an image with several settings together, it's best to process a photo with one setting at a time. This accomplishes several things: You can see the effect that one control has on the image without confusing it with another control. You can toggle back and forth with the undo/redo button to judge the effect of your changes. And you can undo the change by itself if you don't like the results.
- Some programs, even very expensive ones, will only display a thumbnail of your image as you make changes. Until you are more

practiced, choose a program that gives you a full view. In the beginning it is easier to work with a program that allows you to see the photograph full size as you make changes. The free and excellent program IrfanView will allow you to do this, for example.

Creating Your Digital Darkroom

If you have ever been in a photographer's darkroom, you know how personal it is. It is like a person's kitchen or workshop. You can do the same with the digital darkroom. While there are quite sophisticated ready-made programs that will do virtually anything you want, you can also buy, integrate, and customize your own set of tools.

Combining Programs

Your photographs will have a more individual look if you put together your own unique combination of software. For example, a photo file management program may allow you to launch a different program to edit the picture with. So after viewing the file and making some basic corrections, you can launch a program from within the photo file management program that will bring up the photo you are working on along with the new program.

Adding Plug-ins

Plug-ins are small, often customized tools that attach to your main program and work just like another tool in that program. Many photo and graphics programs will accept the Photoshop standard for plug-ins and there are many free and paid plug-ins available. See Chapter 17 for a free plug-in source.

Drag and Drop

In Windows you can often drag and drop an image into another program. For example, with many photo file management programs, you can select a picture and then drop it into the work area of another graphics program.

Applets and Utilities

If you decide that you want to customize your digital darkroom, look for very small programs called applets and utilities. Generally, each one of these will do one basic thing, such as remove noise from nighttime or underexposed images. Yet this one tool could be an important addition to your toolbox if you do a lot of nighttime photography, for example. To find out more about such programs, see Chapter 17.

When you work with two separate programs, close the picture file in the first program before working on it in the second program. If you don't do this, you may get error messages or find that one of the programs erased changes you meant to keep.

Improve Your Digital Images While Shooting

There is no substitute for good photography. It is very rare that a poor photograph can turn into a good one with computer software tools. Besides, would you rather spend hours taking pictures or hours in front of the computer making corrections?

Get It Right from the Beginning

Since it is now so easy to adjust photographs with software, many people assume that they can always correct an image later. This is not true. You will have fewer problems in the digital darkroom if you can shoot well-crafted images from the outset.

The Most Common Technical Photo Errors

Usually there are just a few things that cause a photo to not turn out:

- **Blur:** This is usually caused by a shutter speed that was too slow. Blur is very hard—if not impossible—to correct in the digital dark-

room. *Solution:* Use a higher shutter speed and/or the stabilization control if your camera has one.

- **Under- or overexposure:** Overexposure cannot be corrected in the darkroom and underexposure often leaves an image looking muddy without much contrast or snap to it. Overexposure, especially with digital photography, will leave no detail in the highlights. *Solution:* Bracket—that is, take a series of pictures ranging from underexposed to overexposed. Later in the digital darkroom you can choose the best one to work with. Some digital cameras have an automatic bracket setting that will take these pictures together in a series.
- **Bad color balance:** This happens when the automatic setting did not see the light properly. *Solution:* Use the custom white balance setting.
- **Pictures are too dark when you take them:** *Solution:* Use the exposure compensation to lighten your images during the shoot.

Repetitive Tasks and Batch Processing

As with much computer work, you may find that with digital photography you do a series of steps over and over. If you can isolate which steps are common to a task, you can speed up your time in the digital darkroom.

ALERT!

When working with hundreds of pictures, your hand often goes through the same mouse motions. This can cause repetitive motion (carpal tunnel) problems. To avoid this, take your hand off the mouse often. Also periodically put your hand inside a rubber band and push your fingers out against the tension of the band. This exercise can help prevent problems.

Working Step by Step

When you must make the same corrections, write down each step in order. Since you are working with digital media, each setting should have a specific number that you can input or assign to each change. For example,

the sharpness setting might have a number range from 0 to 100 that you can set. If you are using a mouse, you may find that you can do the same series of steps with keyboard strokes instead and this can make the process go much faster. It may also help with repetitive motion wrist problems. Write down the series of keystrokes in your notebook. This can be useful later for developing macros or redoing the same corrections.

Macros

When you find yourself doing the same series of things over and over, find a way to automate those actions. Some programs allow you to create or record macros. Typically, a macro stores a sequence of actions that is activated by a macro key that you assign, such as Control+F12. In top-of-the-line programs such as Photoshop, you can create "actions," which are essentially macros. Instead of selecting a menu, then a tool, then a setting, and then applying that setting, you can press one macro key to do all of those actions together. If you have several changes, you can do those as well.

If your program does not support macros, you can buy separate macro programs that can work with your program. Some macro programs work better than others, so try several shareware programs that let you try before you buy to find which work best with your existing software. Sophisticated macros will even pause and allow you to input or change data before continuing with their sequence of actions. This means that if you have to do the same basic action to each photo but would like to tweak each one a bit differently, you can do this and still use macros.

If you have taken a series of pictures in the same situation and under the same light, most of them will require the same digital darkroom settings. Therefore, spend time to get the first one exactly right. After you have completed the first one, you can apply the same settings to the rest of the series in rapid succession.

There are a variety of ways to create or record macros. Some can record mouse actions or key combinations that bring up menus and submenus.

Some will let you edit the macros after you have created them to fine-tune them. You can assign a name to each macro and just click on that name.

Black and White from Color

While digital photography and the Internet are in color, much of desktop publishing is still being done in black and white. Local newsletters, newspapers, posters, mailings, and magazines often require black and white for their purposes.

If you need images for this reason, black and white may be trickier than you think. Newsletters are often printed with muddy or very dark black and white photographs. To select the right pictures for monochrome printing and then to make the proper conversions from color takes a little practice.

Some image cataloguing programs will let you view your images in black and white. With this feature you can quickly scroll through your pictures to see which ones will work best. The freeware program IrfanView, for example, will do this. Look for a picture that is also the right size for your needs. Enlarged pictures do not reproduce well.

How to Convert from Color to Black and White

To convert a color photograph to black and white, follow these steps:

- Once you have chosen a photograph, convert it to monochrome with the grayscale option that is usually in the color menu.
- Save it with 'bw' added to the end of the file name.
- Use the brightness control to adjust the highlights and shadows or the gamma correction to bring out the most complete range of tones from black to white.
- Use the contrast control to give the picture some snap. Most black and white pictures do not print well because they do not have enough contrast.

- Dodge and burn as needed to lighten some dark areas or darken some light areas.
- To see if you are on the right track, print out your black and white photo on your black and white printer. How does it look? If it looks okay on paper, then it will probably reproduce okay.
- If the photo does not print well on your printer, go back and try again. You might try starting from scratch—that is, go back to the original color photo and redo the conversion.

Improving Your Black and White Conversion

Even though converting color to black and white is easy, beginning photographers are often surprised by the results. A beautiful picture of greens and reds when converted might look very drab with the same shade of gray throughout.

Black and white deals with lightness and darkness only, it does not deal with color. In the example above, red and green are often the same brightness and therefore will translate to the same shade of gray when converted to black and white. In addition, many black and white images do not print well. Even when a black and white image looks good on the computer monitor, it might print with much less contrast.

CHAPTER 16

Computer Graphics and Photography

When you want to manipulate your digital photos and have the ability to add graphic elements, you will need to apply image editing. For maximum control, you will need just the right set of tools and you will need to understand how they are used. Familiarize yourself with the graphic artist's toolbox so that you know what to look for. Image editing tools are different from digital darkroom tools, which were discussed in Chapter 15.

General Tool Considerations

Before getting to the specific capabilities of each tool, there are some general considerations you should know about. Tools, even when they have the same name, can be quite different in different software programs.

Precise Selecting Tools

Some programs come with simple rectangular and elliptical lasso tools that are used to select rectangular and elliptical areas of an image for editing. If you are interested in doing more sophisticated image editing, you'll need more complex selecting tools. Look for a custom lasso tool so that you can select any area, regardless of its shape.

Layers

When combining images to form photo collages, you will have much more control of the program if each object is assigned to its own layer. Independent objects can be repositioned or deleted without adversely affecting the rest of the image. For example, if you want to utilize a background of brightly colored autumnal trees and place a person in the foreground, layering will allow you to do this. Adjustment layers let you apply color and make other corrections to an image without changing the original content.

Buy a program that allows multiple dos and undos. You may be able to set the number yourself under Options. This setting allows you to go through the image-changing process step by step, backward and forward, no matter how many changes you have made. It is useful both as a learning tool and for saving time and effort.

Soft Edge

A soft edge makes the transition between a selection and another area less noticeable. When you paste an element into another image, the lines of demarcation become less apparent and one seamlessly blends into another.

Rubber Stamp or Clone Tool

The ability to copy objects is absolutely essential when editing an image. This tool will be described in more detail later in this chapter.

Specific Image Editing Tools

You will find that your software program offers quite a wide array of image manipulation tools. Take some time to learn about the uses of each tool. Here is an overview of graphic tools that typically are found in image editors. Different programs have different tools, although there is quite a bit of overlap among programs. Tools with similar functions often have different names.

Many tools have a number of additional settings you can make from a submenu. For example, with the paintbrush you may be able to choose the size, shape, and style of brush as well as the transparency of the color you are applying.

Touch-Up and Retouching Tools

Use these tools to clean up your photo a bit.

- **Smudge:** Lets you blur or sharpen certain areas of an image
- **Sponge:** Adjusts color saturation
- **Highlight/midtone/shadow:** Allows brightening/darkening of different areas
- **Gradient:** Creates a smooth transition from one color to another
- **Rubber stamp/cloning tool:** Allows you to copy, or clone, parts of an image
- **Eraser:** Eliminates any unwanted area

Selection and Movement Tools

Select areas for processing or move areas around.

- **Lasso:** Selects an area of the image
- **Magic wand:** Allows you to select pixels based on similar colors

- **Marquee/crop:** Allows you to select rectangular and elliptical areas for cropping
- **Move:** Allows you to move selected areas and layers
- **Hand:** Moves the image around the screen

Paint, Draw, and Text Tools

Paint with wild brush strokes or tiny points.

- **Airbrush:** Sprays color ("paint") onto the image
- **Paint bucket:** Lets you fill specific areas of an image with a particular color
- **Paintbrush:** Allows you to color your image; has a softer edge than the pencil tool
- **Pencil:** Allows you to hand draw or color; has a harder edge than the paintbrush tool
- **Type:** Lets you add text to the image

Control Tools

Use these tools to help you as you work.

- **History brush:** Allows you to undo certain areas
- **Zoom:** Magnifies the image for easier retouching
- **Measure:** A ruler that measures the image
- **Eyedropper:** Allows you to sample and duplicate a color from an image

Most digital controls can be set precisely at a specific number. When you find a critical point where, for example, color or contrast changes markedly, move the controls number by number to see what changes the tools makes. Use a note-taking program such as the free Treepad program to keep track of your settings. You will save hours of time later when you refer to your notes.

Getting Started

Begin by choosing the quick fix or instant fix option. With repeated use, you'll learn whether or not this option tends to make images look better or worse. (The quick fix won't always improve your digital images.) Hopefully, your quick fix option will correct the most obvious problems for you, saving you editing time and effort. Then you can use your time to make more precise changes in contrast, color, and the like, as needed.

Remember the Cloning Tool

Users often overlook the cloning tool, yet it can prove to be one of the most powerful tools. Rid your image of unwanted elements by simply painting over them using the cloning tool. It is also helpful for matching colors.

Try a Soft Touch

Your image editor's softening tools can help you blend separate images together. Sharpening images can sometimes result in an artificial look. For a more natural image, the softening tools can be very helpful.

Horizontal to Vertical

If you find you've taken a photo of a building in the horizontal format and you'd like to change it to vertical, you can select the area you want to work with and then crop away the rest. Using this approach, it becomes easy to salvage an image by changing its format.

Correcting Color

In image editing, the color tool can be used to exaggerate color or to make a scene look very different than it did originally.

FACT

While you can make slight subtle changes to the color, you can also make dramatic and graphic changes. For example, you can substitute one color for another and add degrees of black or white to the entire color design. You can also make the colors strong and vibrant by adjusting saturation.

More Basic Corrections

Once you have your image looking good, consider making more refinements. These additional basic corrections can improve the impact of your image.

Improving Sharpness

Because of the technology used to capture them, digital images have a tendency to appear fuzzy. Usually the problem is easily corrected by using the automatic sharpening mode. However, sometimes a picture will need extra help.

To add crispness, begin by applying the unsharp masking technique to enhance contrast. Then use the sharpening tool to bring the image into focus. Just be careful not to get carried away with sharpening or your image could end up looking unnatural. As with other image-editing tools, a light hand usually provides the best results.

Getting Rid of Red Eye

Red eyes typically happen in low-light situations. The pupils dilate to let in light, and when the flash fires, it reflects off the blood vessels at the back of the eye. The result: the subject's eyes appear bright red. Some software programs feature an easy-to-use red-eye reduction mode. If your program doesn't offer an automatic red-eye reduction option, you can enlarge the image and paint over the red with the desired eye color.

Refining the Background

Our eyes automatically screen out a lot of the clutter that surrounds us in our everyday lives. That's why when we're busy taking pictures in the field we don't always realize what the background will look like in the finished photo. By using software to change the background of a picture, we can transform it from tiresome to spectacular.

This is another process that requires scrupulous attention to detail as you cut out your image, clean it up, save it, and add it to the background of your choice. You may want to start collecting interesting backgrounds espe-

cially for use as the need arises. Some software programs provide a variety of backgrounds to help you get your image bank started.

Another way to approach changing a background is to isolate the main element in your picture, keeping it sharp while you blur the background. If the result is advantageous, you can even move your subject's position in the frame, perhaps putting more emphasis on the foreground.

Cameralike Results

Image-editing software is not a replacement for a good photographer. However, it can provide some effects that in the past were attained only when a photographer employed certain techniques.

▲ Some edge software controls can turn a photo into an interesting line drawing.

Sophisticated Camera Effects

These effects were once hard to achieve in the traditional darkroom, but with digital photography they are easy.

- **Duotones:** Duotones are created in a traditional darkroom by tinting a black-and-white photograph. The gray area in the photo turns a particular tint, such as sepia, while black stays black and white remains white.

- **Inverting:** The Invert command lets you instantly turn a positive image into a negative image or vice versa.

- **Lithographic effects:** Lithographic film produces extremely high-contrast photographs, reducing monochromatic images to pure black and white. Now, instead of creating these results in the darkroom, you can use an image editor to readily produce dramatic images of high contrast.

- **Masking:** The masking tool preserves areas of an image in the same way a drop cloth protects your furniture while you're painting a room. Masking permits you to apply an effect to one specific part of an image or to vary the strength of an effect within an image.

- **Posterization:** In a traditional darkroom, a posterized image was created by replacing shading and gradations of tone with marked changes in color. It was accomplished through an elaborate process using multiple negatives printed at varied exposures and contrasts. In today's digital darkroom, the same color changes occur, only now the process is effortless and the degree of color change can be carefully controlled by the photographer.

- **Reticulation:** When processing 35 mm film incorrectly, an effect called reticulation sometimes occurs. Reticulation results in a photo that appears very grainy. Using an image editor, you can deliberately achieve a similar effect with your digital images.

- **Retouching:** With an image editor, you can retouch any digital image using a variety of tools and techniques. Retouching allows you to remove dust, scratches, and blemishes, and it is a common feature of image-editing software programs.

- **Solarization:** In the traditional darkroom, solarization is the term used to describe the reversed tones of a photographic image that result from prolonged exposure to an extremely bright light. What once took hours of experimentation in the darkroom to produce can now be created in an image-editing software program.

- **Edge detection:** Program tries to detect and outline edges.

- **Hand coloring:** Before the introduction of color film, hand coloring was a popular way to add color to a black-and-white print. Today, modern image-editing software allows you to "hand color" your photo using painting tools.

def·i·ni·tion

Solarization: The term used to describe the reversed tones of a photographic image. Sabbatier discovered in the nineteenth century that some tones would reverse on previously exposed photosensitive materials that were exposed again to a bright light for a brief period.

▲ Solarization can give photographic imagery a graphic effect.

Blur/Focus

A photographer manipulates the shutter speed and aperture while shooting in order to create a desired effect in a photograph. Sometimes he will deliberately produce a blurry image to suggest a particular mood. Other times, he will choose to have a photo sharply focused. You can get similar results using your image editor. For instance, you can decide to blur the whole image or just a specific area of it.

Software programs offer different types of blur, including random, which creates a general fuzziness, and motion, which is similar to the effect achieved when panning a camera. You can also specify the degree to which you want the image blurred.

Correcting Converging Verticals

The problem of converging verticals frequently happens when the photographer uses a wide-angle lens and looks up to shoot a building. In the resulting photo, it looks as if the building is tipping backward. With a film camera, there is no easy fix for this problem. But digital image editors can do the job in short order. To fix the problem of converging verticals, the top of the original image is stretched until all vertical lines appear upright, then the image is cropped to fit inside a rectangle. There are other minor adjustments that might need to be made, but they can be accomplished quite quickly. By correcting converging verticals, you'll be left with a more realistic image of a building—one that is firmly planted on the ground.

Combining Images

Haven't you ever wished you could take the best parts of two (or more) pictures and merge them? Now you can. Simply use your editing program to copy the element you want to use as a substitute and save it at the same resolution as the base image you're using. Shape it to fit, place it into position, then blend it so that it appears as if it had always been there.

Combining images works well with pictures of people. For instance, let's say you want to capture a picture of your friend, Maria, talking with her son, Joseph. You've got one shot where Maria looks great, but Joseph has his eyes closed. In the second photo Joseph has a sunny smile, but Maria is looking away from the camera. Simply take the smiling Joseph and add it to the shot where Maria is facing the camera, and you've got a winning photo.

Artistic Effects and Filters

There are many artistic effects that you can achieve using your image editor. Image-editing software programs commonly allow the user to choose

"painting" tools, such as a pointed or flat brush tip, an airbrush, or spray paint.

Go to extremes: If you want to see what a tool will do, play with it. Take it past the point that you would normally use it to see the effect it has. Spending some time with each tool will make you a much better photographer or graphic artist.

You also may be given your choice of media, from pencil and ink to crayons, chalk, and pastels. But some of the most interesting effects are achieved through the use of special filters. You can try your hand with different filters and achieve masterly results without having to take expensive and time-consuming art classes.

Filters

In film photography, a filter is attached over the camera's lens in order to alter the light before it reaches the film. In digital photography, the term *filter* refers to an effect achieved by an image editor on a digital image. Digital filters change the effects on your images but in a different manner from traditional photographic filters. Filters may come with your software program or as plug-ins. There are two types of filters: those that improve the quality of images, and those that allow you to be creative and add special effects.

Types of Filters

There are quite a few filters that can yield unusual effects.

- **Contouring filter:** Contour drawing refers to drawing just the outline (contour) of a subject. When you apply contouring to your images, the results will vary widely depending on the photos you're using.
- **Oil painting/palette knife filter:** The palette knife filter gives your photo the look of an oil painting. You can significantly change the effect by selecting a different "brushstroke size."

- **Mosaic/tile filter:** The mosaic filter enlarges the size of the pixels in your digital image so that they resemble tiles in a mosaic, creating an image that is somewhat abstract but still discernible. The user can adjust the size of the pixels to vary the effect.

- **Pointillist filter:** If you have always admired the work of the famous French artist, Georges Seurat, who rendered pictures by painting a series of small dots of paint, you may enjoy using a filter that will cause your digital image to mimic an impressionistic pointillist painting. More sophisticated programs allow you to decide the size and color of the dots and how they will be dispersed. This filter requires a bit of experimentation in order to achieve the best results.

- **Watercolor filter:** If you'd prefer an image that mimics a watercolor, choose the watercolor filter. It works especially well with subjects from nature. Use it sparingly for an ethereal feeling.

- **Ripple filter:** Imagine tossing a stone into a still body of water and watching ripples appear on the water's surface. In the same way that ripples become visible in water, distorting the reflections on the water's surface, the ripple filter produces a distorting effect on your image. There are a number of controls you can use to cause a range of effects, from slight rippling to maximum distortion. When using the ripple filter, you will need to choose your subject wisely in order to obtain satisfactory results.

- **Twirl filter:** When you're looking for a different way to distort an image and create a unique effect, apply the twirl filter. It will twist your image around its center either clockwise or counterclockwise, depending on which you specify. You also control the degree to which your image is twirled.

ALERT!

Most high-end programs allow you to see the change to your image as you make adjustments. Spend some time learning each control, as the change caused by a tool can be quite subtle. Some programs show a change on a small preview in real time, others show before-and-after comparisons in side-by-side thumbnails.

Special Effects

Besides the effects achievable with image-editing software that have been discussed so far, there are myriad other possibilities. Distortion, in particular, can be stretched to the limit, creating surreal images with a rubbery feel.

Distortion/Warping

Some image-editing software programs allow you to distort and stretch an image for unusual effects. A program may offer you the ability to choose the shape and axes of the distortion, the rate of distortion, and the precise area of the image that will be distorted.

There are several types of distortion:

- **Linear:** Using a linear distortion, your image is stretched on the horizontal axis, the vertical axis, or a diagonal.
- **Pinch:** Also known as thinning or imploding, this technique "pinches" the image inward.
- **Spherical:** Also referred to as fat effects or exploding, spherical distortion puffs out the photo at whatever point the user specifies, following a circular pattern. This effect is similar to that provided by a fish-eye lens on a film camera.
- **Stretch or goo:** Some programs allow you to simply click in an area of your image and drag the mouse to give the appearance of stretching the image. It is almost as if you are working with an image made of Silly Putty or rubber.

Adding Text

The ability to add text to an image may seem like a feature that would appeal only to those using image editors for professional uses, such as composing advertisements or catalogs. But you may find that a word or two can make a nice addition to your digital picture. The text tool makes it simple to add type. Consider using it to designate the place shown in a travel photo, to reveal the name of the subject captured in your portrait, or as an added element in a collage.

Infrared Effects

Film photographers obtain unexpected results with infrared film. Infrared film is sensitive to both the light humans can see and some of the longer length infrared radiation that we cannot see with the naked eye. It takes time, experimentation, and considerable effort to use infrared film effectively. A similar result can be obtained with your digital photos and an image editor. If you choose your subject carefully, you can manipulate the hue and saturation to achieve results not unlike infrared photos.

Patterns, Mirrors, and Silhouettes

The possibilities are endless. You can create your own digital patterns, for example, that you can then reproduce throughout an image.

Patterns

You can either shoot patterns or create them using your computer. Find an element of your image that is appealing to you, then experiment with creative ways of duplicating and using it. For best results, you need to pay particular attention to detail when combining the repeated elements so that they blend perfectly together.

Reflections/Mirror Images

One way to use patterns imaginatively is to create images that contain mirror images, or reflections. Begin with an image that is strong enough to stand alone and still be effective. Then experiment with duplicating it by copying it onto its own layer and flipping it. Combining the two images results in a mirror image. You can also get creative with this technique by mixing several images at once to form repeating patterns or multiple reflections.

Silhouetting/Vignetting

It used to be that negatives were actually painted to create a white silhouette, or border, around the edges of the picture. Many software programs

allow you to apply this masking function to your digital images, imparting a vintage look. The technique works best on simple images, especially portraits. Consider scanning an old-time photo, then adding both sepia tones and a vignette effect to recreate the charm of a bygone era.

Collage/Montage/Composite

Using photographic software, it's fun to mix images to create unique effects. Whether you call it a collage, montage, or composite, a collection of different photos grouped together to form one image can be a visually appealing way to tell a story. As part of your collage, you can include artwork and text, as well as your photos.

A collage is not an easy project to execute; it requires far more than simply assembling miscellaneous images. To create a collage that works, you'll need a good eye for composition, some practice using your software program, and, most importantly, an engaging concept. The images in a collage should have a thread or theme that connects them so that they work together to convey one particular idea or impression.

High-end programs permit you to assign weights to the various images in your collage so that certain objects appear more prominent while others seem to recede. You can also choose the transparency of various objects and the extent to which the edges of photos blend together.

Shoot images with a specific purpose in mind. As you become more adept with your image editor, you will want to experiment with different techniques. One good habit to get into is to keep an eye out for interesting backgrounds that can be used later to enhance shots where the subject is interesting but the background is cluttered or bland.

If you enjoy creating collages, keep an eye open for subjects that could be utilized as elements for compositing. One of the interesting aspects of digital photography is the ability to combine photos. By compiling an image bank, you'll be assured of always having plenty of material to draw on.

CHAPTER 17

Software for Digital Cameras and Photographs

Because digital photography saves images in a computer format, there is a ton of software out there for use with your digicam. In addition to programs for managing and editing files, you will find many other types that can expand your abilities as a photographer and maybe even get you out of a jam. You will also find hundreds of freeware and shareware programs that can be downloaded off the Internet. As with other products on the Web, you can check out reviews, complaints, and user comments about programs that interest you. Unless stated otherwise, software listed is for Windows.

Types of Software

We all know what software is, right? Well, sort of. Software is a general term used for programs designed to perform specific tasks within a computer. But there are different classes of software you should know about. Here's an overview:

Freeware

Freeware is software that is available for download and unlimited use and is totally free to the user. Freeware includes many large programs plus utilities, plug-ins, desktop pictures, and fonts.

There is a surprisingly large amount of excellent freeware. This is especially true for the PC IBM Windows standard. Try the most popular freeware programs, when available, before buying software. What do you have to lose?

QUESTION?

Is free software too good to be true?
It's hard to believe that you can get quality software for free—but you can. Some freeware has been around for seven years or more and has been ranked above much commercial software. The free photo browser IrfanView (*www.irfanview.com*) is one such example.

Some freeware tips:

- Never get version 1.0 or a beta version; this is bound to be full of bugs. The best freeware should have gone through major revisions.
- Freeware is reviewed, rated, and given awards just like other software. Look for positive comments before downloading.
- If possible, download from the author or company site. If you must download from another site, make sure that it is a reliable download site like Tucows.com or CNET.com.
- Don't expect support for freeware—after all, it is free. However, there may be a number of FAQs, user comments, and tips at the author's site or posted at a fan's site.

Shareware

Shareware refers to an application or utility that you can try out for free. Sometimes it is a full-featured product, and other times it lacks some of the features of the commercial version. If you like it and want to continue to use it, you'll have to register the software and pony up a small fee to the program's author. The beauty of shareware is that you can try before you buy. There is lots of shareware that you can download directly off the Internet. In addition to enjoying a trial period, you can avoid making a trip to a store.

Software does not have to be run independently or separately. If you like part of one program and part of another, try to use them together. Many programs, for example, will let you launch one program from within another program, and some will let you drag and drop from one to another. Look for these features when you obtain software.

Commercial Software

Made by large companies such as Adobe and Microsoft, this software is of excellent quality and a bit costly. Large commercial companies often offer a series of software programs, from simple and inexpensive to quite sophisticated and very expensive. The software works well and is well thought out. When you want to go to the next level, you can buy the next higher software package. This more sophisticated software is usually compatible with your old one and requires less learning because the design will be similar.

To find commercial software, go to the manufacturer's Web site. At that site you will often find special deals, discounts, software bundling at substantial discounts, thirty-day trials, upgrade offers, and comprehensive descriptions of software, including screen shots that give an accurate display of the look and feel of the software. You may also find notices of bugs and problems.

Some of the biggest commercial names that offer a range of photography and imaging software are:

ACDSee
www.acdsee.com
Corel
www.corel.com
Corel now offers Paint Shop Pro programs, Ulead offerings, and Corel products.
Adobe
www.adobe.com

Visit the Web sites to see the complete list of what each company has to offer. If you want to buy from a retailer, consider a good and reliable online retail seller of software such as *www.adorama.com*.

FACT

More and more commercial companies are offering freebies, demos, and free trials that you can download off the Web. Always check companies' Web sites first before buying a commercial package from a retailer. Most retailers won't let you return an opened package, which means that you'll be stuck with the program.

General Software Tips

Installing new software can sometimes cause problems. There are a few guidelines you should follow to make sure the process goes smoothly:

- Don't let a newly installed software program reset your file associations. For example, if you are happy with the program that launches when you click a .jpeg file, don't let a new program take over. If you are offered this choice during the installation, always say no. You can go back and change the association later.
- Don't let a new program automatically load at startup unless you want it to. Many applications will do this and you will find that

you are soon out of memory or that your computer is running very slowly.

- Some image editing programs have their own file format, such as Adobe Photoshop (.psd) or Paint Shop Pro (.psp). However, this format is often proprietary, meaning that most other programs will not be able to read it. If you use such a format, save the file in a more standard format before exiting the program. Be certain that your image cataloguing program can read these files properly.

- As software evolves, expect new versions to come out. While you should not upgrade with every slight change in the version number—say, from version 4.34 to 4.35—you might want to upgrade when there is a major change—say, from version 4.34 to version 5.0. In this case, many software companies will let you buy the upgrade at a greatly reduced price. The upgrade will usually require downloading over the Internet, and you will most likely need the complete set of serial numbers from the original piece of software you bought.

- If you upgrade, do not assume that the new software is better than the old. Load the new software as a separate program so that you can run both the old and new versions. If you have problems with the new version you can go back to the old one. If you don't have problems with the new version, you can remove the old version later.

def·i·ni·tion

Spyware: Monitors what you do on your computer and can be bundled with Internet software. You can install it without realizing it. Get your Internet programs from Web sites like CNET.com. These sites test their freeware and shareware to make sure that spyware is not part of anything you download.

Consumer Shopping

Over several years, software can cost as much as your photography equipment. Before you go software shopping, take some time to consider your needs. When choosing image-editing software, ask yourself the following questions to help decide which one is right for you:

- **How will you use the software program?** Because technology changes so quickly and software programs are constantly being upgraded, think in terms of your short-term needs. Do you want to create pictures for use on a Web site? E-mail photos to friends? Print images that are good enough to be considered fine art?
- **How easy is it to use?** The program should be intuitive and easy to operate. If not, you will spend more time learning how to use it.
- **What are the program's capabilities?** Can it do what you need it to do?
- **How much does the program cost?** To save money, consider buying through a mail-order or Internet retailer. These can offer reduced prices because once you've purchased the product you'll be turning to the manufacturer, not to them, for support services. Finally, remember that freeware and shareware image-editing programs can be excellent, so don't overlook them.
- **What platform is it compatible with?** Some software programs are only available for a specific platform (Mac or PC).
- **What file formats does the program support?** Most image editors handle the popular image file formats, like TIFF and JPEG. To be certain that the program you're considering can support the file formats of your choice, read the package specifications carefully or check out the manufacturer's Web site for complete details.
- **Does the program include templates to get you up to speed quickly?**
- **Does the software program accept Photoshop-compatible plug-ins?** Plug-ins allow you to customize an image editor. If your program supports plug-ins, you'll benefit from more options.

If at all possible, you should try the program before you buy it. Many demo programs come packaged with magazines and books.

Photo Browsing and File Management

Photo browsing and file management software helps you view and catalog your pictures, which includes copying, moving, renaming, and deleting. In addition to these basic functions, many programs come with a number of photo darkroom features for quick enhancements plus file conversion, sim-

ple printing, and other capabilities. If you are starting out, a good free program may be all you need. Read more about this software in Chapter 14.

Free Photo Management Software

IrfanView

www.irfanview.com

This totally free Windows program has been around for years and may be all you need to get started. Besides normal file management, it supports an impressive number of file formats, generates thumbnails, allows digital darkroom photo editing, and can create self-starting slideshows. It is even compatible with Photoshop plug-ins.

Picasa

picasa.google.com

Picasa is free software from Google that lets you organize and edit your photographs. You can add effects and share your images via e-mail or the Web or with prints.

PicaJet Free

www.picajet.com

This free program works best as a solid organizer and cataloguer. If you like this program you can upgrade to the paid version, which has more powerful features for editing, sharing, and sophisticated management.

XnView

www.xnview.com

Described by the author as "multimedia viewer, browser, and converter," this well-regarded program will allow you to organize, browse, and edit your pictures. It has especially powerful batch editing features that let you change a number of photos at the same time.

Snapfire

www.corel.com

The commercial software company offers a free version for simple organizing, sharing, and quick fixes. If you like it, upgrade to Snapfire Plus.

Commercial Photo Management Software

ACDSee Photo Manager
www.acdsee.com
Cost = less than $50

If you are going to buy a program, this is the one to get and may be all you ever need to pay for. This well-designed software has been around for many years. Besides being a sophisticated organizer, it is very fast, reads virtually any file format, does sophisticated digital darkroom corrections, archives, creates thumbnails and slideshows, and facilitates printing. It even makes sending pictures via e-mail a breeze. However, it should be noted that some people have reported some bugs. The company offers a downloadable free trial.

ThumbsPlus
www.cerious.com
Cost = about $50

A sophisticated database-type software for digital imagery, ThumbsPlus can create and manage large numbers of digital images. It is one of the few programs with ongoing RAW file support. It also supports image modifying features, album and slideshow creations, printing, and versatile batch processing.

Latest Photo Management Software

With new software being developed all the time, it pays to check the Open Directory listing of software every so often. While the listing of the software will change, these Web addresses should remain the same for years.

FACT

The Open Directory Project, or DMOZ, is billed as "the most comprehensive human-reviewed directory of the Web." Used by Google as its own directory, real live human beings examine and include each site that ends up in its listings. This assures that the Web sites are of good quality.

For the latest listing of freeware and other graphics and cataloguing software, check out these listings:

Open Directory Project (DMOZ) directory of free image cataloguing software: *www.dmoz.org/Computers/Software/Freeware/Graphics/Cataloguers*

Open Directory Project (DMOZ) directory of image cataloguing software: *www.dmoz.org/Computers/Software/Graphics/Image_Cataloguing*

Image Editing

Image editing software provides a full set of photographic, image, and graphic tools for a digital image. If you want to make major modifications in your photographs, image editing software is essential.

Free Image Editing Software

Much of the free software listed under the earlier section of photo management software will also do basic editing. If you need more capabilities, however, there are many free and commercial programs.

PhotoPlus Image Editing
www.freeserifsoftware.com
This full-featured image editor is completely free.

GIMP (Windows and Macintosh)
www.gimp.org
GIMP stands for GNU Image Manipulation Program (GNU is the name of the organization that creates the free software). An open source volunteer-created program, it is often called the free Photoshop.

Paint.net
www.getpaint.net
Originally put together by a bunch of college undergraduates, this program has grown into a sophisticated photo enhancer and image manipulator, ranked in the top twenty programs for 2007 by *PC World*.

Commercial Image Editing Software

Image editing software can be broken up by the experience of the user. Someone who is new to image editing should start out with a basic program and progress to the more complicated programs as she gains experience.

Adobe Elements (Windows and Macintosh)

www.adobe.com

Cost = about $100

Beginner software: Famous for its top-of-the-line Photoshop, Adobe Elements is the entry-level program that many people find fulfills all their digital photography requirements, including editing, printing, adding graphics, and organizing.

Corel Paint Shop Pro

www.corel.com

Cost = about $80

Advanced software: Long considered the low-cost commercial rival to the expensive and professional Adobe Photoshop, Paint Shop Pro (now part of Corel) should meet the image editing needs of the most demanding professional. This program also has a full set of organizing features.

Ulead PhotoImpact

www.ulead.com

Cost = about $90

Advanced software: A complete image and photographic editor, the latest version includes automatic white-balance control, noise reduction, and full detail in highlights and shadows. It also includes large screen side-by-side previews with before-and-after comparisons of the changes you make.

QUESTION?

Do you need total image editing power?
If you're an amateur digital photographer who looks to do only occasional retouching of images, you may not need—or want—all the power that Photoshop delivers. Check out some of the less complicated and less expensive programs listed in this chapter.

Adobe Photoshop (Windows and Macintosh)

www.adobe.com

Cost = about $650

If you want the Mercedes-Benz of photography software, Photoshop is it. The program will do just about anything you want, and there are thousands of plug-ins available. However, the cost is high. This program takes a long time to learn and many people will only use a handful of its features.

Backup and Recovery

Many people overlook the crucial task of backing up their photographs. However, the chore can be quite fast and simple with the right software.

Shareware Backup Software

Second Copy

www.centered.com

Cost = about $30

Winner of numerous awards, this wonderful program makes backing up a snap instead of a chore. Once you designate the folders you want to copy and the drive or drives you want to back up to, it takes about two minutes to back up just about anything new. It is highly recommended.

Commercial Recovery Software

Lexar Image Rescue Software

www.lexar.com

Cost = about $30

This software may be able to recover deleted picture files on your memory cards, plus reformat your cards and check that they are working properly. The software requires a USB card reader.

Latest Backup and Recovery Software

Backup storage and software is constantly being developed. For the latest listing, go to this Open Directory page: *www.dmoz.org/Computers/Software/Backup.*

Printer Programs

Integrating text, graphic design, and photographs into a good-looking document is the job of printer programs. Remember that much of what you design will be printed in black and white, so pick photos that will look good in black and white.

Print Shop

www.broderbund.com

Cost = about $40

The granddaddy of all print software, this program was around before digital photography. It allows professional photo editing plus the easy integration of text and graphics (many are included) with your photographs. The design can be a newsletter, a business card, a poster, a postcard, a calendar, or a booklet.

Print Shop Design Suite

www.broderbund.com

Cost = about $120

This five-program suite helps you with professional layout and Web design. It includes powerful graphic and image-editing tools. The package ships with more than 20,000 templates, 400,000 images and graphics, and more than 850 fonts.

Online Software

A number of online Web sites provide not only services but software that you use when you are on the site.

Free Online Services with Software

Flickr

www.flickr.com

You can upload and share your photos with these very popular photo sites. Generally, you can make your pictures available to anyone or restrict the viewing to friends and family. The pages you create will look like a fam-

ily album with thumbnails that link to enlargements. Read the rules before signing on. While the limits are generous, there may be restrictions on the maximum size of each picture you can upload and the number of pictures you can put online.

Photobucket
www.photobucket.com

Blogger
www.blogger.com

What is a blog? It is just about anything you want, but technically it's short for "Web log." You can share your experiences and thoughts on anything you like on your own personal blog, and your blog can follow any format you like. You can create your own photo blog using photos, and you can also add a lot of text if you like. Blogger is owned by Google. The online software is easy to use and also allows you to customize if you so choose.

As the Internet gets faster, you will probably see many more services such as ProtectMyPhotos.com with storage and software online. Many experts believe that this type of service is the wave of the future. Using the Internet would solve backing-up problems and allow you to avoid the headaches of having to regularly update software.

Utilities, Applets, and Plug-ins

Small programs can be quite useful. There are probably thousands of them on the Internet. Here is a sampling of some of the most useful.

Free Utilities

Rename-it
www.softpedia.com, www.download.com

This very small program is useful for sophisticated renaming. It allows you to change virtually any part of a series of file names while keeping or

adding to other parts. With digital photography, you will find you can quickly have thousands of files. Renaming them will help remind you of the images they contain and also prevent new files from overwriting the old files.

Free Plug-ins

Photoshop Plug-ins (Windows and Macintosh)

www.thepluginsite.com

Like Windows, Photoshop is the standard for graphics programs. A Photoshop-compatible plug-in can work with any graphics program that accepts the Photoshop standard. There are many free plug-ins that you can download and test to see if they create the kinds of effects you want. This site lists more than 100 free plug-ins.

def·i·ni·tion

Utilities, applets, and **plug-ins:** Small programs that generally do one thing. A utility is a program that helps you accomplish one task. An applet is a very small application. A plug-in is a small program that plugs into a larger program and can be used as part of that program if it is compatible.

Shareware Utilities

BenVista

www.benvista.com

Cost varies

BenVista makes a sophisticated enlargement utility that can work as a plug-in or stand alone. Its PhotoZoom program uses a patented technology to create quality enlargements from small and low resolution photos.

The JPEG Wizard

www.pegasusimaging.com

Cost = about $30

The JPEG Wizard is a specialized tool that compresses your images more than a standard JPEG compression with no loss in quality.

Macro Express

www.macroexpress.com

Cost = about $40

Macro Express allows you to record and then replay a series of keystrokes or mouse movements within a program. For example, if you perform virtually the same operation on a series of photographs, you could use Macro Express to automate those actions.

Free Applets

Treepad

www.freebyte.com

This is one of the most useful note-taking programs ever written. This free program allows you to organize your notes in a tree structure with unlimited subnotes. This is especially useful for keeping track of your photographs, your picture processing, your filing system, your file-naming conventions, and your camera settings. Files can be saved in text format that can be read by virtually any text or word processing program. It also works well as an Internet bookmarker.

Edit Pad Lite (enhanced notepad)

www.editpadpro.com

Keep simple notes about your pictures along with other photographic info. This simple, straightforward program allows you to open a number of very large text files in the same window. Each file is marked with a tab at the top so that you can go back and forth between open files. Unlimited do and undo plus a host of other features make this program a vast improvement over the Windows Notepad. Many programs such as ACDSee Photo Manager and ThumbsPlus, mentioned earlier in this chapter, have a way that you can add text notations to a picture and then later search for those notes when you want to find certain images.

Web Site Image Display Software

If you are not versed in HTML but want your pictures to look professional, use Web page creator software.

Free Web Page Image Software

JAlbum

www.jalbum.net

With more than 7 million users, this popular program may be the only photo album publishing software you need. Without this software, creating linked pages that displayed thumbnails and full images properly was a daunting task. With it, you can put your photos on your own Web site. JAlbum makes this task very simple.

Shareware—Web Page Image Software

Arles Image Web Page Creator

www.digitaldutch.com

Cost = about $50

If you want complete support for the look and feel of your photography Web pages, Arles will do the job. It creates a main page of thumbnails that links to display pages. The pages it creates can be customized with a variety of settings. For example, Arles can resize your photos for the resolution that you choose. File management and image editing programs can often produce HTML photo albums, but probably without all the bells and whistles of a dedicated program like Arles.

Animation and Slideshows

Still images, especially a series, can be put together in a GIF animation, which is a universal Internet file format. AVI videos taken with a still camera can be edited and modified with an animation program. Many of the image-editing programs listed in this chapter also have GIF animation capability. Photoshop, Paint Shop Pro, and Ulead PhotoImpact are several examples.

Free GIF Animation Software

Movies 13

www.jansfreeware.com

This is an animator with ninety-eight animation wizards. Import/export AVI to GIF. Edit existing animations, add text, and create new graphics.

Commercial GIF Animation Software

Ulead GIF Animator
www.ulead.com
Cost = about $30

After playing with the free GIF animator, buy this version for total image control. You can sandwich a number of photographs together, resize them, position them, and play them at millisecond intervals. Import AVI files and fine-tune. If you like animation, this is the program to get.

If you make a lot of slideshows or animations, you might want a program that specializes in that task. Specialty programs generally have more features and can be easier to use. Read reviews and familiarize yourself with the subtle—but perhaps essential—controls such a program offers.

Photo Slideshow Software

Many of the programs already mentioned in this software chapter include a slideshow capability. The free programs Google's Picasa and Irfan-View and the commercial programs by ACDSee, ThumbsPlus, PhotoImpact, Paint Shop Pro, and Photoshop allow you to create slideshows.

File Formats and Image Compression

A digital camera saves a photo as a digital file to the memory card in the camera. Still photographs are generally saved in one of three formats. The most common format, JPEG, uses compression to reduce the size of the file. Unfortunately, high compression JPEG images can lose detail as JPEG is a lossy (not lossless) compression standard. In addition to still images, many digital cameras can also create videos, which are saved in video formats. This topic is a bit technical, but it is essential.

What Are Photo File Formats?

Digital photography is saved in a form that is compatible with computers. This form is known as a file and there are several different kinds of file formats that cameras can use. In addition, there are many other picture formats that are used in digital imagery and on the Internet. Still image formats can usually be converted from one kind to another kind, if necessary. Information can be lost in the conversion, and in some cases a lot may be lost. While you probably are familiar with files and have worked with them, you may not know exactly what they are.

Computer Files 101

File names have a set format. Every one of your picture files has a name that either the camera automatically assigns or you give it. After the name comes a dot and then the file extension. While you can change the name, you should never change the extension. For example, a photo named Mypicture and saved in the JPEG file format looks like this: Mypicture.jpg.

Displaying the File Extension

The Windows Explorer file manager often hides file extensions. By default it does not show file extensions when it lists files in a folder. To change this and see your extensions listed, go to Tools > Folder Options > View and then uncheck the option that says Hide Extensions for Known File Types.

Main Digital Photography Formats

Digital cameras use three formats of still photo files, JPEG, TIFF, and RAW. Not all cameras will offer all of these file types. For example, RAW files are generally only available on expensive still cameras or DSLRs. JPEG may be the only type of file that a particular camera uses, especially a low-end model.

JPEG (Extension .JPG)

JPEG (acronym for Joint Photographic Experts Group, though sometimes written JPG like the file extension) is by far the most common type of

picture file you will come across. It is a universal format that can be read by PC and Mac computers, can be viewed on the Internet, and can be used by other devices such as cell phones. Yet JPEG is a very sophisticated format with many options, some of which can be quite confusing. To get the best quality JPEG images or to understand how to store photos properly in your camera's memory, you must understand how JPEG works. JPEG is quite different from the other two common camera formats, TIFF and RAW:

- First, it allows considerable compression. This means that the size of a file can be shrunk so that you can save many more pictures on your memory card or your in-camera memory.
- Second, the compression method that JPEG uses loses some picture data. Because of this, JPEG has what is known as lossy compression.

JPEG Picture Quality Setting

The picture quality setting (or a setting with a similar name) in your camera can be quite confusing. The problem has to do with understanding the distinction between size of the image and the amount of JPEG compression.

- First, you must choose the image size. The resolution setting in your camera refers to the size of the image, the pixel count. It is often listed in pixel dimensions such as 640×480 or 1600×1200. These numbers refer to the width and height of the image in pixels. The bigger the dimensions, the better the resolution.
- Next, you often have to choose the amount of the compression. Typically there are three quality settings, such as basic, normal, and fine. The higher the compression, the lower the quality, but the more images you can fit in your camera's memory. The lower the compression, the higher the quality and the fewer you can fit into your camera's memory.

TIFF (Extension .TIF)

TIFF (Tagged Image File Format) allows you to store high-quality images in an optional lossless compression format known as LZW (named after its

developers, Lempel, Ziv, and Welch). The TIFF format supports 8-bit gray-scale and 24-bit color images. In addition, it accommodates 1-bit black and white, 8-bit color, and numerous other color settings. Consider using TIFF if you plan to edit your images repeatedly, use them in a publishing software program, or produce high-contrast photos. The TIFF format is compatible with both Windows and Macintosh and is widely used in desktop publishing.

Although TIFF files can be compressed in a lossless fashion, the reduction in file size is not very large. TIFF is not compatible with Web browsers and therefore should not be used on an Internet Web site. While you can send one as an e-mail attachment, the recipient of your attachment may need a separate program to view the file.

TIFF files are in between JPEG files and RAW files. They are much larger than JPEG files, for example, and smaller than RAW files. With TIFF no data gets lost, yet they retain almost as much information as a RAW file.

If you want a full resolution image with almost total control over its look plus a universal format that is recognized by most photo editing programs, TIFF is the way to go. However, TIFF files will fill up your camera quickly and they will take longer to download than JPEGs.

RAW (Extension .RAW)

The term *RAW file format* refers to the unprocessed image data as it was first recorded by the image sensors in the camera. The RAW file format is not really a format in the normal sense, as every camera manufacturer may have a different RAW format—even different cameras made by that manufacturer may have different RAW formats. RAW formats are proprietary, meaning that each one is unique to its manufacturer.

Professional photographers like the RAW format as it gives them complete control over the final image. Specifically, the RAW format allows more control over white balance, color depth, color saturation, sharpening, and contrast. It has a greater tonal range than a JPEG picture, for example.

However, working with RAW files is not simple. Because they are quite large and uncompressed, they can fill up the camera's memory quickly and also slow down the frame rate of the camera—that is, the lag time between taking sequential pictures. In the computer they will require a lot of RAM

and also take a good deal of time to work with. In addition, they will need to be converted into a standard file format with a converter (usually supplied by the manufacturer), since the format is not standard.

Some newer cameras save a picture in two formats at the same time: the JPEG and the RAW format. This option gives the photographer more wiggle room. If the JPEG file does not meet the photographer's standards, she can go back to the RAW file for fine tuning.

The DNG Standard for RAW Files

Digital Negative (DNG) is a file format developed by Adobe to create a standard way of saving, viewing, and processing RAW files. RAW files are converted to the DNG format using Adobe's free DNG converter. The converter works with Windows and Macintosh. More than 150 cameras and their RAW file formats are supported. Adobe's well-respected Photoshop and all other Adobe photo software supports this format.

While this standard has not yet been widely adopted, the odds are good that it will become a de facto standard. This is because Adobe, the leader in photo-editing software, is pushing its use and making it freely available. To find out more about DNG and to download the free converter, go to *www.adobe.com/products/dng*.

FACT

Adobe calls its format "digital negative" because the RAW format, although positive, is like a film negative in that it gives the photographer the greatest possible flexibility. Adobe has made the DNG format available to all software developers (not just Adobe), so that they can add DNG capabilities to their photo editing programs.

EXIF

EXIF (exchangeable image file format) is not really a file format but a standard that allows considerable information about the camera settings to be saved along with the picture. It is used primarily with JPEG files but also works with TIFF files. JPEG files that use EXIF are considered EXIF

compliant and cameras sometimes list the JPEG format as JPEG (EXIF) or as JPEG (EXIF version 2.2). For learning and diagnostic purposes, this kind of information is invaluable. It also means that you can probably put away that notepad for recording such information and concentrate on shooting.

Digital cameras that use EXIF can record such exposure settings as:

- The camera-assigned file name
- The camera make and model
- Date and time of shot
- Shooting mode
- Shutter speed
- Aperture
- Focal length
- Image size
- Type of metering
- Exposure compensation
- ISO

This extra information is known as metadata, and this list is only a sample of the information that a camera might save. Some cameras may save different data; it depends on the camera. After downloading your images, you may need a special EXIF extractor in order to view the metadata that was captured by your digicam. If your camera did not come with software allowing you to view the metadata, there are several programs you can get for free or buy for this purpose. For example, some free software can extract the EXIF information and save it as text or as CSV files, creating an easy-to-read permanent record of your picture-taking settings. Also, many image editing and processing programs such as ACDSee can display this data.

While the ability to record all the camera settings is quite useful, there are a number of problems with EXIF files and at the moment they have not been solved. Some image editors strip the metadata when saving and other editors cannot read the metadata properly and corrupt the data. Be careful saving EXIF-compliant files, as the information can get lost if it is not saved properly. Read the instructions in your picture file management program.

For more about the EXIF standard, visit a good unofficial EXIF Web site at *www.exif.org*. For examples of EXIF information, go to the MorgueFile

Web site at *www.morguefile.com/archive*. Many of the free pictures include EXIF data that can be quite useful for learning photography.

ALERT!

EXIF focal length information will often be stated in the true focal length of the digital camera lens and not the 35 mm equivalent. This means that you will need to understand the relationship between the actual focal length of your digital camera, which varies from digital camera to digital camera, and the 35 mm equivalent.

How Compression Works

Compression seems mysterious, but it is a very simple concept. In one type of lossless compression, for example, the computer reads every pixel in an image and then notes which pixels are the same color and their position. Then it saves the image with that information instead of saving every single pixel; this results in a drastic reduction in size. The more complicated the image, the less this kind of compression can compress. The less complicated, the more easily a picture can be reduced in size.

Because a compressed file takes up less space, you can fit more image files on your internal flash memory. Compression is essential with digital photography because without it you would not be able to save many pictures on your memory cards.

The most popular compression format is JPG or JPEG. This uses a very sophisticated computer algorithm to remove colors than are not seen by the human eye. However, this compression method changes the image so that it does lose digital detail. As a result, the compression method is called lossy compression.

Lossy Versus Lossless Compression

Lossy JPEG compression removes picture information permanently from a picture file. At the highest quality and lowest compression, few people could tell the difference between an uncompressed file and a compressed

one. At the lowest quality and highest compression, there is a noticeable difference. Yet JPEG is adjustable so that the level of compression can be varied according to the needs of the photographer.

Experiment with JPEG compression levels on your camera and in your image-editing software to see what best meets your individual needs. You may find that when you apply more compression, the quality remains quite high while saving your memory card space and time on downloads. Save two or three photos at different compression levels and compare.

How to Compress a JPEG File

Compression can be quite confusing to the beginner. Part of the confusion is caused by software programs that use inconsistent language for compression settings and that also hide the compression option deep in the program.

Steps for Saving JPEG Files

To set the JPEG compression you may have to save a test file. When you choose Save As, you may see an Options button. Click this button to go to a JPEG dialog box that will allow you to change the JPEG compression level.

◄ This is the dialog box for JPEG compression in the freeware IrfanView program. If you do not make the proper settings, your photos will be saved with the default settings.

Keep the following points in mind when you change the compression setting:

- Low compression means higher quality.
- High compression means lower quality.
- Small file size means lower quality.
- Large file size means higher quality.
- Better quality means a larger file size.
- Lower quality means a smaller file size.

ALERT!

Graphics programs usually come with the JPEG compression set to a default amount. If you want to control the JPEG quality, you will need to change the default setting yourself. With some programs, just changing this number causes it to become the permanent setting. However, with other programs you must also select your new setting as the default.

Keep in mind that for most everyday applications, a high quality save, such as a number 90 compression quality known as the compression factor, can reduce the size of an image by 50 to 70 percent with virtually no loss in visible quality. While the JPEG compression will alter the image permanently, most people will not be able to tell the difference when looking at a photograph.

When to Use Lower Quality JPEG Compression

Sometimes lower compression is useful and desirable:

- When you are e-mailing pictures, send images that are more compressed. They will take less time for you to send and less time for your recipient to download.
- When you post original images on the Internet that you don't want others to steal, use a lower quality. If you have a great high-quality image, compress it significantly before posting it on the Internet. A high compression image will look okay on the Web but will not be

good for printing or other uses. Therefore it will discourage people from taking your image and claiming that they shot it. Also, since you have the original best-quality photo, you should have no trouble asserting your ownership if necessary.

- Whenever you post photos on the Web, you should always compress your images to a number 80 compression factor or less so that they upload and download much more quickly.

FACT

If you are going to work on a picture for a number of saves, convert it to a TIFF file, as repeated savings in the JPEG format results in degradation of that image. This happens because the JPEG algorithm strips data from the photo with every save.

TIFF Lossless Compression

To compress a TIFF file, chose the LZW option when saving the file. Black and white files will compress quite well, though the compression with color files will be less effective.

Other File Formats

For the World Wide Web, GIF and JPEG are the two still image formats most commonly used. These are cross-platform formats, meaning that they can be read by virtually any computer browser including Windows, Mac, and other systems.

GIF

GIF is another lossless compression format; it stands for Graphics Interchange Format. GIF is an older format that was developed in 1987 by CompuServe but is still frequently used on the Internet and is compatible with all browsers. The format also supports animation.

GIF is often used for Web graphics and can be compressed a good deal with different color settings. You can set one of the colors as transparent,

which is ideal for banners and other small graphics on the Internet. GIF can create very small files by saving as few as two colors (typically black and white) or sixteen colors for a basic palette. GIF also accommodates 8-bit color, giving you the option to save up to 256 colors. This is far fewer than the 16 million colors recognized by JPEG and TIFF. However, you should note that the user chooses which colors GIF will use, and they can come from any of the 16 million available from the 24-bit color library. A good image editor will list the colors contained in the GIF file and allow changes. GIF is an especially good file format for line drawings and graphics that use a limited number of colors. In addition, if you want to turn a series of photos into an animation, the GIF format is an easy way to go. Use an animation program that works with GIF files.

ALERT!

If your image has fewer than 256 colors, then there will be no degradation of quality when you choose to save it as a GIF file format. Since the format is not saving color information for unused colors, the file size will be reduced. But if your image contains lots of subtle variation in color, its quality will be greatly decreased.

Windows Graphic File Format

The BMP (Windows Bitmap) file format is unique to Windows and often used by the Windows operating system. These files tend to be quite large and should usually be converted into JPEG, GIF, or TIFF files for personal or Web site use.

Macintosh Graphic File Formats

Before the Mac OS X, the Apple "picture" file format (extensions .pict, .pct, or .pic) was used by and was unique to the Macintosh. The Mac OS X now uses Adobe's PDF files (extension .pdf), which is a cross-platform file and can also be viewed by Windows.

Native or Proprietary Formats

Many software programs save files to native (proprietary) formats, which are designed to support the program's special features. For instance, Photo-Deluxe uses the PDD format, Photoshop uses the PSD (Photoshop document) format, and Paint Shop Pro uses the PSP format. However, most other programs will not be able to read these formats. If you want to use your image in this format with a different program, you will need to save (convert) your image to a common file format such as JPEG or TIFF.

FACT

To convert one still picture file format to another, use the Save As submenu under the File menu. When you pick Save As, also pick a new file format from the ones available within the program you are using. They are usually listed in a drop-down menu.

Video and Sound File Formats

Many still digital cameras can also shoot video while recording sound. Although the results may not be as good as a dedicated digital camcorder, the quality can be quite acceptable and close to television quality. The following is not a complete list but highlights the main formats that are used in digital still cameras.

Video Recording

Video formats can record at various resolutions. The VGA format is equal to television quality at 30 frames per second (fps). Digital still cameras usually record video in one of the following standard resolutions. Not all of these resolutions will be available for all cameras that record video.

- QQVGA = 160×120 (Quarter QVGA)
- QVGA = 320×240 (Quarter VGA)
- VGA = 640×480

With some cameras, the frames per second may change with the image size. Many digital still cameras record video with sound in this format. Some are limited to thirty seconds or so and others provide unlimited recording up to the limit of the camera's memory.

AVI Video Files

AVI is a video file format that stands for Audio Video Interleaved. It can contain both video and sound. Technically, it is called a metafile or container format, as its structure allows both audio and video in the same file and accommodates a variety of video and audio formats.

MPEG or MJPEG Video Files

MPEG (sometime listed as MJPEG) stands for Moving JPEG and has a file extension of .mpg. This is another video/audio format. It can be easily converted to an .avi.

QuickTime Video Files

QuickTime is an Apple format for video that is compatible with the Macintosh and also with Windows. It has a file extension of .mov.

WAV Sound Files

Like AVI files, WAV files are container files, but they only hold sound recordings. Many digital cameras are capable of recording sound along with video or sound by itself. Some cameras can even record in stereo. This file format has the extension .wav and is compatible with both Windows and Mac.

QUESTION?

What in the world is a codec?

Media files must have the correct codec (**compressor/decompressor**) for each kind of file to play properly. A codec compresses and decompresses video and sound; the compression is lossy. If your media player does not have the correct codec, it usually can be found on the Internet and downloaded with very little trouble.

Conversion

There are many conversion programs that allow importing and exporting a number of video file formats. For example, Adobe's Macromedia Flash can accommodate virtually any file format and create Internet-friendly animation or export or convert a file to another format.

Time-Lapse Photography and Video

Many digital cameras have a time-lapse feature that allows you to set time intervals between a sequence of shots and the total number of shots to be taken. The intervals can be a minute or an hour or a day. If you mount your camera on a tripod or place it securely on a bookshelf, you can create a series of still pictures or record a lively animated sequence similar to some MTV video clips. Use the AC power cord so that your camera does not run out of juice.

Animation

With an animation program, you can import a video sequence and manipulate it in a mind-boggling number of ways. These can then be exported in a form common to the Internet, such as a GIF animation or Flash video, so that virtually any browser can see your artwork.

Still Images from Video

You can take a video sequence apart and look at it one frame at a time. You can then save that still image just like a regular photograph. The only limitation is the resolution of the original frame, which is usually not very high. There are some software programs that are designed to make this job easy and allow you to work with a series of still images that originated in video format.

File Associations

When you look at a list of picture files in Windows Explorer file management program, you can often double click on a file name and the picture

automatically displays within a program. When you double-clicked on that file, you launched a program because that file format was associated with that kind of program. Windows often comes with a number of file format associations that are preset by default.

How to Reveal the Association

There are plenty of files, especially picture files, that have not been associated with any program. If you want to know what kind of program is currently associated with a certain kind of image file, right-click the file name and then on Properties, which should list the file association, if any.

You may prefer to associate a different program with a particular kind of picture file, rather than the program that is automatically chosen by Windows, such as Imaging for Windows Preview, a program that comes with Windows. Some programs make it easy for you to reset file associations—they include it as a menu item in the software.

Changing or Adding a File Association

In Windows Explorer or My Computer, display the file you want to make or change an association for. Right-click the file name, choose Open With and Choose Program, then click a program to associate with this file. If you want this program to always open this type of file, also choose Always Use the Selected Program to Open This Kind of File. When you check this option, the program you selected will now automatically open this type of picture file.

Putting Your Photos on the Internet

Sharing your photos with friends and family or making your images public is exciting. The Internet makes it simple. Just minutes after an event, you can upload your pictures so that everyone you know can see them. If you choose, you can make them public so that billions of people worldwide can see your photographic creations. You can share your photos through a photoblog or even your own Web site. The choice is yours, and the cost is reasonable.

Understanding Pixel Dimensions

If posting images on the Internet is something new to you, there are a number of things you need to keep in mind. Uploading pictures that are too tall and wide and pictures that take up too much space is a common mistake for novices. In addition to getting your photo to match a variety of monitor resolutions, you need it to fit with the design of your Web page.

FACT

Most people will be viewing your images with a 1024×768 resolution. However, others will be viewing at an even higher resolution of 1280×1024 and others at a lower resolution of 800×600. To make matters worse, the average resolution of the Internet tends to get higher as the years go by.

Today a standard VGA size of 640×480 (pixel width and height) will fit on just about any monitor. If you have an uncrowded Web page and want to display a slightly bigger image, chose a resolution in between 640×480 and 800×600. In order to do this, you will need to resize or resample your photo. As always, rename your resized photo, using the Save As command, so that it does not overwrite and erase your original image.

ALERT!

People can usually download the images you post. While technically they might be breaking the law, there is little anyone can do. And if you make your work public, it is not unusual to get a "flame" e-mail occasionally. A flame is a very critical message. You could, for example, get a message from someone you don't know telling you that you are a terrible photographer who should not put her photos up on the web.

When you save your image, you can also set the amount of compression for a JPEG image and compress it more than usual. You can play with the compression settings, but generally you should use less than 80 percent quality and aim for a file size of around 50KB to 150KB. Once you've done this, you're ready to post your photos online.

Photo Album Sites

The quick and easy way to put your pictures on the Internet is through a photo album or photo sharing site. These sites are simple to use and make it easy for you to designate your pictures as private for only friends and family if you choose. The cost is usually free.

What You Get in a Photo Album

Photo album sites give you less control over the display of your image than photoblogs or your own Web site, which are described next. But they are quite simple, straightforward, and free. Typically, your pictures will be arranged in thumbnails on a main page with links to the full image. When a friend views your main page, he can click a thumbnail to view the full-size image.

▲ It is easy to put your photos on an online album site, such as this page from Flickr.

Finding a Photo-Sharing Site

See Chapter 17 for Web addresses of free photo album and photo sharing sites. To find the latest entries in this fast-growing field, go to Open Directory listing: *www.dmoz.org/Computers/Internet/On_the_Web/Web_Applications/Photo_Sharing/.*

How to Put Your Photos Online

To post your images, you typically follow these steps:

- Resize, rename, and compress the photos you want to upload to the photo sharing site.
- Put these photos into an easy-to-find folder on your computer.
- Sign up for a free membership or log in if you already have a membership.
- Choose whether you want your images to be private (viewable only by friends and family) or public (viewable by anybody).
- Decide on a template (a general design for your photo album).
- Go to the upload section for your membership.
- Upload photos to your pages (there may be a limit on the size and number of pictures you can upload at one time).
- Go to your album pages and double-check that your pictures are there and that they look the way you want.

Once your photos have been uploaded, you usually have the option of adding more detail. You can give each album a name and include a description of what's in each one. You can also write captions for the photos.

Photoblogs

What is a photoblog? The word *blog* stands for WeB-LOG, which is a personal journal posted online. A photoblog, therefore, is a personal journal that is full of pictures and perhaps text. The choice is up to you. Generally there is no charge for posting photoblogs. Chapter 17 has a list of free photoblogs.

FACT

People often wonder why Internet-related names (such as *blog*) are so odd. The reason is simple. These names are preferred because they are unique, and unique terms can be easily found and identified by search engines. For example, go into Google and search for "photoblogs." You will see that thousands of these photographic journals are listed.

How to Design a Photoblog

Because a blog is like a journal, photographers often add photos from day to day and month to month. Each posting becomes a journal entry, and old entries are saved and catalogued. A blog can usually be about anything you want, and there are often no rules other than restrictions on obscene material and libelous remarks. As with photo albums, you can make your blog public or private.

A photoblog gives you more choice than a photo album site and allows you to customize your template. You will have more control over the placement of your pictures on the blog, for example. You can add links to your favorite sites on each page, include a small biography, and more.

Many photoblog photographers post their images full-size and then add some text. Blogs tend to continue down the screen, and a viewer often has to scroll down to see the bottom pictures. This happens because when a new blog entry is added, the previous entry slides down to make way for the new one. When a blog page gets to be a certain size, the pages are archived according to month. Viewers can access these archives, but they won't be on the same page as the current entry. You can add thumbnails of past entries and recall previous photos as needed and as your photoblog grows.

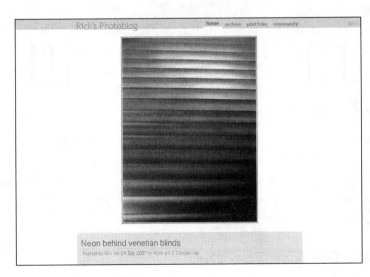

◀ A photoblog allows you to have more control and create a more personal look than an online album does—and at virtually no cost.

To customize a photoblog, you will need to have a basic knowledge of HTML so that you can link your thumbnails to your previous entries and

perform other functions. Depending on availability, you may be able to pick a unique URL such as Yourname.Photoblog.com. If you have a popular name like Smith or Williams, you might have to be creative to find a name that no one else has taken.

To see examples of photoblogs go to:

Photoblogs.org
www.photoblogs.org

You may like the look and feel of some blogs better than others. Notice which free service provides the blog you like best, and then sign up with the provider. (See Chapter 17 for the Web addresses of free photoblogs.)

Photoblogs Versus Photo Albums

Photoblogs are usually put together more carefully than album sites. For example, the photographer usually does not put up every picture taken during a session but instead edits down the photos to show only the best ones.

A photoblog is a very good place for a budding photography artist to begin his Internet presence, because it will teach him the basic discipline of Web page creation and design. Later if he decides he wants to have a full Web site, he can move (known as "publish") the photoblog over to his Web site and make it part of his own Web site. This means that the photoblog allows you to grow as your photographic and Web site skills improve.

Your Web Site

If you want total control over the display of your photographs on the Internet, then you may want to have your own Web site. This means you have complete freedom to design your site any way you please. In addition, individual Web sites are more likely to be found and ranked higher by search engines than photoblogs or photo sharing sites.

Putting Your Web Site Together

Unlike when you upload to photoblogs and photo sharing sites, you will be pretty much on your own when you set up your Web site. Nevertheless,

there is plenty of software you can use to design your Web site and photo galleries. See the listing in Chapter 17.

▲ A personal Web site gives you full control over the display and navigation of your imagery and your commentary.

Generally, you will create a home page and then link thumbnails on that home page to either larger pictures or to a gallery or galleries with more thumbnails. When designing a Web site, keep in mind that it can grow quite a bit over time, and you will need to adopt a design that can accommodate that increase.

Don't bite off more than you can chew. If you are uncomfortable, for example, with the concepts and procedures of uploading, FTP (file transfer protocol), HTML, Web title tags, Web addressing and Web page metatags, you might want to wait a bit before starting your own Web site.

Your Web Site Navigation

Pay special attention to navigation. Your site should be simple to click on, and full-size pictures should not be any more than two clicks from the

home page. This navigation design should be expandable so that as you add new pictures and new galleries, you can use the same style of navigation to reach these pages and return to the home page.

Background Information on Your Web Site

Every standalone photographic Web site should also have background pages about the photographer. If you are looking for jobs or recognition, this page is very important because it gives a sense of your credentials. A biography page might start with a brief paragraph about your vision of photography followed by a condensed history of your photography experience. It could include education, internships, exhibits, awards, jobs, and publications. Naturally this list will grow over time and should be updated every year or so. Many people list these items in reverse chronological order, with the most recent accomplishments listed first and the earliest last.

How to Link to Your Online Photos

If you have put your images on a photo album site, you may be able to link to these images and display them in your Web site or photoblog. This avoids having to upload twice and can help get around image size and total image storage space requirements on your own Web site or on Web pages at community sites such as MySpace.

Never assume that your links are working properly. In the beginning you should manually check each one. Later, with more experience, you can get a free program, called Xenu, to check all your links. Do this every time you put up a new page or make changes.

Relative Addressing Versus Absolute Addressing

This rather nerdy subject can make all the difference between your pictures showing and not showing on the Internet. Relative addressing means that with all images and pages in the same Web folder, you need to only link

to the picture file name or the page name, such as Picture.jpg. However, if a picture or page is not in the same folder, the Web surfer will get an error message and the page or picture will not come up.

Absolute addressing means that you list the full address (URL), http:// and all. So instead of just typing 'Picture.jpg' in the code for your web page with relative addressing, the absolute address might be *http://www.your Website.com/family/picture.jpg* in the code for your page. While Web surfers won't see your code (and it doesn't really matter to them), what they will see is a blank spot where your image should be if you get the addressing wrong in your page code.

FACT

You can never go wrong with absolute addressing, as long as the address is correct. Absolute addressing assures you that your pictures will come up as intended. You can check the validity of any absolute address by simply putting it in your browser address area and pressing Enter. The page or image you have targeted ought to appear in the browser.

Linking How-Tos

When linking to another site, be sure to put the complete address, including the http://. For example, if you have Photo_birthday.jpg at Yourname.Photoalbum.com, you would need to put that complete address in your page code to link to it properly. In this case, the link would look like this: *http://yourname.photoalbum.com/photo_birthday.jpg*. This addressing will vary from site to site, so check your specific site for requirements.

When putting your pictures on your own Web site, pay special attention to uppercase and lowercase letters in file names. Many servers are case sensitive. For example, if a link to one of your photos reads "picture.jpg" but the picture is named "picture.JPG," the picture might not be found.

How Search Engines Find Images

Search engines cannot look at a picture or understand the graphic content of a photograph. Instead, they rely on the picture file name and the text

on the page to explain what the image is about. For a full listing of image search engines, go to Chapter 10.

What You Should Include

You, the webmaster or photoblog author, must include the necessary text information. This information can be included in a number of ways, such as in the title of the page, in the metatags, in the file name, in the alt tag in the link to the image, in the text of the page itself, and in the text of the links within the site that link to a display page.

The Title Tag

The title tag is the most important place for information about your particular page, though often forgotten by webmasters. Search engines look at the title tag first and give it the greatest weight. While this tag is in a sense hidden, it does display at the top of the browser window in the blue area.

You as a Web designer will need to look at the page in HTML and add about sixty characters that describe what is on the page. Put the most important words first, followed by other words that add to its description. This description goes near the top between the following two HTML tags:

<title></title>

For example, a picture of a child's birthday cake might read like this:

<title>Birthday cake with candles, girl's birthday party </title>

File Names, Alt Tags, Captions, and Anchor Text

If you give the file an appropriate name that describes the image and also include an alt tag when you link to the image, search engines will have a much better idea of the content of your photo. Additional text helps as well.

- **The file name:** Give the file a name that reflects its content. For example, a picture of a birthday cake might be: Birthdaycake_1.jpg
- **The alt tag:** The alt tag gives a text description of an image and is part of the code that links to a picture. It is very important for image search engines. When you use HTML to post a picture, insert a

description along with the file name. The HTML code looks like this:

- **Captions:** Many photos have a caption. Below the photo you might put a caption explaining what the photo is about.
- **Image links:** When you link to the page with the birthday cake photo, write a brief description, called anchor text, that you then link to the page that displays the image.
- **Metatags:** These hidden tags are positioned directly below the <title> tag. In these tags you can add a description of what is on the page along with keywords. Metatags are less important than they used to be for search engines, but it never hurts to add them.

def·i·ni·tion

Anchor text: The text that a Web surfer clicks on to go to a page or Web site. Search engines give anchor text more weight because it accurately describes the content of the link. If people link to your pages, be sure they provide accurate anchor text to increase your search engine ranking.

These HTML components will make search engines more likely to flag your Web site and your images.

E-mailing Photos as Attachments

While people e-mail millions of photos around the globe every day, many do not understand how to do this. Very often people send pictures that are too large to view or that take too long to download. Some file formats cannot be read within the e-mail program, and pictures that are embedded in an e-mail image often do not display properly.

Sending Attachments

An attachment is exactly what you think it is. It is a file that is attached to an e-mail message but not part of the message itself. After an e-mail is sent, the receiving program usually signals, with a little icon such as a paper clip, that a file has been attached.

Follow these steps to include a photo as an e-mail attachment:

1. Before sending an attachment, you must save the picture file with an easy-to-understand name in a folder on your computer that you can find easily.
2. In your e-mail, choose the Attach File command. This command may be listed along with other e-mail features such as font style or may be listed under a menu.
3. The Attach command will open up a dialog box. This allows you to browse the files on your computer to find the one you want to attach.
4. Navigate to the folder that contains the file.
5. In the correct folder, pick the file you want to attach.
6. In an online program like Yahoo or Hotmail, you will need to confirm that you want to attach a file or files. It will take a while for those files to upload to the Internet.
7. You can continue to work on the text part of your e-mail. When you are finished, click Send and your e-mail will be sent with the attached files.

QUESTION?

Can you attach any kind of file?
You can attach virtually any file, in any format, size, or resolution, to an e-mail. This does not mean that it can be read in an e-mail message, but the recipient can download the attachment to her computer and open a viewing program that is capable of reading such a file.

Inline and Embedded Photographs

E-mail programs often allow a picture file to be placed in the message area itself. This is called an inline or embedded image. This is very similar to attaching a file except that the picture is displayed in the message and the picture file formats are usually limited to JPEG and GIF formats. Use the inline or embed command to accomplish this.

If you have an image on the Internet, you send a link to that image in an e-mail. You must use absolute addressing. To use the example from earlier

in the chapter, it would look like this: *http://www.yourWebsite.com/family/picture.jpg*. You can copy or type the address in the body of the e-mail so the recipient can see it and go to it.

Mistakes People Make with E-mail Photographs

You have probably received huge photos that took hours to download or pictures so big you could only see a corner of the image. Here's how to avoid doing these things.

Photographs That Are Too Tall and Too Wide

If a picture is too big, it cannot be viewed properly. The recipient will not be able to see the entire picture at one time because the image will go off the screen. The person will have to scroll up and down and side to side and will only see part of the image at one time.

You should match the image size with the resolution of the recipient's monitor. The best all-around resolution for e-mail is a fairly small size such as 320×240 or 480×360. Any e-mail program should be able to view this size. While you can probably get away with a larger size such as 640×480, remember that the e-mail program itself takes up a lot of space on the screen, leaving very little room for a full picture.

Viewing large photos can be confusing because many viewing programs automatically adjust for a size that is too large. Generally speaking, pictures that are e-mailed in the body of the message will not view properly if they are too large. However, attached files can be downloaded and then viewed in a separate program that can resize the image for viewing.

If you know the person you are e-mailing has a high monitor resolution, then by all means send a larger picture. Nevertheless, you will need to keep the picture considerably smaller than the full size of the recipient's monitor.

Photographic Files That Are Too Large

Very large files can take a long time to download. In addition, some e-mail services may not send or receive very large picture files. It is a good idea to keep the size below 150KB and an even better idea to keep a picture below 50KB. Use the JPEG compression feature to compress the file to the right size. JPEG and GIF files are the main still-image file formats. These can be read in an e-mail program and in a Web browser. A few programs might be able to read TIFF and BMP files, but don't count on it.

Prints, Printers, and Scanners

While you may enjoy viewing your digital images on a computer monitor, at some point you'll probably want to see a hard copy of what you've produced. You have several options available: you can get a photofinisher to do the work for you or you can buy your own printer. You may find it more convenient to let someone else do the job, but you might get a better quality print for less cost and with less effort than if you did it yourself.

The Printing Process

Film photographs are continuous tone prints that contain an infinite variation of tones, colors, and hues. If you looked through a loupe (a small magnifying glass used to examine photographs) to examine a photograph, you wouldn't see any white space or dot patterns. Digital prints, on the other hand, can generate 24-bit color, which means that they can reproduce 16.7 million colors. Although that sounds like a lot, it really isn't that many when you realize the billions of color variations the human eye can distinguish. On top of that, because of the way digital printers represent color, most can only print a fraction of these 16 million colors. Printers also do not print color continuously; instead, they lay color on a print dot by dot. Thousands of dots are placed on a page per second, but they are still individual dots. If the resolution of the print is too low or the printer can't generate images with tight dot patterns, the quality of the print will suffer.

Because we look at images on monitors that are back lit, it can be hard to judge how an image will look when it is printed on paper. Paper requires a light source that illuminates the paper. Printed images need to have more contrast plus darker and lighter tones than a computer image to look okay on paper.

Outsourcing Your Printing Needs

You don't have to own a printer or go through the hassle of getting a print just right. If you don't need to do a lot of printing on a regular basis, buying a printer is probably not a good idea. For a variety of reasons, a minilab or online photo lab might make more sense than purchasing another piece of equipment that you have to keep track of.

Take Your Prints to a Photofinisher

When you do the math for both time and money, you may decide that outsourcing your printing jobs is the way to go. Consider the following points:

- Photo labs print more than half of all digital photographs today.
- A lab can charge as little as 10 cents for a 4" × 6" print while the average cost for a DIY print is 40 cents.
- Large 8" × 10" prints can cost about the same as DIY prints, and the quality may be much better.
- Printing your own takes time, more than two minutes on average for small prints and as much as twelve minutes for larger prints.
- A good lab will have much better equipment than you could ever afford, and its equipment is well maintained.
- You can schedule your prints to be processed so that it takes almost no time out of your schedule.
- You can avoid all the problems of buying a color printer and stocking supplies for it.

FACT

You can often attach your photos to an e-mail that you send to a local business. Later you can pick up your prints at your convenience or when you run your errands.

Snapshot Prints

Wal-Mart and Walgreens and other such places offer comprehensive services for printing family snapshots and basic enlargements. You can usually bring a CD or a memory card to the printer. Typically, you insert the card or CD into a kiosk-type display and a touch screen walks you through the process. If you use the minilab service at these places, prints usually cost more and they can take up to an hour to process, but the quality is often better than a kiosk.

Copy centers and office supply stores such as Staples may offer more sophisticated printing with larger sizes, a variety of papers, and better quality.

Online Snapshot Services

Shutterfly (*www.shutterfly.com*) and Kodak (*www.kodakgallery.com*) both offer photo-sharing services geared toward family photos. For example,

their two free photo album gallery services allow your friends to view pictures online and also to order prints simply and easily.

Take time to correct, edit, and crop your pictures with your photo editing software. Then burn a CD or put your photos on a memory card that you take to a lab. This gives you the best of both worlds: You have total control over the look of your pictures and you avoid problems involved with doing your own printing.

Quality Online Labs

Other services, such as Adorama (*www.adoramapix.com*), have a reputation for producing exhibit-quality enlargements for very little cost. Read their guidelines for acceptable image size and print size, then upload your files. Professional photographers often rave about the high quality and low cost of this service. Online labs usually mail your photos to you in a matter of days.

Types of Printers

If you want to buy your own printer, there are a variety to choose from. Color printers for home or small business use usually range in price from $100 to $500. Printers in the middle of this range may offer higher print quality, but read reviews because some less expensive printers have ranked above more expensive ones. Generally, if you spend more, you'll gain faster output speed and additional features such as the ability to print directly from your camera's memory card or dual paper trays. On the downside, a printer can take up a lot of space, and ink can dry out if it is not used often.

Inkjet Printers

Inkjet printers work by forcing little drops of ink through nozzles onto the paper. Today's inkjet printers can produce excellent prints. They are designed for home or small business use, and they range in price from about

$60 to almost $400. With inkjet printers, you can output pictures on plain paper or more expensive thicker, glossy photographic-type paper stock. Pictures have better color and sharpness and more snap on glossy paper. If you are doing serious printing, you might print some work prints on plain paper and then your final prints on glossy.

Some inkjet printers have only three colors; typically they have three colors plus black. Avoid printers that do not have a black cartridge, as the quality is not as good. A few printers have more colors, such as six, seven, or even eight. Generally speaking, the more colors, the better the color rendition will be.

The wet ink that is forced onto the paper can also cause the paper to warp slightly, and prints can smear if you don't allow them to dry properly. Always handle newly printed photos with care. You can lessen these problems by using specially coated inkjet paper in your printer.

Color Laser Printers

Small laser printers are more expensive than inkjet printers, and they are also much larger. They generally do not accept glossy paper. However, although up-front costs are higher, money can be saved in the long run on consumables such as toner, ink, and paper. These printers are best for networked groups of people who need high-speed quality output.

Dye Sublimation Printers

For many years, dye sublimation printers have been heralded as the top-of-the range output device for digital printing. Dye subs (for short) transfer images to paper using a plastic film or ribbon that's coated with color dyes. During the printing process, heating elements move across the film, causing the dye to fuse to the specially manufactured transfer paper. These heating elements make a separate pass through the printer for each color.

You really won't know how well you will like a printer until you try it out. Make sure you can return the printer if you don't like the results. However,

many stores these days charge restocking fees, especially if you return a printer with partially used cartridges.

The advantages of dye sub printers are that they produce a high-quality, continuous-tone image with little or no evidence of pixelization. Dye sublimation printers are either three-color (cyan, magenta, and yellow) or four-color (cyan, magenta, yellow, and black).

There are several disadvantages to dye sub printers. The cost of consumables, particularly of the dye ribbon, is relatively high. Print paper for dye sub printers is also more expensive than photographic paper of equivalent size. Finally, questions have arisen about the stability of dyes over time, especially when prints come in contact with certain protective sleeves.

ALERT!

The best way to find out how well a printer handles photos is to look at a sample output. Unfortunately, the sample photos you see at a store will be designed to take advantage of the strongest aspects of the printer. Your best bet may be to carefully read reviews in newsgroups and on the Internet.

Thermo-Autochrome Printers

A handful of printers use thermal wax to heat pigment-carrying wax from a print ribbon. They are faster than dye sublimation printers because they use sticks of wax or ribbons of dye rather than ink cartridges. The technique is similar to that seen on fax machines that print on thermal paper. The major disadvantages of thermo-autochrome or thermal wax printers are that they reproduce color using a half toning process and that they can only use specially manufactured paper.

Computer-Free Printing

Some printers allow you to print images directly from your digital camera's memory card or other storage device. Other printers provide you with the option of cabling your camera to your printer for direct image download.

PictBridge

PictBridge is a standard that allows a digital camera to send pictures directly to a printer without having to go through a computer. The camera connects to the printer via the USB connector. Most new inkjet printers have this capability. This allows quick and easy printing but makes editing and tweaking much harder.

Digital Print Order Format (DPOF)

Digital print order format (DPOF) allows you to select images you want to print through your camera's user interface. The camera records your instructions and passes them on to the printer, and you can transfer images between the two devices. The downside of this technology is that you can't edit images on your computer.

Printers and Resolution

The standard for inkjet resolution is 600×600 dpi (dots per inch), but you can find higher resolutions such as 1200×1200 dpi or 1440×1440 dpi or even 2880×1440 dpi, all of which are considered photographic quality. In general, you'll want to avoid lower resolutions. Don't insist on 1200 dpi unless you need high-quality photographic output. Keep in mind that many inkjets have different resolutions for color and monochrome.

Resolution isn't the only factor that determines the output quality of your photographic prints. You also need to know whether the printer offers resolution enhancement, and if it does, what kind. Edge enhancement typically varies the size or position of dots on edges of lines, text, and solid blocks. Because this feature smoothes edges, it can produce an apparent resolution nearly double the dpi rating. However, it won't improve continuous-tone images such as photos. For photos, you can get very different output quality at any given resolution, depending on how the printer creates shades of gray and shades of colors.

Dots per Inch (DPI) and Pixels per Inch (PPI)

Probably the most confusing and often misused terms in digital photography are dpi and ppi. Manufacturers often don't use these terms as accurately as they should, and even professionals get them confused.

- **ppi:** Pixels per inch means just what it says, the number of actual pixels in one inch. For example, at 300 ppi a 5" × 7" inch print would be 1500 pixels by 2100 pixels.
- **dpi:** Dots per inch is really a printing term but is often used to mean ppi, which it is not. The resolution of a printer, for example, is listed at dpi, but in this case each pixel may be printed as several dots.

To get the best possible print, you want the ppi to be in synch with the dpi output of the printer. However, you may need to read the printer manual and/or talk to a knowledgeable person at the print shop.

Other Printer Considerations

The type of printer, paper required, type of connecting cable, and duration of the cartridges should all be part of your decision about what kind of printer to buy.

Specialized Photo Printers

If you need to print photos at the highest possible quality, consider an inkjet specifically designed for photos. These printers typically offer six ink colors rather than the usual four. The additional two colors improve photo quality in two ways: they increase the range of colors the printers can print, and they decrease the number of individual dots the printers need to create most colors.

Lowering the number of dots is important because it reduces the likelihood of showing noticeable "dithering" patterns. Because six-color printers can print any individual dot in more possible colors than four-color printers, they don't need as many dots to fake other colors. Fewer dots mean smaller, less visible patterns of dots.

Interface

The conventional choice for connecting to a standalone system is USB ports. Older printers use the parallel port.

Cartridge/Toner Life

Take a look at both the price of an ink or toner cartridge for any given printer and the number of pages it will print. An inexpensive cartridge that prints relatively few pages may actually be much more costly than a more expensive cartridge that prints more pages. Higher-capacity cartridges also mean that you won't have to change them as often, which can be particularly important for a network printer in an office that prints a large number of pages. Also, some color cartridges must be replaced all at one time, as they are bundled together. This means that if you use a lot of one color but not a lot of another, you will have to throw away cartridges full of ink. Look for cartridges in which each color can be replaced as needed. In addition, avoid low-cost inkjet cartridge refill kits. While they seem like a good deal, many people who have used them say that they are of low quality and a lot of trouble.

Photos fade primarily because they are exposed to UV or direct sunlight. Inkjet photos are especially vulnerable. This means that for maximum permanence, you should display photos away from sunlit windows. Some inkjet prints are also susceptible to smearing if they get wet, so handle with care.

Using the Right Type of Paper

When it comes to printing photographic quality prints, choosing the right paper is very important. The four basic types of paper are:

- **Copier paper:** Plain paper or copier paper is the least desirable type of paper for printing photographic images. This paper is okay for

printing text, but you'll get a smeary image if you use this paper for printing photos. Because it is less expensive than other papers, it is often a good choice for printing drafts.

- **Inkjet paper:** Special inkjet paper is good for printing photographic images. Inkjet paper absorbs ink well and creates a crisp image.
- **Photographic paper:** Special photographic paper comes in various sizes and stocks, and it is the best choice for printing photographs. It absorbs ink very well, but it is also quite expensive—about one dollar per sheet. To save money, print a few drafts on plain paper before you print a final copy on photographic paper.
- **Other papers:** You can find all types of specialty papers to use for producing stickers, color transparencies, iron-on transfers, decals, bookmarks, and the like. These can be a lot of fun to work with and can be purchased almost anywhere.

How Long Can I Expect My Prints to Last?

It is actually light that kills the color in prints, and ultraviolet light is the worst. The magenta and purple color dyes in inkjet prints fade the quickest. Bright magenta often turns red or brown fairly quickly. One manufacturer claims that its prints can last for twenty-five years if they are not exposed to UV light. Another way to make your prints last longer is to protect them under UV absorbing glass, which you can find in frame shops. It is estimated that a print that is protected in a low ultraviolet environment could last thirty years or more. And although it's true that the images you print today aren't going to be as colorful ten years from now, the same can be said about traditional photographs.

Wilhelm Imaging Research (*www.wilhelm-research.com*) is a well-respected authority that rates the archival quality of digital printing. Canon, Epson, Hewlett-Packard, and Lexmark use Wilhelm certified ratings for their products. Wilhelm offers a free e-book at its Web site called *The Permanence and Care of Color Photographs* that covers digital photo preservation.

Scanners

A scanner takes a picture of a page and then digitizes that image. Film photographers use scanners to rescue old negatives and prints. You can use scanners to gather interesting backgrounds for your image editing projects and even scanning real objects like leaves or flowers.

Scanners Are Included with All-in-One Printers

"All-in-one" inkjet printers include scanners as part of the package. The more-expensive ones allow you to scan in slides and negatives. The all-purpose printers often come bundled with other capabilities as well, such as being able to copy and fax documents. Some include an LCD preview screen, a memory card reader, and the ability to communicate directly with your camera using PictBridge.

Flatbed Scanners

A flatbed scanner takes its name from the flat glass platen (or bed) where you place the object to be scanned. It is versatile and can be used to scan flat materials such as photographs and printed pages. Purchase a scanner with an optical scanning resolution of at least 600 dpi so that you can scan detailed images and line art from photographs or other printed originals.

You can have fun scanning three-dimensional objects with your scanner. Because your scanner will place a slight shadow on one side of the object, you'll want to experiment. Scan the object, and if you don't like the effect you've achieved, reposition it on the glass platen and try again.

Film Scanners

A transparency or film scanner allows you to scan everything from a 35 mm slide to a 4" × 5" transparency. Film scanners generally feature an optical resolution of 1200 dpi or higher. In fact, most affordable transparency scanners scan images at 2700 dpi. That's because the higher resolution is needed to compensate for the small size of the item being scanned.

Glossary

35 mm equivalent
Before digital photography, 35 mm cameras were the standard for film based cameras. Since most people are familiar with the old 35 mm standard, it is used as a reference in digital photography just like horsepower is still used as a reference in automobiles. In digital photography, focal length and ISO are often stated in terms consistent with 35 mm.

alias
Jagged stair-step type lines that can occur when an image is resized.

aperture priority
A camera mode used in picture taking that allows the photographer to choose the aperture (controlling depth of field) while the camera sets the best matching shutter speed for desirable exposure results.

aperture, maximum
The largest lens opening, such as f-2; the f-number is usually stated on the lens along with the focal length.

aperture
The opening that controls the amount of light that passes through the lens. The size of the aperture is measured in f-stops, which control the length of time the shutter stays open and the depth of field.

applets
Tiny software applications.

aspect ratio
The ratio of image width to image height.

authorized dealer
A retailer designated by a camera manufacturer to sell its product line and who is held to the highest standards.

autoflash
A feature that enables a camera to gauge the available light and fire the flash if needed.

autoexposure
The automatic exposure setting of f-stop and shutter speed that is determined by the camera's automatic calculating system.

autofocus
A feature that automatically adjusts the focus depending on the distance of the subject from the camera.

available light
Light that exists in the environment.

back lighting
A lighting condition that occurs when you are photographing subjects with a bright area behind them, casting them in a shadow.

batch processing
Processing of multiple files at one time.

black and white
Term describing images that are monochrome or shades of gray.

blog
A weB-LOG, usually displayed in a long scrolling format that is archived from month to month; a blog can be just about anything the author wants.

bounce lighting
A lighting technique that allows light to bounce off the background and onto a subject, rather than using a light source aimed directly at the subject.

brightness
A measurement of the light in an image; used by scanners and software.

burst mode
A feature offered in some cameras that lets the photographer take photo after photo while holding down the shutter button.

camera menus
Menus displayed and controlled by the camera's software.

channel
An isolated part of the information that makes up a digital image.

cloning
A tool or process in an image editing application that allows the user to "paint" one section of an image onto another.

CMYK
Initialism for Cyan, Magenta, Yellow, and blacK.

collage
A combination of photographs and/or imagery into one composition.

color balance
The process by which most digital cameras automatically adjust for the correct color temperature; also *white balance*. Color balancing determines what combination of red, green, and blue light the camera should perceive as pure white under the current lighting conditions. From there, the camera determines how all other colors can be accurately represented.

color correction
The adjustment of an image to make the colors truer.

color depth
The term used to refer to the number of colors in an image. It is also called pixel depth or bit depth.

composition
The arrangement of elements and their relationship to the background in an image.

compression
A technique used to reduce the size of an image file. It works either by reducing the number of colors in an image or by grouping together a series of pixels of a similar color.

continuous mode
A feature that allows you to snap an entire sequence of photos, such as in time-lapse photography or simple animation.

crop
An image software command that allows you to resize an image so that parts of it are deleted.

dedicated flash
A flash that is designed to work with a specific camera make and model and can take advantage of many of the camera's exposure features.

depth of field
The measure of the area of a photograph that is in focus.

download
To transfer a file from a camera to a computer or from one computer to another.

dpi
Dots per inch, not to be confused with ppi, pixels per inch.

DSLR
Digital single-lens reflex; a type of high-end camera.

experimental photography
Photography that pushes the normal boundaries and definitions of what constitutes photography.

export
To send files from one system to another.

exposure compensation
Allows the photographer to increase or decrease the exposure from what the autoexposure setting typically delivers.

exposure
The combination of f-stop, shutter speed, and ISO that determines how much light hits the digital image sensors. The most important concept in photography.

extended warranties
Expensive multiyear warranties that are often given the hard sell by retailers but are not worth the money.

f-number
The f-stop.

f-stop
The lens aperture setting.

file format
A specific type of computer file that can contain a digital photograph or other digital information.

fill flash
A mode that allows you to add light to an image without affecting the exposure settings.

fill
A feature that lets you pour a color, effect, or texture into a closed space within an image.

film scanner
A type of scanner that allows you to scan everything from a 35 mm slide to a 4" × 5" transparency. These scanners are more expensive than flatbed scanners, but they are excellent for people who want to scan a lot of transparencies because they are the only scanner that will produce quality transparency scans.

filter
An effect, such as emboss, stretch, or warp, that modifies an image.

fixed focus
A lens with a focus that cannot be changed. Rather, the lens depends on the use of depth of field to produce sharp images.

fixed storage
Memory that cannot be increased or decreased. Once you've filled up the camera's memory, you cannot continue shooting until you've downloaded your images to a computer. Also called onboard storage.

flash memory
Nonvolatile electronic memory.

flash
A camera component that provides additional lighting to the scene being photographed.

flatbed scanner
A scanning device that takes its name from the flat glass platen (or bed) where you place the object to be scanned. It is very versatile and can be used to scan flat materials such as photographs and printed pages.

flip
An image software command that reverses the image left to right or right to left.

focal length
On film cameras, the measurement of the distance between the center of the lens and the film. On digital cameras, the focal length measures the distance between the lens and the image sensor. In both cases, focal length is measured in millimeters.

focus lock
Feature that allows the photographer to center the subject in the frame, lock the focus, then reframe and take the shot. When taking a shot of a scene with many elements, this can be a useful feature because it allows you to specify which object you want to be in focus.

freeware
Totally free software; much of the best image editing software is completely free.

gamma correction
A brightness image editing correction that lightens the darker areas faster than the lighter areas.

GIF animation
Usually a small animation; these can be viewed by just about any browser.

grayscale
Refers to black and white images that include all shades of gray.

hot spots
Effects that occur when light bounces off a reflective surface and creates areas in your image that have no detail; they look like white blobs on your picture. Also known as dropouts.

hot-swappable
Describes a camera or other peripheral equipment capable of being plugged into or unplugged from the USB port of a computer without the computer needing to be turned off or restarted.

image sensors
Light-sensitive computer chips that record the image captured by a digital camera. They serve the same purpose as film in a 35 mm camera.

import
To receive files sent from another system.

inkjet printer
A printer that works by forcing little drops of ink through nozzles onto the paper.

integrated lens
A lens that is part of the camera and is not detachable.

interchangeable lens
A lens that can be detached from the camera and replaced with another lens having the same type of mount.

interpolation
An algorithm that attempts to resize an image while maintaining the original sharpness of the picture.

ISO numbers

Numbers that are found on film packages and represent the film's speed, or sensitivity. Image sensors are also rated using ISO numbers, which are meant to be approximately equivalent to film ISOs. The lower the ISO of an image sensor, the more light is needed for a good exposure.

ISOE

ISO equivalent.

jaggies

Stairstep-type pixels that occur with simple resizing or poor interpolation.

layers

Stacking elements in an image. The layering tool lets you edit elements such as images, graphics, and text separately from each other. You also can change the settings, coloration, effects, and many more variables for each layer.

LCD

Liquid crystal display; an LCD monitor is on the back of most digital cameras.

lens cap

A camera accessory that protects your camera's lens and is especially important for your digicam. Digital cameras are particularly susceptible to scratching and smearing because the cameras are so small that your fingers may wind up on top of the lens.

lens hood

A camera accessory that hinders unwanted light from striking the lens. It also affords your lens some protection from knocks and bumps. Also called lens shade.

lens

An optical glass or plastic element designed to gather and focus rays of light and form an image.

light-balancing filter

A filter that compensates for different lighting conditions.

light meter

A device in a camera that reads the amount of light in a scene and then calculates the exposure.

line

An essential aspect of well-composed photographs. Shapes are defined by lines. As we view a photo, our eyes follow its lines. One of the most important uses of line is to lead the viewer to the center of interest in a photograph.

locking

Pushing the shutter button down part way to set the exposure and focus; the photographer can then reframe the picture while keeping those locked-in settings.

macro lens

A lens that allows you to focus while standing very close to your subject in order to take close-up shots.

macro photography

Very close photography; quite different from normal photography due to depth-of-field considerations.

magnification

The effect that a long lens has on a photograph. Magnification goes hand-in-hand with angle of view. A short lens, with its wide angle of view, requires all the objects in a scene to be reduced in size in order to fit into the image sensor. It has the effect of pushing the subject away from you. Conversely, the long lens, with its corresponding narrow angle of

view, will have the effect of pulling objects in a scene close to you, causing them to appear larger.

mAh
Milliamp hours; the amount of power stored in a battery.

manual override
A camera exposure setting that allows the photographer to override the automatic f-stop and shutter speed settings.

masking
A photo-editing tool that preserves areas of an image. Masking permits you to apply an effect to one specific part of an image or to vary the strength of an effect within an image.

megapixel
Used to describe the resolution that can be produced by a digital camera's image sensor; indicates that there are millions of pixels in the image.

memory card
The device that holds flash memory or nonvolatile memory.

metering
A built-in light meter that determines the correct exposure. Metering can be bottom- or center-weighted or spot.

monochrome
Black and white imagery.

newbie
A person new to a computer or Internet subject.

nickel metal hydride (NiMH) battery
A type of battery that is interchangeable with most NiCd batteries but generally delivers greater

capacity than NiCds. NiMH batteries are the most popular batteries for digital camera use because they are rechargeable, nontoxic, and relatively inexpensive.

night flash
A photography mode that combines a flash exposure with a longer capture speed. This mode is ideal for shooting room lights or an evening sky with a brightly lit subject. Also known as night portrait mode.

noise
Small imperfections that can ruin a perfectly good photograph. Noise comes from the light sensors in your digicam, resulting in an image that appears grainy or snowy, similar to a grainy film photograph or a snowy image on your TV screen. Noise tends to appear when a photographer chooses an ISO rating that is too high or uses image-editing software to correct an underexposed area.

nonvolatile memory
Flash memory.

overexposure
An exposure that causes too much light to hit the image sensors, causing a picture to be too light and to remove all detail in the highlights.

panoramic mode
A mode that allows a series of photographs to be taken together and then later stitched into one large wide image of a landscape.

parallax
The difference between the viewfinder and the taking lens, which results in different views seen through each. With DSLRs and through-the-lens viewing, parallax is avoided. Most LCD monitors display a true through-the-lens view as well.

pixel count

The number of pixels (in megapixels) in a photo.

pixel dimensions

The width and height dimensions of a digital image in pixels, such as 640×480.

pixel

The basic element of resolution. Derived from "picture element" or "picture cell."

plug-ins

Software components that are designed to be compatible with large image editing software programs; most image plug-ins need to be compatible with Adobe Photoshop to work with a variety of image editing programs.

polarizing filter

A filter that removes glare caused by reflected light and tends to improve color saturation.

ppi

Pixels per inch.

proprietary

A term characterizing software, file formats, or hardware that only works with one manufacturer's products.

prosumer

A high-end digital camera, but not as high as a DSLR.

readout

Information that displays in the LCD monitor or viewfinder during exposure, such as shutter speed, f-stop, and exposure mode.

reciprocity

A basic law of photographic exposure: when a shutter speed, f-stop, or ISO is halved or doubled, a corresponding change must be made in one of the other settings to maintain the same exposure.

red-eye

An effect that occurs when a flash is reflected in the subject's eyes.

resampling

A process that deletes or blends pixels in order to reduce an image's resolution without changing its width and height. Resampling can help reduce the size of files used on a Web site so that they download faster.

resizing and resampling

A software process that enlarges or reduces the size of an image; it usually involves some interpolation to improve picture quality.

resolution

A measure of the amount of detail that an image possesses.

resolution (computer monitor)

The pixel dimensions of a computer monitor display, such as 800×600.

resolution (digital camera photos)

The highest resolution is usually expressed at the highest pixel dimensions or the highest megapixel file size; lower resolutions can be chosen from the camera's menu.

RGB

Red, green, and blue; the primary colors for transmitted light. Your computer monitor, TV, and digital camera display their pixels based on values of red, green, and blue. When mixed together, red, green, and blue create white light.

rule of thirds

A formula for achieving balance, which requires that the photographer mentally divide an image into thirds, both horizontally and vertically. For instance, subjects are placed near one of the four intersections to provide immediate off-center emphasis or placed at diagonally opposed intersections to create a balanced composition.

saturation

The intensity of a color. Image-editing software allows the user to boost or reduce saturation as needed.

selection

The specified section of an image to which an effect will be applied.

self-timer

A mechanism that delays the shutter release for about ten seconds, allowing you to jump into a picture before the shutter releases. This is a useful feature when you want to take a self-portrait or include yourself in a group shot.

shape

The first thing our eyes distinguish when looking at a photograph.

shareware

Try-before-you-buy software that normally is downloaded off the Internet; some of the best software is shareware.

shutter priority

A camera mode used in picture taking that allows the photographer to choose the shutter speed while the camera sets the best matching aperture.

shutter speed

The setting that determines the amount of time that a camera's image sensors will be exposed to light.

slave unit

A small, battery-operated flash unit with built-in light sensors. The slave unit fires a flash when it senses another flash of light.

slow-sync flash

A flash that increases the exposure time beyond the normal flash. This mode helps illuminate background shadows that normal flash mode misses. The slow-synchronized mode works by allowing the shutter to remain open longer than normal so that the background appears lighter.

SLR

Single-lens reflex; a type of camera that uses one lens for both shooting and viewing. Allows the photographer to see exactly what the camera sees.

solarization

An experimental process that reverses some of the photographic tones; now an image-editing control.

spot reading

A technique for combating backlighting. Spot reading enables the photographer to take a reading in a smaller area, such as the shaded area of your subject. Once the spot reading is complete, the camera automatically opens the aperture, creating an image that is properly exposed.

spyware

Software that is sometimes bundled with legitimate software; it spies on the user and monitors the user's activities. Many software sites now test for spyware and remove it.

stabilization

A device on many digital cameras that steadies the camera and allows sharper photographs or slower hand-held shutter speeds.

thumbnails
Very small postage stamp size images of larger pictures; often clicking on a thumbnail will bring up the large photo.

tolerance
A setting that determines how discriminating a selection tool will be in matching the criteria you specify.

tonal range
The range from dark to light, expressed in f-stops, that photography can capture. Digital photography has a narrower tonal range than film photography.

tool
A device to assist a user in adjusting an image. Raster tools modify individual pixels; vector tools modify the entire image.

transparency
An effect that changes the opacity of an element so that underlying elements can show through.

tripod
A device that allows a camera to be positioned and steadied. Tripods are available in all sizes.

TTL
Through-the-lens. This is a term often used with SLR and DSLR cameras. It means, for example, that the metering is calculated from the light that comes through the lens rather than a general reading of the light in the environment.

underexposure
An exposure that is too dark; an underexposed picture loses detail in the dark or shadow areas.

unsharp mask
A sharpening filter frequently used to regain sharpness lost in the scanning process.

UV filter
A UV (ultraviolet) filter removes ultraviolet light, which commonly shows up in the background of distant shots as a bluish haze.

vector images
Shapes defined using the mathematical principle of vectors. Digital drawings are vector images. Some software programs let the user draw well-defined vector images of various shapes.

VGA
A standard monitor, television and image size of 640×480 pixels.

viewfinder
The device in a digital camera that the photographer uses to view the picture before taking the picture.

warm and cool colors
Categorization of colors. Reds and oranges are considered warm while blues and greens are considered cool.

white balance
See *color balance*.

APPENDIX B

Resources

ACE Index

✍ *www.acecam.com*

This extensive portal has links to thousands of camera stores worldwide, plus mail-order dealers and suppliers of digital, darkroom, lab, lighting, and studio equipment.

CLICK AND MORTAR

The following chain stores also offer online ordering. If you have a problem with a digital camera, you may be able to return it to the local store within the specified return period with no restocking charge. However, always check the return policy before buying.

Staples

✍ *www.staples.com*

This office supply store stocks a large number of digital cameras and accessories.

Wal-Mart

✍ *www.walmart.com*

You can order from Wal-Mart online and have an item delivered to your local store.

Radio Shack

✍ *www.radioshack.com*

Order from the catalog and return to the local store if you encounter any problems.

ONLINE RETAIL STORES

The following stores have been in business for a number of years and have established a reputation for honesty and reliability. However, check the store's return policy before buying.

B&H Photo & Video

✍ *www.bhphotovideo.com*

This long-established photography emporium based in New York City offers more than 130,000 items. The products in its massive inventory are well-categorized, and each comes with complete specifications, warranty information, features, and appropriate accessories. Purchasing is easy, and you can log in to track orders. A comprehensive customer service section covers returns, repairs, and the like.

Adorama

✍ *www.adorama.com*

This uncluttered site features a wide assortment of photography products. Specify price range, manufacturer, lenses or other features, or just click Search and get the complete inventory for each product.

Norman Camera & Video

✍ *www.normancamera.com*

This brick-and-mortar store has been located in Kalamazoo, Michigan, for more than forty years. One key to its longevity is undoubtedly its staff of friendly, knowledgeable salespeople who will go out of their way to help you.

Precision Camera & Video

www.precision-camera.com

This popular Austin, Texas–based store has a digital department with digicams from more than a dozen manufacturers, plus accessories, printers, and scanners. Extensive product listings include summaries, features, and all the specs you could want.

Ritz Camera

www.ritzcamera.com

Ritz is a popular choice among shutterbugs. From children's cameras to advanced photo systems, you'll get detailed product information and good discounts on all the merchandise Ritz offers.

REVIEWS AND SPECIFICATIONS SHEETS

Digital Photography Review

www.dpreview.com

Comprehensive site with reviews of hundreds of digital cameras. You can find specifications for many cameras at this site as well.

The Imaging Resource

www.imaging-resource.com

Hundreds of reviews of digital cameras with full specifications.

NEWS GROUPS

Participate in or search these news groups for digital camera or printing information. Get comments from hands-on users.

rec.photo.digital

comp.periphs.printers

HISTORY OF PHOTOGRAPHY ONLINE

Smithsonian Images

http://smithsonianimages.com

From the Smithsonian Institute in Washington, D.C.

The Light Factory

www.lightfactory.org

A museum in Charlotte, North Carolina, that celebrates film and offers courses on digital photography.

George Eastman House

www.eastmanhouse.org

A museum based on the estate of the founder of Kodak.

The International Center For Photography

www.icp.org

For decades the ICP has been a center for humanitarian documentary photography with collections and courses in photography.

BOOKS

Books of Photographs

Steichen, Edward, ed. and Carl Sandburg, contributor. *The Family Of Man.* New York: Museum of Modern Art, 2002.

Cartier-Bresson, Henri, and Yves Bonnefoy, contributor. *Henri Cartier-Bresson: Photographer.* New York: Bulfinch, 1992.

Books About Image Processing

Cope, Peter. *Creative Digital Photography: A Practical Guide To Image Enhancement Techniques.* London: Carlton Books, 2005.

Busselle, Michael. *Creative Digital Photography.* New York: Amphoto Books, 2002.

Digital Photography Careers

Doble, Rick. *Career Building Through Digital Photography.* New York: Rosen Publishing Group, 2007.

APPENDIX C

Photography Reference Tables

PHOTO IMAGE RESOLUTION TABLE

Print resolutions are calculated at 300 ppi (pixels per inch). However, 200 ppi is often acceptable for prints. To calculate the pixel dimensions for 200 ppi, simply multiply the height and width in inches of the print times 200. For example, a 5" × 7" print at 200 ppi = 1000×1400.

Pixel Dimensions	E-mail	Web	Prints—4" × 6"	Prints—8" × 10"
320×240	okay	okay	no	no
480×360	good	okay	no	no
640×480	okay	good	no	no
1800×1200	no	no	good	no
3000×2400	no	no	no	good

RECIPROCITY

All photographic calculations are doubles or halves. When you double or halve an f-stop, shutter speed, or ISO, you must make a corresponding change in one of the other settings to compensate.

F-stops: Each f-stop lets in half as much light as the one before it.
F-stops: 1.4, 2.0, 2.8, 4.0, 5.6, 8, 11, 16, 22

Shutter Speeds: Each shutter speed lets in light for half as long as the one before it.
Shutter Speeds (in seconds): 1, 1/2, 1/4, 1/8, 1/15, 1/30, 1/60, 1/125, 1/250, 1/500, 1/1000, 1/2000

ISO: Each ISO is twice as sensitive to light as the one before it.
ISO: 25, 50, 100, 200, 400, 800, 1600, 3200

EXAMPLE OF RECIPROCITY

The following exposures are all the same:

Setting	Exposure 1	Exposure 2	Exposure 3	Exposure 4
F-stop	f-8	f-5.6	f-8	f-11
Shutter Speed	1/125	1/250	1/250	1/250
ISO	100	100	200	400

DEPTH OF FIELD FACTORS

Depth of field is affected by focal length, aperture, and distance. Photographers often juggle their settings so that they can use depth of field to their advantage. For example, in macro photography where the depth of field is very small, a tripod allows a long shutter speed and a high f-number so that depth of field can be increased.

Factor	Minimal	Some	Moderate	Considerable
Focal Length (35 mm eqv.)	200 mm	100 mm	50 mm	35 mm
Aperture	2	4	8	11
Distance	inches	5"	>10'	<10'

SPECIFICATIONS SHEET EXAMPLE

This is a spec sheet for a fictitious camera.

Spec Sheet for Fantastic Digital Camera, XG1000

Item	Specifications
Camera model	Fantastic Digital Camera, XG1000
File formats	JPEG (EXIF), TIFF, RAW
Number of pixels recorded	3072×2034, 1600×1200, 640×480
Video	640×480 at 30 fps, monaural sound
Video format	MPG
Memory card type	SD (512MB, 1GB, 2GB)
Lens	zoom 35 mm–200 mm (35 mm equivalent)
Max aperture	f-2.8–f-4
ISO range	50–400
Shutter speeds	1/2–1/1000
Exposure modes	autoexposure, aperture priority, shutter priority, manual
Direct printing	PictBridge, DPOF
Power supply	4 AA alkaline batteries, AC adapter
Connector	USB 2.0
Viewfinder	electronic LCD
Flash	auto, red-eye reduction, slow sync, off

HOW TO NAME AND DATE FOLDERS

The following folder and file system works quite well and will keep your images in the order that they were shot. Years later you will be able to locate any photo you shot. Modify the following to suit your own needs.

Under the first folder, **C:\Photos**, create a subfolder called "Originals." Now you have your first subfolder: **C:\Photos\Originals.**

Next, when you download new originals, store them in subfolders under the Originals subfolder. Generally, it is most convenient to give each folder a YYM-MDD date-type name, such as 080712.

Your first folder that you download pictures to is now: **C:\Photos\Originals\080712.**

HOW TO NAME DATED FOLDERS

Assigning folder names with dates can be a bit confusing to the novice, so here is some advice from years of working with tens of thousands of saved images:

Be consistent: While you can assign numerical names in any manner you choose, you should be consistent.

Add extra zeros: Add zeros to single-digit months and days and years. Instead of 6 for the month of June, put 06; instead of 5 for the fifth day of the month, put 05.

Put the year, then month, then day for correct computer sorting: If you want your folders to sort properly in the order that you created them, name your dated folders as follows:

For August 6, 2009, name your folder: 090806. The full path (including drive C:) looks like this: **C:\Photos\Originals\090806\Cameraphotoxyz.jpg.**

This folder will now sort correctly when you add another folder in the following year, such as January 21, 2010. The folder name will be 100121, and the full path will be: **C:\Photos\Originals\100121\Cameraphotoxyz.jpg.**

While you can use the normal way of writing a date by putting the month first, then the day and then the year as the name of your folder, it will not sort correctly. After the first year, the computer will sort on the month instead of the year so that all the June folders from different years will be together, rather than the folders being in chronological order.

Index

THE EVERYTHING SERIES!

BUSINESS & PERSONAL FINANCE

Everything® Accounting Book
Everything® Budgeting Book, 2nd Ed.
Everything® Business Planning Book
Everything® Coaching and Mentoring Book, 2nd Ed.
Everything® Fundraising Book
Everything® Get Out of Debt Book
Everything® Grant Writing Book, 2nd Ed.
Everything® Guide to Buying Foreclosures
Everything® Guide to Mortgages
Everything® Guide to Personal Finance for Single Mothers
Everything® Home-Based Business Book, 2nd Ed.
Everything® Homebuying Book, 2nd Ed.
Everything® Homeselling Book, 2nd Ed.
Everything® Human Resource Management Book
Everything® Improve Your Credit Book
Everything® Investing Book, 2nd Ed.
Everything® Landlording Book
Everything® Leadership Book, 2nd Ed.
Everything® Managing People Book, 2nd Ed.
Everything® Negotiating Book
Everything® Online Auctions Book
Everything® Online Business Book
Everything® Personal Finance Book
Everything® Personal Finance in Your 20s & 30s Book, 2nd Ed.
Everything® Project Management Book, 2nd Ed.
Everything® Real Estate Investing Book
Everything® Retirement Planning Book
Everything® Robert's Rules Book, $7.95
Everything® Selling Book
Everything® Start Your Own Business Book, 2nd Ed.
Everything® Wills & Estate Planning Book

COOKING

Everything® Barbecue Cookbook
Everything® Bartender's Book, 2nd Ed., $9.95
Everything® Calorie Counting Cookbook
Everything® Cheese Book
Everything® Chinese Cookbook
Everything® Classic Recipes Book
Everything® Cocktail Parties & Drinks Book
Everything® College Cookbook
Everything® Cooking for Baby and Toddler Book
Everything® Cooking for Two Cookbook
Everything® Diabetes Cookbook
Everything® Easy Gourmet Cookbook
Everything® Fondue Cookbook
Everything® Fondue Party Book
Everything® Gluten-Free Cookbook
Everything® Glycemic Index Cookbook
Everything® Grilling Cookbook
Everything® Healthy Meals in Minutes Cookbook
Everything® Holiday Cookbook
Everything® Indian Cookbook
Everything® Italian Cookbook

Everything® Lactose-Free Cookbook
Everything® Low-Carb Cookbook
Everything® Low-Cholesterol Cookbook
Everything® Low-Fat High-Flavor Cookbook
Everything® Low-Salt Cookbook
Everything® Meals for a Month Cookbook
Everything® Meals on a Budget Cookbook
Everything® Mediterranean Cookbook
Everything® Mexican Cookbook
Everything® No Trans Fat Cookbook
Everything® One-Pot Cookbook
Everything® Pizza Cookbook
Everything® Quick and Easy 30-Minute, 5-Ingredient Cookbook
Everything® Quick Meals Cookbook
Everything® Slow Cooker Cookbook
Everything® Slow Cooking for a Crowd Cookbook
Everything® Soup Cookbook
Everything® Stir-Fry Cookbook
Everything® Sugar-Free Cookbook
Everything® Tapas and Small Plates Cookbook
Everything® Tex-Mex Cookbook
Everything® Thai Cookbook
Everything® Vegetarian Cookbook
Everything® Whole-Grain, High-Fiber Cookbook
Everything® Wild Game Cookbook
Everything® Wine Book, 2nd Ed.

GAMES

Everything® 15-Minute Sudoku Book, $9.95
Everything® 30-Minute Sudoku Book, $9.95
Everything® Bible Crosswords Book, $9.95
Everything® Blackjack Strategy Book
Everything® Brain Strain Book, $9.95
Everything® Bridge Book
Everything® Card Games Book
Everything® Card Tricks Book, $9.95
Everything® Casino Gambling Book, 2nd Ed.
Everything® Chess Basics Book
Everything® Craps Strategy Book
Everything® Crossword and Puzzle Book
Everything® Crossword Challenge Book
Everything® Crosswords for the Beach Book, $9.95
Everything® Cryptic Crosswords Book, $9.95
Everything® Cryptograms Book, $9.95
Everything® Easy Crosswords Book
Everything® Easy Kakuro Book, $9.95
Everything® Easy Large-Print Crosswords Book
Everything® Games Book, 2nd Ed.
Everything® Giant Sudoku Book, $9.95
Everything® Giant Word Search Book
Everything® Kakuro Challenge Book, $9.95
Everything® Large-Print Crossword Challenge Book
Everything® Large-Print Crosswords Book
Everything® Lateral Thinking Puzzles Book, $9.95
Everything® Literary Crosswords Book, $9.95
Everything® Mazes Book
Everything® Memory Booster Puzzles Book, $9.95
Everything® Movie Crosswords Book, $9.95

Everything® Music Crosswords Book, $9.95
Everything® Online Poker Book
Everything® Pencil Puzzles Book, $9.95
Everything® Poker Strategy Book
Everything® Pool & Billiards Book
Everything® Puzzles for Commuters Book, $9.95
Everything® Puzzles for Dog Lovers Book, $9.95
Everything® Sports Crosswords Book, $9.95
Everything® Test Your IQ Book, $9.95
Everything® Texas Hold 'Em Book, $9.95
Everything® Travel Crosswords Book, $9.95
Everything® TV Crosswords Book, $9.95
Everything® Word Games Challenge Book
Everything® Word Scramble Book
Everything® Word Search Book

HEALTH

Everything® Alzheimer's Book
Everything® Diabetes Book
Everything® First Aid Book, $9.95
Everything® Health Guide to Adult Bipolar Disorder
Everything® Health Guide to Arthritis
Everything® Health Guide to Controlling Anxiety
Everything® Health Guide to Depression
Everything® Health Guide to Fibromyalgia
Everything® Health Guide to Menopause, 2nd Ed.
Everything® Health Guide to Migraines
Everything® Health Guide to OCD
Everything® Health Guide to PMS
Everything® Health Guide to Postpartum Care
Everything® Health Guide to Thyroid Disease
Everything® Hypnosis Book
Everything® Low Cholesterol Book
Everything® Menopause Book
Everything® Nutrition Book
Everything® Reflexology Book
Everything® Stress Management Book

HISTORY

Everything® American Government Book
Everything® American History Book, 2nd Ed.
Everything® Civil War Book
Everything® Freemasons Book
Everything® Irish History & Heritage Book
Everything® Middle East Book
Everything® World War II Book, 2nd Ed.

HOBBIES

Everything® Candlemaking Book
Everything® Cartooning Book
Everything® Coin Collecting Book
Everything® Digital Photography Book, 2nd Ed.
Everything® Drawing Book
Everything® Family Tree Book, 2nd Ed.
Everything® Knitting Book
Everything® Knots Book
Everything® Photography Book
Everything® Quilting Book

Everything® Sewing Book
Everything® Soapmaking Book, 2nd Ed.
Everything® Woodworking Book

HOME IMPROVEMENT

Everything® Feng Shui Book
Everything® Feng Shui Decluttering Book, $9.95
Everything® Fix-It Book
Everything® Green Living Book
Everything® Home Decorating Book
Everything® Home Storage Solutions Book
Everything® Homebuilding Book
Everything® Organize Your Home Book, 2nd Ed.

KIDS' BOOKS

All titles are $7.95
Everything® Fairy Tales Book, $14.95
Everything® Kids' Animal Puzzle & Activity Book
Everything® Kids' Astronomy Book
Everything® Kids' Baseball Book, 5th Ed.
Everything® Kids' Bible Trivia Book
Everything® Kids' Bugs Book
Everything® Kids' Cars and Trucks Puzzle and Activity Book
Everything® Kids' Christmas Puzzle & Activity Book
Everything® Kids' Connect the Dots
Puzzle and Activity Book
Everything® Kids' Cookbook
Everything® Kids' Crazy Puzzles Book
Everything® Kids' Dinosaurs Book
Everything® Kids' Environment Book
Everything® Kids' Fairies Puzzle and Activity Book
Everything® Kids' First Spanish Puzzle and Activity Book
Everything® Kids' Football Book
Everything® Kids' Gross Cookbook
Everything® Kids' Gross Hidden Pictures Book
Everything® Kids' Gross Jokes Book
Everything® Kids' Gross Mazes Book
Everything® Kids' Gross Puzzle & Activity Book
Everything® Kids' Halloween Puzzle & Activity Book
Everything® Kids' Hidden Pictures Book
Everything® Kids' Horses Book
Everything® Kids' Joke Book
Everything® Kids' Knock Knock Book
Everything® Kids' Learning French Book
Everything® Kids' Learning Spanish Book
Everything® Kids' Magical Science Experiments Book
Everything® Kids' Math Puzzles Book
Everything® Kids' Mazes Book
Everything® Kids' Money Book
Everything® Kids' Nature Book
Everything® Kids' Pirates Puzzle and Activity Book
Everything® Kids' Presidents Book
Everything® Kids' Princess Puzzle and Activity Book
Everything® Kids' Puzzle Book
Everything® Kids' Racecars Puzzle and Activity Book
Everything® Kids' Riddles & Brain Teasers Book
Everything® Kids' Science Experiments Book
Everything® Kids' Sharks Book
Everything® Kids' Soccer Book
Everything® Kids' Spies Puzzle and Activity Book
Everything® Kids' States Book
Everything® Kids' Travel Activity Book
Everything® Kids' Word Search Puzzle and Activity Book

LANGUAGE

Everything® Conversational Japanese Book with CD, $19.95
Everything® French Grammar Book
Everything® French Phrase Book, $9.95
Everything® French Verb Book, $9.95
Everything® German Practice Book with CD, $19.95
Everything® Inglés Book
Everything® Intermediate Spanish Book with CD, $19.95
Everything® Italian Practice Book with CD, $19.95
Everything® Learning Brazilian Portuguese Book with CD, $19.95
Everything® Learning French Book with CD, 2nd Ed., $19.95
Everything® Learning German Book
Everything® Learning Italian Book
Everything® Learning Latin Book
Everything® Learning Russian Book with CD, $19.95
Everything® Learning Spanish Book
Everything® Learning Spanish Book with CD, 2nd Ed., $19.95
Everything® Russian Practice Book with CD, $19.95
Everything® Sign Language Book
Everything® Spanish Grammar Book
Everything® Spanish Phrase Book, $9.95
Everything® Spanish Practice Book with CD, $19.95
Everything® Spanish Verb Book, $9.95
Everything® Speaking Mandarin Chinese Book with CD, $19.95

MUSIC

Everything® Bass Guitar Book with CD, $19.95
Everything® Drums Book with CD, $19.95
Everything® Guitar Book with CD, 2nd Ed., $19.95
Everything® Guitar Chords Book with CD, $19.95
Everything® Harmonica Book with CD, $15.95
Everything® Home Recording Book
Everything® Music Theory Book with CD, $19.95
Everything® Reading Music Book with CD, $19.95
Everything® Rock & Blues Guitar Book with CD, $19.95
Everything® Rock & Blues Piano Book with CD, $19.95
Everything® Songwriting Book

NEW AGE

Everything® Astrology Book, 2nd Ed.
Everything® Birthday Personology Book
Everything® Dreams Book, 2nd Ed.
Everything® Love Signs Book, $9.95
Everything® Love Spells Book, $9.95
Everything® Paganism Book
Everything® Palmistry Book
Everything® Psychic Book
Everything® Reiki Book
Everything® Sex Signs Book, $9.95
Everything® Spells & Charms Book, 2nd Ed.
Everything® Tarot Book, 2nd Ed.
Everything® Toltec Wisdom Book
Everything® Wicca & Witchcraft Book, 2nd Ed.

PARENTING

Everything® Baby Names Book, 2nd Ed.
Everything® Baby Shower Book, 2nd Ed.
Everything® Baby Sign Language Book with DVD
Everything® Baby's First Year Book
Everything® Birthing Book

Everything® Breastfeeding Book
Everything® Father-to-Be Book
Everything® Father's First Year Book
Everything® Get Ready for Baby Book, 2nd Ed.
Everything® Get Your Baby to Sleep Book, $9.95
Everything® Getting Pregnant Book
Everything® Guide to Pregnancy Over 35
Everything® Guide to Raising a One-Year-Old
Everything® Guide to Raising a Two-Year-Old
Everything® Guide to Raising Adolescent Boys
Everything® Guide to Raising Adolescent Girls
Everything® Mother's First Year Book
Everything® Parent's Guide to Childhood Illnesses
Everything® Parent's Guide to Children and Divorce
Everything® Parent's Guide to Children with ADD/ADHD
Everything® Parent's Guide to Children with Asperger's Syndrome
Everything® Parent's Guide to Children with Asthma
Everything® Parent's Guide to Children with Autism
Everything® Parent's Guide to Children with Bipolar Disorder
Everything® Parent's Guide to Children with Depression
Everything® Parent's Guide to Children with Dyslexia
Everything® Parent's Guide to Children with Juvenile Diabetes
Everything® Parent's Guide to Positive Discipline
Everything® Parent's Guide to Raising a Successful Child
Everything® Parent's Guide to Raising Boys
Everything® Parent's Guide to Raising Girls
Everything® Parent's Guide to Raising Siblings
Everything® Parent's Guide to Sensory Integration Disorder
Everything® Parent's Guide to Tantrums
Everything® Parent's Guide to the Strong-Willed Child
Everything® Parenting a Teenager Book
Everything® Potty Training Book, $9.95
Everything® Pregnancy Book, 3rd Ed.
Everything® Pregnancy Fitness Book
Everything® Pregnancy Nutrition Book
Everything® Pregnancy Organizer, 2nd Ed., $16.95
Everything® Toddler Activities Book
Everything® Toddler Book
Everything® Tween Book
Everything® Twins, Triplets, and More Book

PETS

Everything® Aquarium Book
Everything® Boxer Book
Everything® Cat Book, 2nd Ed.
Everything® Chihuahua Book
Everything® Cooking for Dogs Book
Everything® Dachshund Book
Everything® Dog Book, 2nd Ed.
Everything® Dog Grooming Book
Everything® Dog Health Book
Everything® Dog Obedience Book
Everything® Dog Owner's Organizer, $16.95
Everything® Dog Training and Tricks Book
Everything® German Shepherd Book
Everything® Golden Retriever Book
Everything® Horse Book
Everything® Horse Care Book
Everything® Horseback Riding Book
Everything® Labrador Retriever Book
Everything® Poodle Book
Everything® Pug Book

Everything® Puppy Book
Everything® Rottweiler Book
Everything® Small Dogs Book
Everything® Tropical Fish Book
Everything® Yorkshire Terrier Book

REFERENCE

Everything® American Presidents Book
Everything® Blogging Book
Everything® Build Your Vocabulary Book, $9.95
Everything® Car Care Book
Everything® Classical Mythology Book
Everything® Da Vinci Book
Everything® Divorce Book
Everything® Einstein Book
Everything® Enneagram Book
Everything® Etiquette Book, 2nd Ed.
Everything® Guide to C. S. Lewis & Narnia
Everything® Guide to Edgar Allan Poe
Everything® Guide to Understanding Philosophy
Everything® Inventions and Patents Book
Everything® Jacqueline Kennedy Onassis Book
Everything® John F. Kennedy Book
Everything® Mafia Book
Everything® Martin Luther King Jr. Book
Everything® Philosophy Book
Everything® Pirates Book
Everything® Private Investigation Book
Everything® Psychology Book
Everything® Public Speaking Book, $9.95
Everything® Shakespeare Book, 2nd Ed.

RELIGION

Everything® Angels Book
Everything® Bible Book
Everything® Bible Study Book with CD, $19.95
Everything® Buddhism Book
Everything® Catholicism Book
Everything® Christianity Book
Everything® Gnostic Gospels Book
Everything® History of the Bible Book
Everything® Jesus Book
Everything® Jewish History & Heritage Book
Everything® Judaism Book
Everything® Kabbalah Book
Everything® Koran Book
Everything® Mary Book
Everything® Mary Magdalene Book
Everything® Prayer Book
Everything® Saints Book, 2nd Ed.
Everything® Torah Book
Everything® Understanding Islam Book
Everything® Women of the Bible Book
Everything® World's Religions Book

SCHOOL & CAREERS

Everything® Career Tests Book
Everything® College Major Test Book
Everything® College Survival Book, 2nd Ed.
Everything® Cover Letter Book, 2nd Ed.
Everything® Filmmaking Book
Everything® Get-a-Job Book, 2nd Ed.
Everything® Guide to Being a Paralegal
Everything® Guide to Being a Personal Trainer
Everything® Guide to Being a Real Estate Agent
Everything® Guide to Being a Sales Rep
Everything® Guide to Being an Event Planner
Everything® Guide to Careers in Health Care
Everything® Guide to Careers in Law Enforcement
Everything® Guide to Government Jobs
Everything® Guide to Starting and Running a Catering Business
Everything® Guide to Starting and Running a Restaurant
Everything® Job Interview Book, 2nd Ed.
Everything® New Nurse Book
Everything® New Teacher Book
Everything® Paying for College Book
Everything® Practice Interview Book
Everything® Resume Book, 3rd Ed.
Everything® Study Book

SELF-HELP

Everything® Body Language Book
Everything® Dating Book, 2nd Ed.
Everything® Great Sex Book
Everything® Self-Esteem Book
Everything® Tantric Sex Book

SPORTS & FITNESS

Everything® Easy Fitness Book
Everything® Fishing Book
Everything® Krav Maga for Fitness Book
Everything® Running Book, 2nd Ed.

TRAVEL

Everything® Family Guide to Coastal Florida
Everything® Family Guide to Cruise Vacations
Everything® Family Guide to Hawaii
Everything® Family Guide to Las Vegas, 2nd Ed.
Everything® Family Guide to Mexico
Everything® Family Guide to New England, 2nd Ed.
Everything® Family Guide to New York City, 3rd Ed.
Everything® Family Guide to RV Travel & Campgrounds
Everything® Family Guide to the Caribbean
Everything® Family Guide to the Disneyland® Resort, California Adventure®, Universal Studios®, and the Anaheim Area, 2nd Ed.
Everything® Family Guide to the Walt Disney World Resort®, Universal Studios®, and Greater Orlando, 5th Ed.
Everything® Family Guide to Timeshares
Everything® Family Guide to Washington D.C., 2nd Ed.

WEDDINGS

Everything® Bachelorette Party Book, $9.95
Everything® Bridesmaid Book, $9.95
Everything® Destination Wedding Book
Everything® Father of the Bride Book, $9.95
Everything® Groom Book, $9.95
Everything® Mother of the Bride Book, $9.95
Everything® Outdoor Wedding Book
Everything® Wedding Book, 3rd Ed.
Everything® Wedding Checklist, $9.95
Everything® Wedding Etiquette Book, $9.95
Everything® Wedding Organizer, 2nd Ed., $16.95
Everything® Wedding Shower Book, $9.95
Everything® Wedding Vows Book, $9.95
Everything® Wedding Workout Book
Everything® Weddings on a Budget Book, 2nd Ed., $9.95

WRITING

Everything® Creative Writing Book
Everything® Get Published Book, 2nd Ed.
Everything® Grammar and Style Book, 2nd Ed.
Everything® Guide to Magazine Writing
Everything® Guide to Writing a Book Proposal
Everything® Guide to Writing a Novel
Everything® Guide to Writing Children's Books
Everything® Guide to Writing Copy
Everything® Guide to Writing Graphic Novels
Everything® Guide to Writing Research Papers
Everything® Improve Your Writing Book, 2nd Ed.
Everything® Writing Poetry Book